Child Art in Context

Child Art in Context

A Cultural and Comparative Perspective

Claire Golomb

AMERICAN PSYCHOLOGICAL ASSOCIATION

WASHINGTON, DC

Copyright © 2002 by the American Psychological Association. All rights reserved. Except as permitted under the United States Copyright Act of 1976, no part of this publication may be reproduced or distributed in any form or by any means, or stored in a database or retrieval system, without the prior written permission of the publisher.

Published by
American Psychological Association
750 First Street, NE
Washington, DC 20002
www.apa.org

To order
APA Order Department
P.O. Box 92984
Washington, DC 20090-2984
Tel: (800) 374-2721; Direct: (202) 336-5510
Fax: (202) 336-5502; TDD/TTY: (202) 336-6123
Online: www.apa.org/books/
Email: order@apa.org

In the U.K., Europe, Africa, and the Middle East, copies may be ordered from
American Psychological Association
3 Henrietta Street
Covent Garden, London
WC2E 8LU England

Typeset in Berkeley by EPS Group Inc., Easton, MD

Printer: Edwards Brothers, Inc., Ann Arbor, MI
Cover Designer: Nini Sarmiento, Baltimore, MD
Technical/Production Editor: Kristen Sullivan

The opinions and statements published are the responsibility of the authors, and such opinions and statements do not necessarily represent the policies of the American Psychological Association.

Library of Congress Cataloging-in-Publication Data

Golomb, Claire.
 Child art in context : a cultural and comparative perspective / Claire Golomb.—1st ed.
 p. ; cm.
 Includes bibliographical references and index.
 ISBN 1-55798-903-6 (alk. paper)
 1. Drawing ability in children—Cross-cultural studies. I. Title.
 [DNLM: 1. Child Psychology. 2. Art—Child. 3. Cross-Cultural Comparison. 4. Symbolism—Child.
WS 105.5.C7 G627ca 2002]
BF723.D7 G635 2002 *OVERSIZE*
155.45'—dc21

2001056719

British Library Cataloguing-in-Publication Data
A CIP record is available from the British Library.

Printed in the United States of America
First Edition

For our young artists, Raphi, Mali, Evie, Sari, and Micah

Contents

List of Figures

Acknowledgments

I thank the many children from diverse backgrounds who participated in our studies and allowed us to observe and question them while they were drawing, painting, and modeling. They taught us much about the meaning of their artwork and about the sources of their enjoyment and wonder as a composition begins to take shape. They were our partners in this long-term project who helped us gain an understanding of their conceptions of representation in diverse media and of the significance of individual differences in style, talent, intention, and motivation.

I also acknowledge the contributions of my students at the University of Massachusetts at Boston who participated in my research on the development of child art, in studies devoted to drawing, painting, and sculpture. Special thanks are due to the Department of Psychology and its chair, Steve Schwartz, for the substantial support of the color plates that grace this book.

I am grateful for the generous assistance provided by Michael Pollard and Bob White in the preparation of many of the illustrations and for the much-valued comments of colleagues who read selected sections, chapters, or the complete manuscript. Their reviews increased the accuracy of the presentation and sharpened the focus of this book. My sincere thanks to Monni Adams, Sven and Ingrid Andersson, David Pariser, and Anath Golomb. I also thank my editors at the American Psychological Association, Lansing Hays and Anne Woodworth, for their constructive criticism and helpful suggestions, which greatly improved the organization of this book. Their assistance and support are much appreciated.

The cooperation of the following individuals and institutions that provided me with photographs of artworks is gratefully acknowledged:

- Art Resource, New York, for two "Venus" figures
- Harald Floss from the University of Tübingen, Institut für Ur-und Frühgeschichte und Archäologie des Mittelalters, for the Vogelherd horse
- the French Ministry of Culture and Communication for two wall art reproductions from the Chauvet-Pont-d'Arc Cave
- Rafael Martínez Valle, director of the Museo de la Valltorta, Spain, for permission to reproduce two Mesolithic rock paintings of battle scenes
- the Peabody Museum of Archeology and Ethnology, Harvard University, for permission to reproduce two Anasazi petroglyphs from the Scott files
- the Paul Klee Stiftung, Kunstmuseum Bern, for three drawings by Paul Klee
- Kathleen Jones from the Krannert Art Museum of the University of Illinois for *The Blue Gable* and the Städtische Galerie im Lenbachhaus, Munich, for *Village Street in Winter*, both by painter Gabriele Münter

- the van Abbe Museum in Eindhoven, The Netherlands, for *View of Murnau With Church II* and the Städtische Galerie im Lenbachhaus for *Sketch for Composition II*, both by painter Wassily Kandinsky
- Max Kläger and the Schneider Verlag Hohengehren for two paintings by Willibald Lassenberger
- Malka Haas for paintings from her collection
- Lorna Selfe for permission to reproduce two drawings of Nadia
- Sven and Ingrid Andersson for the Himba drawing
- the Artists Rights Society, New York/VG Bild-Kunst, Bonn.

Child Art in Context

INTRODUCTION

Since the "discovery" of child art at the end of the 19th century, children's drawings have engaged psychologists, educators, anthropologists, and artists in their quest to understand the significance of children's early drawings and paintings. The typical characteristics of children's drawings—for example, the appearance of flat two-dimensional forms that lack specificity, the omission of parts, and the depiction of anatomically inaccurate body proportions—led most psychologists to conclude that the child's mental immaturity and conceptual deficiencies best explained the distortions and deviations in the pictorial medium from what was assumed to be an optimal representation based on optical realism. Children's productions in a three-dimensional medium, for example, clay, were not considered.

What appeared to psychologists as seriously deficient pictorial productions that necessitated correction in the course of cognitive development were hailed by artists as a mark of originality and inspiration. The modernist revolution in the visual arts of the late 19th century and early 20th century, with its impulse to return to an original language of simple forms of artistic expression, welcomed the deviations from realistic representation that are characteristic of the drawings of children and people with a mental illness. Many artists were intensely interested in children's artwork, among them Léon Bakst, André Derain, Wassily Kandinsky, Paul Klee, Henri Matisse, Joan Miró, Gabriele Münter, and Pablo Picasso. Some of these artists had extensive collections of children's drawings, and their work very clearly shows this influence. According to Fineberg

(1995, 1997, 1998), the roots of their fascination with child art lie in the Romantic movement of the late 18th century and early 19th century, which exalted the naiveté of the child and lauded its freshness of vision unencumbered by centuries of academic training. To the artists who, at the beginning of the 20th century, rejected the naturalistic traditions of art, childhood presented the prehistory of the adult, a period of authenticity, inspiration, innocence, and truth to which many artists felt drawn. Simplicity of representation became a much-valued quality of art, and the graphic language of childhood was praised as the mainspring of creativity.

A similar spirit of innovation can be seen in the philosophy of art education most commonly associated with Franz Cizek, an artist and art educator who came to prominence around the turn of the 20th century in Vienna (Viola, 1936). The Romantic vision of Jean Jacques Rousseau, most clearly articulated in his fictional character Emile (Rousseau, 1762/1964) had fostered an interest in folk art, tribal art, and the art of the child (Champfleury, 1869, 1874; Töpffer, 1848). The concept of childhood implied an unspoiled, authentic vision with direct access to the sensory world. Educators were admonished to protect this innocence from the corrupting impact of civilization and its social conventions that were supposed to stifle creativity and the emergence of a truthful self. This vision of childhood led to innovations in the teaching of children, including the teaching of drawing. Cizek and his followers fostered the child art style as a means for self-expression, and they rejected traditional meth-

ods designed to train youngsters in the techniques of perspective and other projective devices for rendering space.

Underlying these diverse perspectives on child art are questions about the nature of representation, its origin and development, the course it takes in the visual arts, and whether this course can best be understood as a progression toward a specific endpoint, such as optical realism in art. Of equal interest are questions regarding the role of cognition, motivation, talent, and the sociocultural environment in artistic development. The studies reported in this book address fundamental questions regarding the meaning and intellectual status of the childish forms; the role of internal models or mental images; the significance of the medium; the motivation to draw, paint, and model with clay; and the language of child art as cultural convention or universal rule system.

THE CONTEXT OF REPRESENTATION

Starting from the premise that child art ought to be studied within an ecologically meaningful context, I chose themes that interest the young artist and paid special attention to the process of creation and to the child's ongoing commentary and interpretation. On the basis of my data on diverse tasks and media, I was able to infer the logic of the representational strategies children use when drawing and modeling. Over the course of this work, I have come to appreciate the intelligence of children's artistic endeavors to invent symbol systems that can represent their ideas in the two- and three-dimensional media of drawing and sculpture.

My findings militate against the prevailing notion that children's drawings reflect their conceptual immaturity, that they represent a kind of "printout" of a primitive internal image. This position and its variants ignore the nature of the medium of representation; they stem from the uniquely Western perspective that progress in drawing consists of a unilinear path toward optical realism in art. The history of art in diverse cultures, however, indicates that naturalism or realism is not a universal endpoint of human artistic development, that there are multiple and divergent routes to artistic excellence, and that the

model of child art as symptom of mental deficiency is outdated and ought to be revised. The notion that child art is a manifestation of a primitive and conceptually immature mind that recapitulates historical developments has not been supported, and its reference to children as well as preliterate people is misleading.

Reviewing the theories that have long dominated the field, I found that, over the past century, children's drawings have been studied largely from a Western cultural viewpoint. While the discipline of developmental psychology has moved toward situating the study of childhood within a broader network of sociocultural relations (Cole, 1996; LeVine, Dixon, LeVine, & Richman, 1994; Rogoff, 2000; Saxe, 1991; Vygotsky, 1962, 1971, 1978; Wertsch, 1985, 1991; Whiting & Edwards, 1988), the study of child art has lagged somewhat behind because of its nearly exclusive focus on the conception of a linear development that starts from a primitive, naive, and object-centered depiction and eventually reaches the verisimilitude of optical realism.

My focus throughout these chapters is on child art and how the young artist deals with the constraints and possibilities of the medium in which artistic representation occurs. Because the core questions relate to the nature of representation and its diverse manifestations, I need to clarify what is meant by *representation* and how it is to be distinguished from perception and other cognitive processes. Following Jean Piaget (1951), the concept of representation in its broad meaning refers to thought that is based on a system of differentiated symbols and their referents, to signifiers and their meanings (signified) that can be evoked in thought in the absence of the real object. In the more restricted sense of the visual arts, representation refers to the invention of pictorial forms that can stand for the intended object without confusing the symbol with its referent. For example, the child who draws a circle with facial features and calls this production "a mommy" does not confuse the drawing with the existence of the real person. In this action the child exhibits an intuitive understanding that one thing can represent another thing without it being a replica, a truly symbolic action. Artists throughout the ages have acted on this understanding, regardless of

the particular style of painting that characterized an era and the works of its individual members.

In the development of child art, we need to differentiate between mere *sensory–motor actions* on a medium and *intentional actions* designed to create a specific object that can stand for an aspect of the world. The child who engages in such sensory–motor actions as scribbling on paper or pounding clay may well evoke images that go along with the action and create pretend scenarios, but these are fleeting associations that cannot sustain their meaning without a recognizable end product. These actions and gestures are meaningful and satisfying to the child, and they bear a significant relationship to the events they intend to signify (Kindler, 1999; J. Matthews, 1984), but they are not yet meant to create specific shapes that bear a likeness to the object. Representation implies an understanding that a mental action such as a thought can lead to the intention to create specific forms that can stand for the object and can be recognized after the action of drawing or modeling with clay has been completed. It is a more enduring mental action that can lead to further developments in the specific medium or mode of representation. Thus, the concept of representation implies a mental activity that goes beyond the perception of objects and events and transforms them with the means available in the chosen medium. In the artistic domain of drawing, painting, and sculpting, representation refers to the intention to construct an image that corresponds in some way to an aspect of the outer or inner world of the artist. It is a potentially conscious mental activity.

It is important to keep this distinction between prerepresentational sensory–motor actions and truly symbolic representations in mind because the terms *symbol* and *representation* have in recent years been applied much more broadly to include neurophysiological processes that are not accessible to consciousness and last a fraction of a second (Marr, 1982; Willats, 1997). In the conceptual framework of artificial intelligence, representation is defined in terms of computational operations that occur outside awareness as patterns of neural firings (Hacker, 1991). In the somewhat different domain of infant cognitive research, representation has been evoked to describe young infants' responses to certain experimental conditions that indicate short-term memory of an object in a particular location (Baillargeon, 1987; see also DeLoache, Pierroutsakos, & Troseth, 1996; Karmiloff-Smith, 1992; Mandler, 1988, 1998). Early forms of memory and perhaps a primitive form of perceptual or conceptual analysis do not qualify as representations as I have previously defined the term. They are short-lived and difficult-to-elicit phenomena, a far cry from representation meaning a potentially conscious and intentional mental activity. It is unfortunate that the distinction between signifier and signified, the symbol and its referent as a conscious mental activity that can be reflected on, has been lost in the discourses mentioned above (Müller & Overton, 1998). Intentionality and the ability to relate intention and production constitute defining attributes of the concept of artistic representation. At the heart of artistic activity lies the intention to represent an aspect of the real or imagined world that creates a relationship of resemblance and keeps the distinction between the two in mind.

I use the term *representation* in its restricted meaning of a symbolic activity that constructs in its particular medium, with the tools at its disposal, a representation of its world. Representation is a constructive mental activity; it is not a literal or exact imitation or copy of the object, although the perceiver may, at times, find a resemblance striking or even deceptive. Representation in this sense is a major biological, psychological, and cultural achievement. It has an ancient history, as the cave art of 35,000 years ago indicates. Although the meaning of these awesome works is unknown, they indicate a representational mind that speaks to us across a void of a pictorial activity that played an important role in the lives of our prehistoric ancestors who faced a harsh reality in their struggle for survival. Reviewing the surviving records of this early artistic endeavor leads to the question of whether there is a relationship between prehistoric art and child art, a question I address in later chapters.

Investigators disagree significantly about whether the onset of conceptual thought—that is, of categorical and reflective activity that goes beyond the recording of perceptual events—appears in infancy or during the second year of life. In the realm of child

art, there is considerable agreement that the beginning of representational activity in drawing is the intention to make a form that can stand for the object and resemble it in some primitive way. The child who recognizes this resemblance acknowledges its equivalence to the object qua form. This recognition involves a transformation that changes the earlier scribble marks on paper or in sand into forms that point beyond themselves. Mere gestures or words, as in symbolic play, do not qualify as pictorial representations.

ORGANIZATION OF THIS BOOK

In the following chapters, I bring a cultural and comparative perspective to bear on the child and his or her artistic activity when I address the nature of the progression; the effects of two- and three-dimensional media; the role of intelligence, talent, motivation, learning, and culture; and the evidence from atypically developing children. I devote a chapter to the development of sculpture (modeling figures with clay), a subject long neglected by students of child art.

This book is intended for developmental and educational psychologists, anthropologists interested in the arts, art historians, and educators. It is of interest to undergraduate and graduate students in these fields.

Chapter 1 provides a brief historical review of the study of child art and the different perspectives artists and psychologists have brought to this topic. Contrasting orientations to child art are introduced, and positions that continue to engage theorists are highlighted. These positions concern the nature of representation in the artistic domain, the effects of the two-dimensional medium, the role of internal models or mental images, and theories of artistic development as progression toward realism in art or as a multidirectional course with diverse objectives.

Chapter 2 examines the development of drawing and painting from several theoretical perspectives that are currently influential in the field, followed by an extensive examination of data on the artwork of ordinary children, artistically gifted children, and atypically developing children who have mental retardation and sometimes also autism. This chapter delineates the evolution of forms, the pictorial differentiation of figures and their spatial relations, and the role of color in narrative depictions and its expressive function. Across all these dimensions of the artistic domain, development is seen as a meaningful mental activity that serves cognitive, affective, social, and aesthetic functions. Analysis of studies of children's artwork provides the basis for a clarification of contested theoretical issues and outlines new directions for understanding child art and its development in diverse sociocultural environments.

Chapter 3 is devoted to the development of sculpture. It provides a more comprehensive account of the child's representational concepts by going beyond the traditional single medium of drawing and focusing on modeling in a three-dimensional medium. Its documentation is based on a set of systematic investigations of children ages 2–12 years. The research strategies derive from the discipline of experimental psychology, with its emphasis on standardized procedures and careful construction of protocols, but they also include qualitative analyses of children's conceptions that guide their work. The studies were conceived within broadly formulated theories of pictorial development that provided the initial set of hypotheses that underpin this investigation. Their conclusions are relevant to the development of drawing as well as modeling by highlighting the importance of media-specific effects in the representation of three-dimensional aspects of objects and scenes.

In chapter 4 I systematically compare the similarities and differences in children's drawn and modeled human and animal figures, calling attention to the different mental models that underlie their representation in different media. To distinguish between general symbolic processes and the impact of cultural variables, I extend my review beyond the work of Western children living in an industrialized society and consider principles of continuity and change in the context of individual development and communal values, with special emphasis on preliterate societies. This review includes the pictorial record of a past civilization—the rock art of the Anasazi people of the southwestern United States, practiced continuously over 1,000 years—and continues with findings from more contemporary, pre-

dominantly illiterate societies. The findings indicate that artistic changes tend to occur along diverse routes, that meaning can be conveyed without the use of perspective pictorial devices, and that level of graphic differentiation need not correspond to cognitive achievements in other realms. Overall, this survey suggests that the basic language of pictorial and plastic representation, at least in its early stages, is universal, and that cultural conventions tend to produce meaningful variations on the same underlying structural forms.

Because child art deals with beginnings in ontogenetic development, I extend my inquiry to the "beginnings of beginnings" in the search for the roots of artistic representation. I first consider antecedents of art making in some species of nonhuman primates and then turn to the earliest available records of the art of our human ancestors. Chapter 5 explores cave art, both mobiliary (portable engravings and carvings on small objects of stone, antler, bone, and ivory) and wall art, a record that extends over 25,000 years of the Upper Paleolithic period. To gain some understanding of the conditions under which this early art making evolved and to assess its cultural significance, I review data on lifestyle, crafts, art, and social organization and report on radically different views regarding the intellectual capacities of our ancestors, *Homo sapiens*, in Europe. The search for beginnings has not yielded the hoped-for answers, because the earliest records of artistic representational activity reveal a sophisticated level of skill, which cannot be the work of novices and most likely reflects an ongoing artistic tradition. Counter to the expectation of early investigators, prehistoric art does not mirror the changes researchers observe in the development of child art. However, comparing the work of children with the work of our remote ancestors provides useful suggestions for understanding both domains and strongly suggests that the intellectual capacities of these prehistoric people by far exceeded those of children. The stunning naturalistic representations of the Paleolithic artists, made at a very early period in the history of modern humans in Europe, clearly indicates that optical realism or naturalism in art is not a natural endpoint of human artistic development. This record of early artistic achievement challenges the notion of

developmental stages invariably progressing from primitive global representations to realism in art, along a singular path that reflects the artist's increasing cognitive complexity.

In contrast to the devaluation of child art as a primitive and deficient product of an immature mind, chapter 6 explores the fascination many modern artists have felt for child art, their aesthetic delight in the freedom from conventions, and their respect for the simplicity and directness of the representation. I note their search for a basic, more truthful language and grammar of the pictorial arts, a desire to recapture childhood perceptions, and an antiestablishment sentiment that rebelled against established traditions that no longer served to express their thoughts and feelings. Of course, a return to a child art style was not seen as an end in itself but rather a new beginning that could free the artist from worn-out conceptions. The modern artists' respect for child art and adoption of some of its characteristics encourage us to go beyond listing the child's deviations from anatomical correctness to an appreciation of the inventive intelligence that underlies the creation of graphic and plastic symbol systems.

In chapter 7 I propose a reconsideration of child art that emphasizes the creative problem-solving activities of children engaged in the visual arts and highlights considerable cognitive flexibility in their approach to representation. This orientation rejects the "conceptual deficit" notions of child art and of the art of so-called primitive people and delineates the various routes artistic development can take in the individual and across cultures and historical periods. The style of a pictorial representation will depend on the communicative function it serves, the personal skills and inclinations of its maker, the peer culture, and the values of the artist's society. Such an approach has educational as well as aesthetic implications and calls for a new orientation to the systematic study of child art and its developmental trajectories that goes beyond an exclusive concern with form to a more encompassing research agenda that is sensitive to the ecological validity of the findings. Situating child art more distinctly within a sociocultural and historical context provides a novel perspective on the relationship of child art to adult art

and a more balanced account of the role of intelligence, talent, motivation, learning, and cultural transmission.

The extended discourse over different media, sociocultural similarities and differences, the pictorial language of preliterate people, the sophisticated accomplishments of the Paleolithic artists, and the interest and respect of modern artists for children's work have yielded new insights. The broader comparative, cultural, and historical perspectives on artistic development enable students of child art to go beyond long-held convictions of the superiority of optical realism in art that equate simplicity of forms

with the mind of primitives doomed to conceptual immaturity, and the notion that artistic excellence is correlated with a particular style of representation. Studies of talent, IQ-independent artistic skills, training, motivation, and the availability of models lead to a better understanding of the arts as a history-bound phenomenon that calls for a reassessment of child art and its developmental course and for new directions of research. Although these recent studies have didactic implications for art education and clinical assessment, a discussion of their practical application is beyond the scope of this book.

THE DEVELOPMENT OF DRAWING

For more than 100 years, children's drawings, to the exclusion of other media, have received the attention of students of child art who have pondered the nature of artistic development and the principles that best account for its course. The early drawings of children puzzled observers faced with odd figures that did not resemble everyday appearances. How does one account for the "tadpole" humans composed of a disproportionately large head and spindly legs? What could be the "model" for these unrealistic creatures that violated representational norms? The odd drawings called for an investigation of the mental processes that underlie these creations.

This chapter begins with a brief historical overview of approaches to children's drawings, followed by a review of the kinds of issues addressed by current theories of pictorial representation. I then present my own views on artistic development and consider a series of questions regarding the nature of drawing development: Is it an orderly process comprised of recognizable phases in pictorial thinking and problem solving, or is it merely the product of social conventions? Can it best be described in terms of stages in logical thinking? What are the underlying determinants of children's drawings, and what role does talent play in this development? Finally, what propels the changes observed over time and with experience, and what is the impact of the medium? These questions are intimately related to how we conceive of the nature of progress in drawing and whether it is a unilinear path toward ever-increasing optical realism in the depiction of three-dimensional space or whether there are multiple and divergent routes to artistic accomplishments. To seriously consider these issues, I report data from "normally" and atypically developing children, from studies of talented children, and from cross-cultural studies.

INFLUENTIAL COGNITIVE THEORIES OF DRAWING DEVELOPMENT

Around the turn of the 20th century, artists and educators organized the first exhibitions of child art, and many publications appeared on the development of children's drawings. This new interest was sparked by a confluence of major movements in the arts, art education, and psychology. In the arts, such influential movements as impressionism, postimpressionism, expressionism, cubism, and surrealism challenged the academic adherence to realism and the emphasis on rendering scenes in perspective. Art educators were closely aligned with the artists who spawned this revolution in the visual arts; they appreciated the aesthetics of children's paintings and emphasized that child art was an original language that needed to be fostered and valued in its own right (Franz Cizek, cited in Viola, 1936). Many artists drew inspiration from their own childhood drawings and from the drawings of their own children.

The beginnings of a systematic psychological study of child development can be dated to the latter part of the 19th century, and the first publications devoted to child art stem from this period (Barnes, 1894; Götze, 1898; Hall, 1883; Lukens,

1896; Maitland, 1895; Ricci, 1887; Sully, 1896). On the basis of extensive observations of children's drawings, these studies fostered a new appreciation of children's graphic productions as insights into their mental life. From a developmental perspective, the drawings seemed to chronicle the steps the human mind takes from a primitive state to a phase of intellectual enlightenment. Thus, the collection of children's drawings became a respected endeavor, and researchers undertook many longitudinal and cross-sectional studies. The great value of these pioneering studies lies in their description of developmental phases in drawing and provision of basic information about children's style of drawing and preferred subject matter (Ballard, 1912; Burt, 1921; Katz, 1906; Kerschensteiner, 1905; Krötzsch, 1917; Lamprecht, 1906; Levinstein, 1905; Luquet, 1913, 1927; Rouma, 1913; Stern, 1908, 1909; Stern & Stern, 1910).

However, unlike the artists who valued the graphic language of children and lauded its expressive quality, the professional scholars of child art called attention to many peculiarities of children's drawings. They pointed to the omission or misplacement of important body parts (e.g., arms emanating from a head) and to "transparencies," depictions of parts not visible from the viewer's vantage point (e.g., a baby inside the mother's womb). They noted the young child's disregard for the relative size of figures, the odd proportions within the figures, and the schematic nature of the drawings that violates the rules of realism or naturalism in art. These peculiarities were seen as the typical manifestations of an immature, confused, and conceptually deficient mind. These widely held assumptions, which saw "primitivism" as a mental handicap that needed to be overcome, were quite congruent with positions articulated in related fields. They fit in well with emerging views in developmental psychology (Baldwin, 1895; Bühler, 1930; Hall, 1883, 1904; Stern, 1914), and they seemed to corroborate anthropological perspectives on primitive cultures (Lévy-Bruhl, 1910/1966, 1923) and to extend them into the ontogenetic realm. These assumptions were also in agreement with a position espoused by some art historians that realism or naturalism in art presented the highest artistic achievement a culture could attain (Minardi, 1843/1987; Riegl, 1893; Ruskin, 1843; Zerffi, 1876).

This general attitude of scholars of children's drawings received powerful support in the writing of two psychologists who affected the study of child art for decades to come. Florence Goodenough (1926) transformed the earlier, qualitative measures of children's drawings into a quantitative instrument that assessed children's intelligence on the basis of their drawings of the human figure. This test of intelligence became a widely used measure of the child's conceptual maturity, a practice that was further elaborated by Dale Harris (1963), who restandardized and extended the test.

An equally important influence on the study of child art as an index of the mental or conceptual maturity of the young child was proposed by Jean Piaget (1926, 1928, 1929, 1951; Piaget & Inhelder, 1956, 1971). From the beginning of his highly productive career, Piaget was convinced that mental life was best described in terms of qualitatively different stages in the evolution of mental development. At an early phase of development, the child uses symbols that lack differentiation and yield a distorted understanding of self and others. The child's mental life is dominated by cognitive egocentricity, an inability to take diverse perspectives into account which, in Piaget's view, is a characteristic of prelogical thought and its conceptual limitations.

Piaget postulated a close correspondence between children's drawings and their spatial–mathematical reasoning. His position has been consistently spelled out in several publications (Piaget, 1928; Piaget & Inhelder, 1956, 1969; Piaget, Inhelder, & Szeminska, 1960) but most clearly in his book *The Child's Construction of Space* (Piaget & Inhelder, 1956). In this work, Piaget delineated a developmental progression that begins with the drawing of closed, general-purpose forms that ignore the true shape, size, and proportion of the object they represent. These drawings are based on topological relations that differentiate between the inside and the outside of a form, between being connected and disconnected, and show a beginning respect for the ordering of parts. Piaget, who related this phase of drawing with the preoperational period of cognitive development (ages 2–7 years) and its conceptual

deficiencies, adopted the classification system developed by George Henri Luquet (1913, 1927), an influential art historian who identified a series of stages in the drawings of his young daughter. In Piaget's view, this classification system was congruent with his own conception of cognitive development, and he proposed a series of transformations in drawings that lead from early topological relations to a stage of *intellectual realism*. Such drawings show progress in the differentiation of parts of a figure, and they depict more varied forms, but these accomplishments are limited to relations that are internal to the figure, and their resemblance to the model remains crude.

Piaget saw a major shift occurring during the concrete operational period (ages 7–11 years), which ushered in a transition to *visual realism* in drawing. The drawings now display greater attention to detail and increasing differentiation of forms, sizes, and proportions, and by the age of 8 or 9, the child's intuitive understanding of Euclidean concepts of measurement and projective geometry lead to a more visually realistic rendition of a scene. Children can now explore new techniques for representing depth, use occlusions and size diminution, and eventually progress to linear perspective. Visual realism or photographic realism depicts a scene as it is supposed to appear to the viewer from a stationary position. For Piaget, the ability to adopt another's vantage point, acquired during the middle childhood years, ought to correspond to visual realism and the use of perspective in children's drawings. One might say that Piaget treated drawings as a kind of "printout" of the child's mental image and of his or her conceptual status. In Piaget's view, the construction of logical thought is mirrored in the child's drawings, and photographic realism is seen as a desired endpoint in a developmental sequence whose highest achievements are based on concepts of measurement, scale, proportion, and projective relations. By the end of the concrete operational period and the beginning of the formal operations stage, children are supposed to have achieved this ideal level of realistic depiction. Of course, this conception is based on art as replication or close approximation of the three-dimensional world.

Here I have to note that Piaget was not studying artistic development as such but focusing on the child's ability to depict certain spatial relations on a set of specified tasks. Piaget found Luquet's stage-dependent classification of the various kinds of "realism" congruent with his own theory of spatial–mathematical reasoning and incorporated Luquet's scheme into his own analysis of drawing as spatial representation.

Piaget's overall view of cognitive development is that of a steady progression toward a specific endpoint. In science, that endpoint is logico–mathematical reasoning; in the visual arts it is optical realism. In various guises, Piaget's position has dominated the study of child art for the better part of the 20th century, and this standard of realism also underlies Goodenough's evaluation of children's drawings and their correlation with intelligence as measured by IQ tests. Despite significant differences in the theories of cognitive development, many investigators have shared the assumption that graphic development progresses toward a norm of realism in art and that deviations from photographic likeness are marks of conceptual limitations.

This view continues to inspire many researchers who study normally and atypically developing children. These researchers tend to adopt a stage conception of graphic development that is wedded to Piaget's stages of development, with special emphasis on his stages of intellectual and visual realism and the transition between them. In their view, visual realism and the acquisition of perspective in drawing required the construction of highly developed concrete and formal operations, in addition to the capacity for dynamic imagery that includes the rotation of mental images (Blatt, 1994; Lange-Küttner & Reith, 1995; Milbrath, 1998; Reith, 1988, 1997). These researchers assume that the domain of logico–mathematical reasoning that underlies Piaget's grand scheme of cognitive development is also applicable to the domain of the visual arts. Frequently ignored is the evidence, by now considerable, that visual realism is not a generally achieved representational stage and that few adolescents reach it without explicit training or copying of appropriate models (Cox, 1992, 1993; Golomb, 1992b; Milbrath, 1998; Pariser, 1995b; Thomas & Silk, 1990; van Sommers, 1995; Willats, 1977, 1997). The empirical

findings indicate that there is, on the one hand, a significant delay or arrest in the graphic development of normally developing adolescents and adults, while on the other hand there is an early achievement of visual realism in artistically talented children, both normally developing (Beck, 1928; Golomb, 1992b, 1995; Milbrath, 1998; Paine, 1981; Winner, 1996; Zimmerman, 1995) and some with mental retardation (Selfe, 1977, 1995; Wiltshire, 1987, 1989, 1991).

Although Piaget's theory has received widespread acceptance among developmental psychologists, it has also been subjected to serious review, criticism, and revisions. In the 1970s, investigators demonstrated the significant effects of task variables and the nature of the medium on the child's representation and thus challenged the notion of an underlying immature, conceptually primitive, mental image or schema responsible for the so-called defective global and tadpole figures (Freeman, 1977, 1980; Golomb, 1972, 1973, 1974). At the same time, Howard Gardner and his colleagues (Carothers & Gardner, 1979; H. Gardner, 1980; Winner, 1982) focused on symbolic and aesthetic factors in children's perception and production of pictures. Research conducted over the past 30 years indicates that young children are not as egocentric as Piaget postulated and that even four- and five-year-olds can consider view-specific aspects of an array.

To assess the current state of affairs in this domain, I review four contemporary approaches to the field of drawing development represented in the work of Norman Freeman, Maureen Cox, Constance Milbrath, and John Willats. Their respective theories demonstrate new conceptions while revealing the continued impact of Piaget's theory. The latter can be seen in the continued emphasis on the hypothesized progression toward optical realism in art and the importance attributed to a shift from an object-based description (Piaget's intellectual realism) to a view-based depiction (Piaget's visual realism).

Norman Freeman: The Production Deficit Hypothesis

Norman Freeman and his colleagues (1980, 1985) have challenged Piaget's emphasis on conceptual deficits in children's drawings. Freeman proposed that the child's understanding is not impaired or immature and that the "defective" drawings reflect production problems and built-in biases. Children's planning strategies are limited; they do not access all the information that is available to them; and inborn biases will lead to odd body proportion effects, omission of parts due to serial order effects, and preference for canonical views. Canonical representations convey structural information about an object and display its most easily recognizable features. Planning, foresight, the temporal and spatial ordering of parts, and monitoring the whole process require the cognitive and attentional capacities of middle childhood. The faulty drawings of young children are but imperfect expressions of a complete and coherent underlying image and are not due to a failure in perceptual analysis or conceptual understanding of spatial relations. Although, according to Freeman, the concept is complete, the child draws from an internal generic exemplar or model and not yet from a visual model.

In a series of ingenious experiments that mostly focus on the representation of single objects (e.g., cubes) or of two items in a specified relationship (e.g., in-front/behind, inside/outside), Freeman and his colleagues explored the effects of tasks and instructions and characterized the child's graphic efforts in terms of an *object-centered* description (a generic representation of the object that depicts its defining characteristics) or *view-centered* description (a representation that considers the drawer's particular and momentary view of the object). Such formulations show an enduring attachment to Piaget's notion of intellectual and visual realism as major milestones in the child's graphic development. These studies provide important information on children's approach to graphic problems and their task-dependent solutions. However, they focus on children's responses to the somewhat artificial tasks of a time-limited experimental situation and ought to be distinguished from studies that examine the self-initiated and personally motivated development of child art that concern me here. More recently, Freeman (1987) acknowledged that researchers have underestimated the pictorial skills of young children by studying their responses under impoverished testing conditions.

Maureen Cox: An Expanded View of Internal Models

Maureen Cox (1992, 1993; Freeman & Cox, 1985) adopted a somewhat modified view of the production deficit hypothesis Freeman proposed. She maintained that this hypothesis cannot fully account for the fact that children's drawings of the same object or figure can vary as a function of the task, the child's intention, and perhaps his or her mood. Cox's (1993) view of the nature and function of internal models is best captured in her own words: "Internal model or mental image informs or guides the drawing . . . mediates between the child's perception and knowledge of an object on the one hand and his drawing on the other" (p. 27). According to Cox, different tasks generate different models. She left open the question of the nature of the underlying image and considered such alternatives as graphic schemas, visual image, a verbal list of features, and a program of movements that guides performance in a spatial–temporal order.

Although Cox noted that culture plays a role in the style of children's drawings, she agreed with Freeman that artistic development progresses from an object-centered to a view-centered depiction, which is seen as a higher order achievement. According to Cox (1992), children eventually aspire to draw realistically and teach themselves to see the object as flattened, using a kind of imaginary da Vinci Window (also called Leonardo's Window) that aids aspiring artists in the representation of perspective. (This device consists of a glass plate that is placed between the artist and the object or scene to be drawn. The artist peers with one eye at the scene through a small opening in a fixed position and traces the scene onto the glass.) Cox acknowledged that this kind of "seeing" does not come spontaneously; it is a trained response that even great artists have had to acquire and practice. That this kind of drawing does not come naturally to most children can be inferred from studies that restrict the child's view to the optical display and yet show that children rarely draw it (Phillips, Inall, & Lauder, 1985). As Gombrich (1969) remarked, there is no ecological validity to such a view because it does not aid adaptation to one's environment; it is an artistic achievement.

Neo-Piagetian approaches have attempted to validate Piaget's stage conception of graphic development by providing a more detailed and careful analysis of task demands and competencies (Case, 1991; Dennis, 1991; Krampen, 1991; Lange-Küttner & Reith, 1995; Milbrath, 1998; Morra, 1995; Porath, 1997). What these and the other approaches mentioned so far have in common is the notion that the graphic development of children has a natural endpoint, namely *optical realism*. Realism then becomes the standard against which these researchers measure "stage" and progress, and they assume that conceptual thought and drawing development are intimately linked and in lockstep. This position is most clearly represented in the work of Constance Milbrath (1998).

Constance Milbrath: A Piagetian Perspective on Giftedness

Constance Milbrath adopted a clearly formulated Piagetian approach to her investigation of the development of artistically gifted children. She compared the drawings of artistically talented children with drawings of less talented children who are enrolled in art classes. Milbrath's criteria for identifying artistically gifted children included the ability to draw recognizable forms at an early age, originality in a child's artwork, and a strong commitment to the domain. Above all, talented children are supposed to display a precocious ability to draw in a realistic style. The less talented children did not show the developmental sequence predicted by Piaget, and the discrepancy between the artistic achievements of both groups posed a problem: how to account for the paucity of drawings in perspective by the less talented children and how to interpret the relatively early projective achievements of the talented group. On the basis of her analysis, Milbrath concluded that talented and artistically average children rely on different mental processes: Ordinary young children draw from concepts from which they derive their drawing schemas. These children are object centered (intellectual realism), and this conceptual orientation blocks their access to visual information. Even the older children rarely learn to draw in perspective.

In contrast, the artistically gifted children perceive the world differently; they see it less in terms

of categories and more in terms of forms, apparent shapes, and visual surface features (visual realism). They discover early on that lines can represent edges and surfaces of solids and thus are effective means for the drawing of objects and scenes. The artistically gifted children rely on figurative thought which, easily captured by appearances, is dominated by perceptual and imitative processes that constitute the child's mental images. According to Milbrath (1998), "Figurative thought is based on imitation, which reproduces events and relationships in the world" (p. 11), a formulation derived from Piaget's theory of symbol formation and the construction of representational thought (Piaget, 1951; Piaget & Inhelder, 1956, 1971). In this account, the drawings of the artistically talented children benefit from their heightened figural abilities, which distinguish their work from the concept-driven drawings of their less talented peers.

Milbrath emphasized that the conceptual abilities of both groups of children are alike and correspond to Piaget's account of cognitive development. Although the gifted children early on discover techniques for representing volume, rotation, and foreshortening, these are the products of lower order figural and not operational processes; they do not reflect true thinking or problem solving. A truly unified perspective rendering of a scene requires the coordination of both figural and operational processes, and even the gifted children achieve a unified viewpoint only at ages 9–10, toward the end of the concrete operational period. According to Milbrath, even highly talented children cannot fully use figurative processes to generate perspective in the absence of conceptual supports.

In these findings about talented children, Milbrath claimed to find confirmation for Piaget's theory of drawing development, in which progress toward optical realism in art is a highly valued achievement, an integral aspect of cognitive development. In Milbrath's account, Piaget's theory regarding the gap between young children's accurate perception but deficient graphic representation, captured in the aphorism "the child draws what he knows, not sees," does not apply to the gifted artist, and his theory regarding normative development of drawing does not apply to the less gifted, that is, to the nor-

mative sample. Because Piaget formulated his theory as a general account of the development of intelligence and did not address individual differences, reducing his theory to account for only an exceptional and small segment of the general population does not seem to support his views on drawing development. To maintain her distinction between perceptual–figurative processes and conceptual–operative ones and to draw a sharp distinction between lower order and higher order processes, Milbrath devalued the visual problem-solving activity of the younger children and lost sight of the abstract cognitive processes involved in the invention of pictorial representation (Pariser, 1999).

Milbrath's analysis of the progression that can be observed in the drawings of artistically gifted children provides important information about the representation of form: their superior use of line and shape, progress in rotation, and use of foreshortening and three-quarter views. However, her conception of "talent" is mostly limited to drawing in perspective; she ignored styles that deviate from this standard (e.g., the ornamental style, the expressionistic and colorful forms of gifted child artists whose work is reminiscent of folk art). Although the graphic development of line and shape is of central importance, color, expression, composition, culture, and personality are equally important aspects of the artistic processes we wish to understand. Overall, Milbrath's data call for a more comprehensive analysis that does not tie their interpretation to a somewhat outdated representational model.

John Willats: A Theory of Picture Perception and Production

John Willats's influential work *Art and Representation* (1997) proposed a new theory of picture perception and picture production. Willats provided a sophisticated analysis of pictures: how they are constructed; how the visual system analyzes dots, lines, and regions; and, following Marr (1982), how the visual–perceptual system constructs three-dimensional images. His analysis of the relationship between perception and pictorial representation has led to a taxonomy that identified drawing systems on the basis of the spatial relations that are presented in a picture and denotation systems that relate the basic

elements of pictures to their corresponding features of a real scene. Drawing systems (e.g., perspective) map spatial relations in the real-world scene into corresponding relations in the picture; the denotation system maps scene primitives, the most elementary units of shape information in a scene that can be used to describe features of real or imagined objects, into corresponding primitives—that is, the regions, lines, and dots in the picture. Scene primitives may be three-dimensional, two-dimensional, one-dimensional, or zero-dimensional. These systems are useful for the analysis of line drawings, and they demonstrate how the visual system analyzes the information provided by lines and shapes.

Willats's developmental account of children's drawings chronicles the emergence of different drawing systems: beginning with an early system based on topological relations; continuing with drawings in orthographic, horizontal, and vertical oblique projection; and culminating in oblique projections and linear perspective. His denotation system delineated a progression from a system in which two-dimensional regions denote whole volumes, to regions that denote the faces of objects or their projections in the visual field, and finally to a new level of representational effectiveness where one-dimensional lines come to represent edges and contours. With further progress, some children are able to use zero-dimensional T-junctions to denote points of occlusion and end-junctions to denote points at which contours end on the surfaces of smooth forms. These more advanced achievements represent the youngster's learning of new techniques and are not due to seeing more or becoming aware of one's own viewpoint.

Willats distinguished between picture *primitives,* the more abstract units of meaning in a picture, and *marks,* the actual physical area of paint or lines of ink or pencil in which these primitives are realized. Thus, according to Willats, a young child's drawing such as a tadpole figure may be realized in terms of lines and dots as marks, but the underlying units of meaning are usually two-dimensional *regions.* In this account, the picture primitives of dots, lines, or enclosures always denote regions: dots represent small regions, lines represent long regions, and closed curves represent round regions, a somewhat contentious aspect of Willats's theory.

Willats described a developmental progression whose beginnings are innately determined, mostly derived from object-centered internal descriptions of the shapes of objects that are quite independent of any view and whose ideal endpoint is some form of viewer-centered depiction. He saw it as a problem-solving activity, an interaction between perception and production, a kind of dialogue in which the child determines whether his drawing "looks right" or requires modification. The more advanced denotational rules yield more effective representations that overcome the ambiguity of earlier systems, and this desire for effectiveness becomes the prime motivator for drawing development.

Willats adopted Marr's distinction between object-centered and viewer-centered descriptions. According to Marr (1982), the visual system takes in local, unorganized, point sensations whose positions on the retina change with each new direction of view and then computes three-dimensional internal shape descriptions that are independent of any particular view. The three-dimensional shape descriptions are relatively stable because their coordinate system is based on the objects themselves. Recognition of objects occurs only on the basis of these descriptions. In contrast, viewer-centered descriptions refer to point sensations on the retina whose positions change with each new position or direction of view. These images are based on a coordinate system that is centered in the viewer, and they are dependent on the direction of the viewer's line of sight. The perceptual process that begins with a viewer-centered phase of visual stimulation and ends with an object-centered recognition of an object is largely unconscious and automatic.

In Willats's account, the term *internal description* or *internal representation* comes to stand for neurophysiological processes that are not accessible to consciousness but are nevertheless discussed in terms of descriptions on which drawings are based. Thus, some times *internal description* suggests the familiar usage of mental image or model, and at other times the term refers to a purely physiological process that identifies an early and very short-lived phase in the processing of visual information. Willats's account of drawing development, proceeding from an object-centered description that avoids dis-

tortion of shape to a viewer-centered description, reversed the perceptual processes Marr described. In Willats's view, this linkage of perceptual and production processes provided additional insight into the representational process. Perhaps one might think of internal description as a confound of two different levels of analysis: Marr's microgenetic stages of perceptual processing and drawing rules that map scene primitives onto picture primitives. Internal description merges the unconscious processes of Marr's perceptual model with the conscious choices involved in mapping relationships.

Willats is, of course, well aware of cultural factors in pictorial representation, and his art historical insights are thought provoking. But his account of children's artistic development pays little attention to cross-cultural findings. Cox (1992, 1993) considered Willats's denotational analysis of children's drawings somewhat inadequate. She did not think that he made a convincing case for why children should progress from dots to regions and why they should not continue to use dots for eyes and other body parts. She rejected the notion that the child can add more body parts only if he or she can go on finding different ways of representing them. Cox also took issue with the universality of Willats's taxonomy and pointed to the stick figures whose bodies are represented as vertical or thickened lines, models that are popular among unschooled African children who do not use a two-dimensional shape or lump to denote the body.

Willats provided an enlightening and in-depth analysis of how people perceive and interpret pictures, but he offered a narrow account of child art. His studies are limited to the representation of mostly rectilinear cubic objects and their variants and to some investigation of children's ability to represent a foreshortened view. These are tightly controlled experimental studies that have little in common with children's natural inclinations in their spontaneous artistic explorations and with the aesthetics of child art. The emphasis on perspective and other projective devices as a major developmental milestone documents Piaget's far-reaching influence even in an information-processing account of artistic development. Willats, however, considered his own theoretical position more closely aligned

with Arnheim's view of the nature of representation as the creation of equivalences in an artistic medium (J. Willats, personal communication, 2000). Commenting on the different pictorial systems, Willats considered perspective good for showing views, topology suitable for subway maps and electrical circuit diagrams, and a system based on regions appropriate for highway signs.

Rudolf Arnheim offered a major challenge to the Piagetian orientation and its variants. His many publications, especially his influential books *Toward a Psychology of Art* (1966) and *Art and Visual Perception* (1974), transformed the study of child art and formulated a radically different framework for an inquiry into its origins and course of development.

A REPRESENTATIONAL THEORY OF GRAPHIC DEVELOPMENT

At the core of the debate on how to interpret children's drawings lies the so-called gap between perception and representation. Because even very young children perceive the visual world quite accurately, how do we account for their drawings that so radically deviate from the way they perceive the world? Why do they draw tadpoles, comical figures comprised of a big circle, facial features, and legs? Surely this is not merely a technical difficulty, because a detailed representation could be drawn composed of circles. Four-year-olds can be astute observers, carefully inspecting pictures, quick at finding embedded or bizarre figures in a highly structured pictorial design, able to construct puzzles and designs with Lego blocks. Why then do they draw incomplete and canonical figures? The traditional theories stressed children's cognitive limitations, their inadequate analysis of a figure or scene, and their inability to organize the perceived elements into a coherent representation. Implicit in this view is the notion that reality can be copied, provided the drawer has the ability to adopt a stationary view vis-à-vis a scene.

Rudolf Arnheim challenged the conception of art as copy of reality; he contrasted the nature of representation with that of replication. Unlike replication, which aims for a faithful rendition of the elements that comprise an object, representation requires the

invention of forms that are structurally or dynamically equivalent to the object. Arnheim's position is based on a representational theory that is intimately connected with the domain of the arts and with a view of cognitive development that places visual thinking and the gestalt laws of perceptual organization at its center (Arnheim, 1969, 1974, 1986, 1988, 1997). Whereas Piaget extrapolated from his conception of logico–mathematical and spatial reasoning to the visual arts, Arnheim's analysis is steeped in an understanding of the arts and art history as a domain that is worthy of study in its own right. In Arnheim's view, the visual art of the child and the adult is a cognitive activity; it provides a record of visual thinking and problem solving in a medium that, despite its special constraints, offers opportunities for the expression of the artist's subjective experience of himself and his world. In Arnheim's view, artistic representation is not a reproduction of selected items, nor is it an attempt to copy reality. In fact, copying reality is altogether impossible given the intrinsic differences between the properties of a two-dimensional medium and a three-dimensional world.

The naive notion that reality can be copied rests on an inadequate analysis of the nature of representation and ignores the impact of the medium. In drawing and painting, the medium is a two-dimensional surface, and its tools are pencils, markers, crayons, ink, paints, and brushes. The constraints of this medium preclude any real attempt to copy the three-dimensional solid world, and the child or adult artist has to invent structurally adequate forms that can stand for the complex object. According to Arnheim, artists do not aim for a one-to-one correspondence of elements, nor do they aspire to copy a scene. All artistic form is based on abstraction, and it differs from the model by reproducing some of its essential features in a structurally purified way. Artistic thinking begins with the creation of highly abstract and simplified forms that the novice can conceive and give form to, and only later does the artist strive for a more complex representation. With increasing development comes a desire for greater complexity and the ambition as well as the skill to depict the multiple aspects and meanings of an object.

For Arnheim, pictorial art rests on the invention of forms of equivalence that can stand for the object. He defined *equivalence* as a relation between two parties: objective reality and the inventory of the medium. The constraints of the latter are the fundamental elements of the medium: the basic shapes of form such as line, square, circle, and parallels, and the primary colors (red, blue, yellow), and black and white. For Arnheim, human perceptual experience is a highly intelligent and dynamic activity, an organized and adaptive process that enables humans to make sense of their environment and to respond to it in meaningful ways. However, the transition from perception to representation is not a simple process of duplication; it requires the invention of representational concepts that mediate between perceptual concepts derived from our direct experience with the world and its representation in a particular medium. Thus, representational concepts are not automatically given in the perceptual experience but are conceptions of forms deemed adequate to represent the perceived structure of the object within the constraints of its medium.

Pictorial representation begins with global forms, the circle and the line, that represent its object in a very general way, where one entity can stand for another more complex one. This process of creating equivalences between forms and lines on paper and the three-dimensional object is first based on the principle of simplicity, namely, that the simplest and most abstract equivalent will be deemed acceptable. Thus, a horizontal line can serve as the surface for objects to stand on, which is a structural equivalent for the ground in three-dimensional space, and a zigzag line can stand for the waves of the ocean. With further development, equivalences tend to be based on more complex relationships that provide more information to the viewer while respecting the specific demands and constraints of the medium.

According to Arnheim, development is orderly and meaningful from the start, and there is an intrinsic logic to its course, a lawful progression in visual thinking where universal structuring tendencies determine its course. He carefully delineated the steps by which the beginning artist, regardless of age, evolves a coherent graphic vocabulary of forms and how they might be arranged in pictorial space.

At an early level of development, abstraction or simple generalized forms are the only options available to the inexperienced artist; inexperience, not childhood, is the true starting point for representational development.

Arnheim posited an underlying continuity in the artistic aims of children and adults and in the primary principles of art that are displayed in the child's work. In all its phases, the processes of differentiation reveal the level of visual thinking reached by the individual who grapples with the task to represent a complex three-dimensional object on a flat two-dimensional surface. Arnheim's conception of pictorial differentiation implies that there are multiple solutions to representational problems and that there is no objective priority for any one form over another. Many routes are possible for the attainment of artistic excellence, and the perspective inventions of the artists of the Renaissance and their followers are only one among many achievements, none of which can be privileged from the perspective of artistic merit or ought to indicate an ideal endpoint for development.

In summary, a representational theory of drawing development sees representational drawing as a truly creative activity of the child who, in every generation, invents a basic vocabulary of universally similar and meaningful graphic shapes. It is a remarkable feat, because there are no real "models" available to the young child that might lend themselves to imitation. The flat paper and the tools for making lines, dots, and circles do not correspond in any strict sense to the objects in the real world, and artistic activity of children and adults is a process in which lines and forms merely "stand" for objects that differ vastly from the materials with which the artist works. At the heart of the artistic enterprise, as Arnheim has argued, is the urge to create *equivalences of form* in a particular medium, forms that correspond structurally or dynamically, but not literally, to the object.

A conception of representation that is not based on one-to-one correspondence between the elements that constitute an object and the depicted image calls for a reassessment of the nature of child art. If symbolization is at the core of the artistic enterprise, children's drawings ought not to be viewed as either more or less representational than the works of more accomplished artists. The drawings children produce at their different levels of pictorial competence are complete within their system of representation, for example the tadpole figure composed of a big circle, some facial features and legs represents a person, globally conceived. In this sense, nothing is missing although the figure is simple and sparse. Its gradual elaboration produces a more differentiated and thus more meaningful figure.

Arnheim's theory provides a broad framework for the study of art, including child art. His concepts set the stage for a productive examination of theories and findings and for a more detailed analysis of the development of child art. He provided an insightful analysis of artworks from different historical periods and documented his concept of equivalences across culturally different forms of artistic expression. These are abstract concepts and do not easily lend themselves to operationalization.

I see myself as working within Arnheim's general theoretical framework, inspired by his formulations, and extending it more fully into the realm of child art. In my work I have provided empirical evidence for the visual intelligence he has postulated and for the effects of the medium. I also show the extent and range of diversity in the drawing schemas used by the same child on different tasks and themes, which challenges the notion of a unitary underlying mental image or model. My description of the child's artistic progression is not strictly stage or age related, and I tend to view it as a series of phases that can be short-lived, depending on practice, motivation, talent, and mental maturity. I have found significant individual differences in the style of representation children pursue and attempt to perfect, differences that are not age related. My criticism of Piaget is directed toward his account of drawing development as a unidirectional progression toward optical realism, a theory that ignores the diversity of cultural models and the effectiveness of alternative modes of representation that depend on the intentions of the artist, a position shared by other scholars of child art (Kindler, 1999; Kindler & Darras, 1994, 1998; Pariser, 1995b; Wolf & Perry, 1988). My own position is spelled out in the major chapters of this book.

This brief review reveals a rich diversity of opinions about fundamental issues of development, including the reality of stages of artistic progression, the kind of stages, and the legitimacy of diverse drawing systems. How well has Piaget's hypothesized progression withstood the test of empirical investigation, and how well does it account for artistic development of ordinary and talented children? A review of relevant findings provides some answers to these questions.

TRENDS IN DRAWING DEVELOPMENT

Young children begin their exploration of paper and pens by making gestural motions that leave a trace, often described as "scribbles." Even two-year-olds seem interested in the marks their hands create, and this visual motor activity is not a completely random event (Kindler, 1999; Kindler & Darras, 1997a, 1997b, 1998; Matthews, 1984, 1994; Tarr, 1992). At first, children may be perfectly satisfied with their scribble productions, but when under pressure to explain to an adult observer what their "picture" is about they tend to *romance*, that is, to invent a narrative that bears no visible relationship to the scribble. Somewhat later, these youngsters may discover an accidental similarity between their drawing and a familiar object and attempt to *read off* what the picture might represent (Golomb, 1973, 1974). These early efforts can best be seen as *prerepresentational* devices to make sense of their nonintentional scribble creations.

The true beginning of representation as a pictorial symbolic activity occurs when the drawn shape points beyond itself to an entity that it merely "stands" for. When preschool children begin to control their movements and the first recognizable shapes emerge, they tend to see a resemblance between the drawn shape, most commonly a circle, and a familiar object. The first representations are composed of very simple forms, mostly circles, dots, and lines; they are the child's inventions, and they present a major milestone in his or her artistic development. The ability to abstract out of the myriad details that comprise a human some general characteristics that define his or her animate nature is a true hallmark of a symbolizing intelligence. It indi-

cates an understanding that symbols "represent," that they are not to be mistaken for the actual object they refer to (i.e., symbol and referent are to be distinguished).

Form

Children prefer to draw humans as some of their first subjects, and they are delighted to discover that they have created an entity, a figure, that was not there before. The first representational figures are *globals*, composed of spherical shapes endowed with only a few details, most commonly the facial features. The principles that underlie these early representational drawings are simplicity and economy of form. The child creates equivalences between the flat, two-dimensional circle with dots for eyes, nose, and mouth he or she has drawn and the whole person it stands for (Cox, 1993; Golomb, 1974, 1992b). Children comment on their work by stating "That's all I'll do," "He is missing," "He has enough," or even "You can't see," thus indicating that they differentiate between what they know and think about the human figure but do not include in their drawing (Figure 1).

In relatively short succession, figures become graphically differentiated by the addition of parts or their subdivision. The human figure, which begins as an undifferentiated circle or oblong, sprouts arms and legs. Researchers often name this the "tadpole" figure (Figure 2). Thereafter, this figure tends to be restructured first by lengthening the vertical extensions, by creating a stick figure or an open-trunk

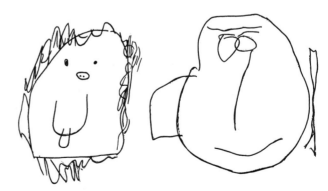

FIGURE 1. Global humans. The circle with facial features is one of the earliest graphic models of a person. Created by girl, age 3 years, 3 months, and boy, age 3 years, 8 months.

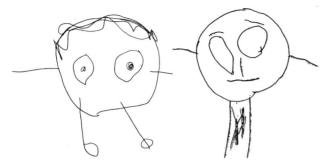

FIGURE 2. Tadpole figures. Created by boys ages 3 years, 6 months and 4 years, 7 months.

figure, and by drawing a separate unit for the torso (Figures 3, 4, 5, 6). Similar processes of differentiation can be observed with animal figures and other favorite items. With some practice in drawing simple forms comes the desire to eliminate ambiguity, to provide the kind of detail that will distinguish, for example between a human and an animal. That the drawn figure is merely a useful graphic schema, a temporary solution to a graphic problem, can be seen in the significant variations children produce when asked to dictate to the examiner the parts of the figure to be drawn; construct a figure from unmarked wooden shapes; complete a set of incompletely drawn figures; explain their preferences for specific graphic models, and, when they show flexi-

bility by changing, on request, the starting point of their drawing sequence (Golomb, 1973, 1992b).

Other examples highlight the important distinction between conceptual knowledge and drawing competence: An inexperienced child, a three-year-old girl, within the span of 10 minutes, produced first a set of ovalish forms; invented her first human figure composed of head, facial features, body, arms, fingers, legs, and toes; and ended with a series of firmly drawn tadpole figures, the last of which is "myself as a baby" (Figure 7). In this and similar cases, the child is faced with the problem of creating a representational concept and then translating it into graphic form. The notion of a unitary mental image or inner model that underlies the drawing cannot account for the diversity of graphic models children use. Depending on their intentions and their perception of the nature of the task, children who usually omit arms will equip their drawings with an arm if the figure is playing ball, draw ears if the person is wearing earrings, and include a tummy if she is pregnant (Figure 8).

In the beginning, children tend to be mostly concerned with creating a basic likeness, and the relative size, proportion, and color of the drawn figure are of secondary importance. Form is the major vehicle for creating a meaningful representation. Once this has been achieved, children pay attention to the relative size of figures (e.g., when drawing a

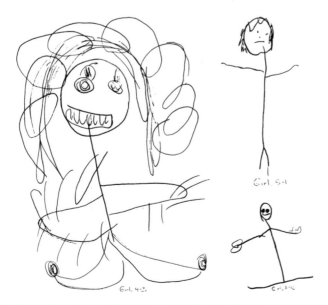

FIGURE 3. Stick figures. Created by girls age 3 years, 10 months to 5 years, 1 month.

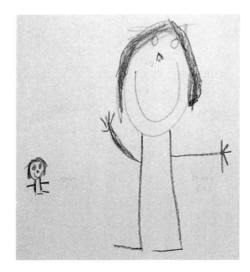

FIGURE 4. Open-trunk figure. Created by boy, age 6 years, 5 months.

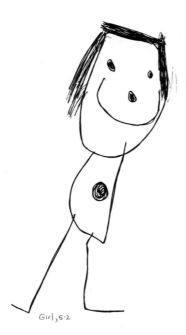

FIGURE 5. **Armless figure with a separately drawn trunk. Created by girl, age 5 years, 2 months.**

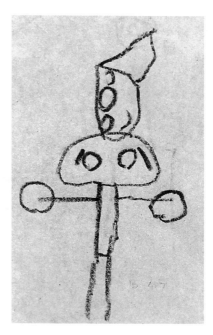

FIGURE 6. **Full-fledged figure with a differentiated trunk and limbs. Created by boy, age 4 years, 7 months.**

family). In general, however, the child is not yet concerned with anatomical fidelity and the portrayal of realistic proportions in drawing. Aesthetics emerges as an important factor with forms that tend toward balance (e.g., equal-sized circles for head and body) and the use of bold, contrasting primary colors that can create striking effects (Figures 9, 10). Figures may also be embedded in a decorative framework, and for some children ornamental designs vie with representational tendencies (Figures 10; 11a–b, see color insert).

During this early period, and extending through most of the childhood years, children strongly prefer presenting frontal views of objects drawn in an orthographic projection system (i.e., parallel to the line of sight of the observer). Each figure is drawn as a separate unit, its boundaries are respected, and occlusions of one object by another one are usually avoided (Figures 12a–b, 13). When children discover these early rules of representation, they can provide relevant information about the referent and draw objects in a way that represents their most characteristic features. In the case of the human figure, the frontal orientation provides the most pertinent information, often called the *canonical view,* whereas in animal drawings mixed views are quite

common, depicting the body of the animal in its preferred side view and its head drawn frontally (Figure 14). During their early experience with art making, children are not interested in depicting momentary and changing views of a scene. Finding out what can be done with this medium of paper, markers, and paint initiates a process of visual thinking, a dialogue between the child artist and his or her medium of problem setting and solving within the artistic domain.

Progress in differentiation occurs along several dimensions, from the primordial circle to more varied rectangular and triangular shapes; from the straight line to curved and bent ones; from one-dimensional lines to denote extension to two- and three-dimensional lines. The strict right-angular relationship between parts of the figure (e.g., outstretched arms) that is typical for the early drawings gives way to more varied relations. As oblique directions are incorporated into an expanding vocabulary, the ability to portray gesture and movement increases (Figure 15). The earlier canonical orientation of a figure, which was limited to a single frontal view of the object, continues to be a much-preferred stance, although the youngster can depict more diverse orien-

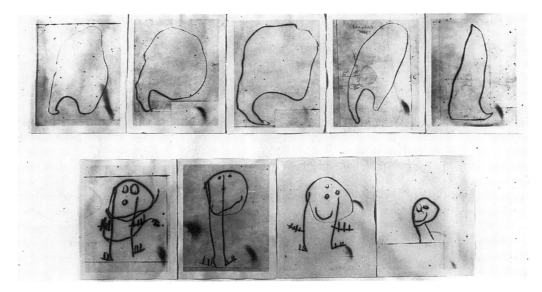

FIGURE 7. Evolution of the human figure in a single testing session. Created by girl, age 3 years, 8 months.

tations when the theme calls for it. Depending on the chosen topic, children begin to experiment with front, side, top, and rear views of the object (e.g., a bicyclist in profile, a child standing on a ladder picking apples in rear view, a swimmer in a pool seen from above, a child playing the piano; Figure 16). Concurrently, sizes and proportions gain importance in the depiction of relations among various items (e.g., family relations). Children also begin to

experiment with a single body contour (Figure 17a–b; Golomb, 1992b).

Space

Representing space that extends into the third dimension on a two-dimensional surface presents a formidable challenge. The earliest attempts to organize pictorial space begin with the application of a principle of proximity. Nearness provides the most

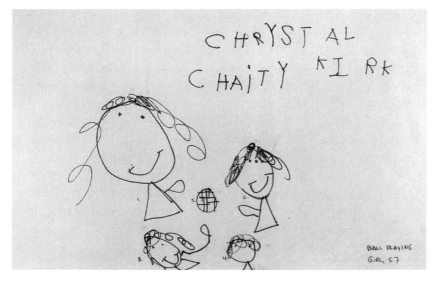

FIGURE 8. Children playing ball. The three players are drawn with a single arm reaching for the ball; the fourth child, a mere observer, is armless. Created by girl, age 5 years, 7 months.

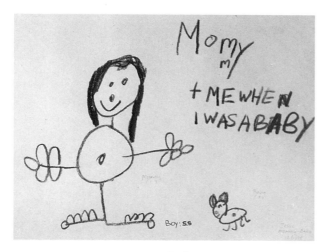

FIGURE 9. Figure composed of equal-sized circles for head and body. Created by boy, age 5 years, 5 months.

primitive connection among items in the pictorial plane. With the addition of a directional rule that yields side-by-side arrangements of figures, a new ordering principle emerges that privileges the horizontal direction. Children now organize space along the horizontal and vertical axes, beginning with one or more parallel arrangements on real or imagined lines, and only gradually do they organize planes into a continuous space. The vertical and horizontal axes of the page come to specify two directions of space. The horizontal axis represents left–right directions, and the vertical represents up–down as well as near–far dimensions (Figure 18).

The problem of depth is vexing because the vertical dimension has to serve two very different functions. Practical experience with this problem, for example drawing children playing hopscotch on a vertically aligned grid that uses the vertical axis to depict the space occupied by the game, elicits the surprised comment, "They are touching the clouds!" This kind of experience can promote reflection and new graphic strategies that yield various solutions as the child experiments with different drawing systems. Of course, cognitive development is also a relevant factor as children critically review their work, consider whether or not to invest energy into changing the drawing, and weigh alternative solutions. Many children, especially younger ones, accept their limitations and merely comment on their observation of, for example, uneven legs: "It does have a broken leg, it came from the hospital." The earliest and most favored system of representation is based on a projection system in which the lines stay within a strictly horizontal and vertical framework. To overcome the limitations inherent in this system—for example, to indicate that the house has more than one side, that the table is not tipping over—children eventually tend to introduce oblique lines that can represent additional sides of an object (Figure 19a, see color insert; 19b; Golomb, 1983b, 1992b; Golomb & Farmer, 1983; Willats, 1977).

FIGURE 10. Twins in a bassinet. Equal-sized circles for head and body. Created by Varda, age 5 years. *Note.* From the collection of Malka Haas.

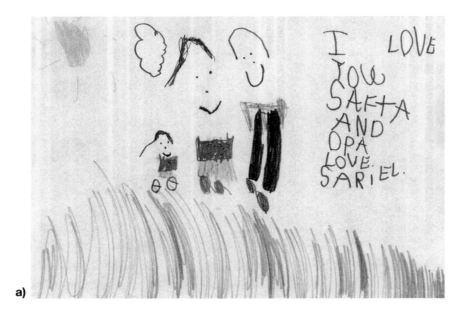

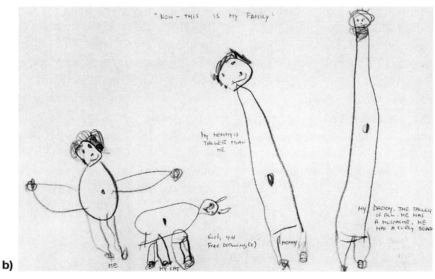

FIGURE 12. Family. All the members are presented in frontal view. a. Created by girl, age 4 years, 4 months. b. Created by girl, age 5 years, 11 months.

Over time, and having gained experience with the medium and its constraints, children show greater coordination among the elements of their composition as they discover new ways to unite foreground, middle ground, and background into a unified representation of space (Figures 19a, see color insert; 20). Of course, children differ in the extent to which they aim for verisimilitude or a realistic likeness to the object or scene. During their middle and late childhood years, many talented and highly motivated children aspire to create the illusion of volume and depth on the flat surface and tend to experiment with several pictorial devices. They may diminish the size of objects to imply distance; use partially overlapping forms to distinguish near and far objects; introduce diagonals to depict the sides of an object; use foreshortening, color texture, and color gradients; and eventually experiment with the converging lines of linear perspective. However, few children will arrive at perspective render-

FIGURE 13. Frontal view of house and scenery. Created by girl, age 9 years.

FIGURE 14. Mixed view. In this drawing of an animal, the body is depicted in side view and the head in frontal view. Created by boy, age 6 years, 5 months.

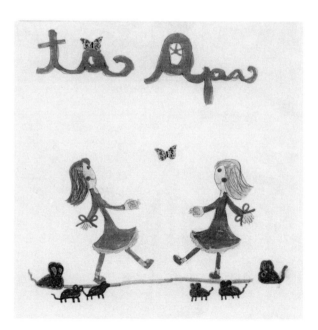

FIGURE 15. Figures in action. The beginning portrayal of gesture and movement. Created by girl, age 7 years.

FIGURE 16. Piano player. Rear view of pianist and oblique lines to depict the piano keys. Created by girl, age 6 years.

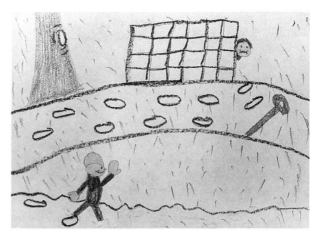

FIGURE 18. Organization of space. The horizontal–vertical axis represents left–right and up–down directions. Created by boy, age 8 years.

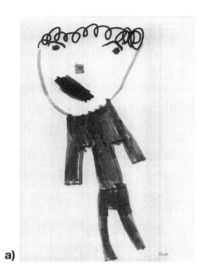

a)

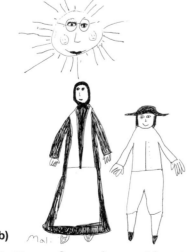

b)

FIGURE 17. Human figures drawn with a single body contour line. a. Created by girl, age 5 years. b. Created by girl, age 7 years.

ings on their own and without training. With the exception of highly gifted children, drawing in perspective is not spontaneously acquired.

Color

Color is central to humans' perception of the world and our relations to it. Form does not exist in isolation but is suffused with color and brightness. In life as well as in art, color serves multiple functions, among them aesthetic, expressive, and adaptive ones. Colors elicit and convey mood and feelings, arouse our attention, and serve as markers that identify significant aspects of the visual world. Indeed, ethologists have called attention to the role of color in eliciting courtship patterns, signifying approach and avoidance vis-à-vis a stranger. Likewise, psychologists have long been fascinated by the expressive quality of colors and their quick association with feelings and mood states, an association represented in the language of "seeing red," "feeling blue," "green with envy," and "a black mood." Colors can have an arousing or calming effect on the observer and, depending on color and brightness, our environment looks friendly, cold, or menacing.

What role does color play in children's drawings and paintings, and can we detect developmental trends in their color use? As previously mentioned, when children make their first discoveries with marks that yield recognizable shapes, form tends to dominate, and a single color is sufficient to create a

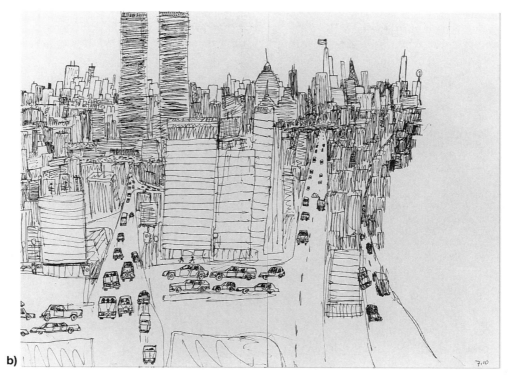

FIGURE 19. Oblique lines are useful in the representation of more than a single side of an object. b. New York City. Note top and side view of buildings and automoblies. Created by boy, age 7 years, 10 months.

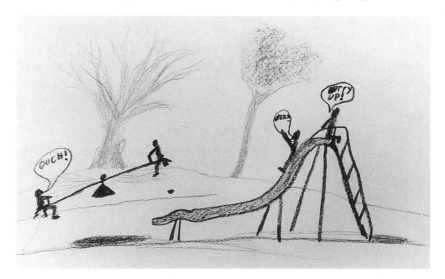

FIGURE 20. Playground. Size diminution, shading, and texture create a more differentiated pictorial space. Created by boy, age 12 years.

recognizable figure. At first, the choice of color may well be determined by personal preferences. Once children have mastered the creation of basic shapes, and this process no longer requires sustained efforts, children begin to revel in the use of diverse colors to embellish their drawings. Colors are now used for the sheer pleasure they afford the child, who at first pays little attention to their realistic function. For example, humans can be drawn with bold and contrasting primary colors that hold our interest and give genuine aesthetic pleasure (see color insert for Figures 21a–b, 22a–b; Golomb, 1992b).

Gradually, some restrictions in the use of color appear. The human figure tends to be drawn with a monochromatic outline, and dramatic violations of realism occur less frequently in the depiction of animals and plants. Depending on the theme of the drawing, children may use multiple colors yet obey certain realistic constraints, such as using green for grass, brown for tree trunks, red for strawberries, and yellow for the moon.

Along with a growing awareness of the utility of local true colors, color also emerges as a major factor for ornamental designs that can "frame" a painting or embellish it. Creating decorative designs and colorful patterns is a playful and imaginative activity, and for some children it is an alternative to pursuing naturalistic depiction (see color insert for Figures 11a–b, 23a–b). By the middle childhood years, color is no longer subservient to form or merely conjoined to a previously drawn contour; it now becomes a major determining force of the picture. For example, a light coloring of the background can create the airy impression of being outdoors, and it also can suggest distance, both of which unify the composition. Color can also become the dominant organizing principle of a composition (Figures 24a–b, 25, see color insert; 26; Kläger, 1998).

Studies that have examined children's use of color to depict mood and specific feelings by having children draw a happy person, a sad person, and an angry person show that in the depiction of such emotions as happiness, sadness, and anger, colors tend to be used fairly indiscriminately (Golomb, 1992b). Emotion seems most prominently and effectively portrayed by the shape of the facial features and somewhat later by changes in body posture. Most commonly, it is the theme or topic of the drawing that is the carrier of affective meaning, and colors amplify the intended message. In general, bright and more numerous colors dominate portrayals of happy and joyous events, for example a happy dream of a party, and darker colors tend to dominate depictions of adverse events. Although younger children's color choice may not convey a specific emotion, when a theme is meaningful to a child, color use is not random. Overall, the option to use color in their paintings strongly attracts children to this medium, and color becomes one of the criteria by which children judge the appeal of a drawing or painting. In a study designed to explore children's preferences, color emerged as a highly potent factor (Golomb, 1992b).

The selection of a theme and its colors does not by itself indicate that the child artist is personally happy, sad, angry, excited, or disappointed. The ability and the inclination to portray emotionally evocative themes need not imply that such themes ex-

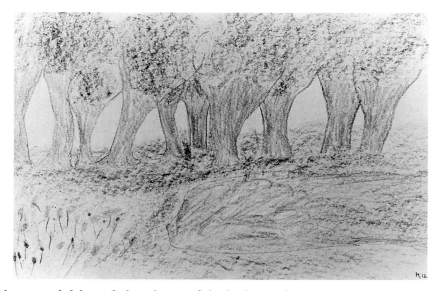

FIGURE 26. Landscape with lake. A light coloring of the background creates an airy impression of being outdoors. Created by boy, age 12 years.

press the child's inner state of mind. A painting does not directly tell us whether a theme is deeply rooted in the child's personal experience, reflects a momentary and passing concern, or was chosen for its social relevance to events such as a holiday or an accident.

Composition

Composition refers to an arrangement of the elements of line, form, space, and color that indicates to the viewer what the work is about. Of course, composition also has an aesthetic function that relates to the manner in which the various elements are coordinated and balanced. To compose means to use grouping principles that determine how figures are arranged to form meaningful units, and the organization of figures into patterns facilitates communication of meaning and elicits appreciation and enjoyment of the work.

An examination of children's drawings of diverse themes reveals two compositional tendencies that account for the organization of children's drawings: a gridlike alignment of figures along horizontal and vertical axes and centering strategies that organize items around a pictorial center. These principles are at work in the early and somewhat primitive creations of children, and they can also be discerned in the more sophisticated and accomplished works of older and more experienced youngsters (Golomb, 1983a, 1983b, 1992b; Golomb & Farmer, 1983).

In the earliest phase of creating forms, items appear unconnected and seemingly distributed at random over the page. This phase is short-lived, followed first by the clustering of shapes drawn in close proximity to each other and then by attempts to align figures either horizontally or vertically. These alignments impart a primitive sense of belonging to the various items that are lined up on one or more horizontal axes (Figure 27). This strategy of alignment is gradually perfected, with attention paid to equal distances between the figures that by now have achieved greater differentiation of form, size, and proportion. Soon thereafter, baselines are introduced that anchor all figures in the common plane. Objects tend to be located in the bottom part of the page, which implies a distinction between the ground and the sky (Figure 28). Items increase in number, detail, and definition and, depending on the theme, subgroupings begin to appear (e.g., children at play, a picnic, a collection of houses depicting a village, or a table with presents suggesting a birthday party). The grouping of figures indicates a special relationship or a common interest. Such groupings are formed on the basis of similarity of size, color, form, and activity, and they facilitate the communication of meaning. This compositional strategy can effectively organize all the elements of a drawing and yield a fairly advanced level of thematic unity (Figures 18, 29a–b).

The second compositional principle finds expression in the tendency to center figures on the page

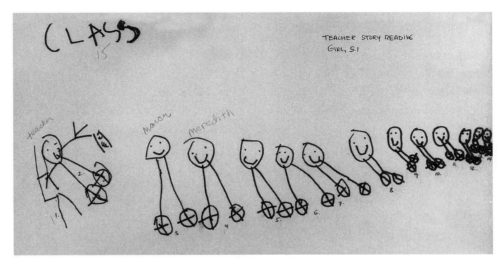

FIGURE 27. Simple form of alignment on a horizontal axis. Created by girl, age 5 years, 11 months.

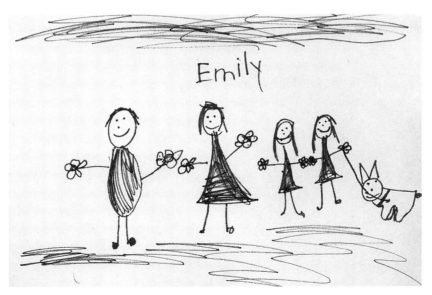

FIGURE 28. Advanced alignment strategy. This strategy includes spatial differentiation of ground and sky, and the grouping of family members. Created by girl, age 6 years.

and to create symmetrical arrangements. Like the alignment strategy, this tendency also emerges early in development and continues as an active organizational force at later levels of achievement. At its simplest form, centering bestows a degree of stability on the figure (Figure 6). Along with the centering of single items, primitive precursors of symmetry appear, and somewhat later children use symmetry more deliberately (Figures 15, 30, 31a–b).

Symmetry can be defined as the correspondence in size, shape, and relative position of parts that are on opposite sides of a dividing line or distributed about a center. More complex symmetrical arrangements include equal spacing among figures, similar distances from the edges of the page, systematic variation in size of figures, pair formation, and repetition of subpatterns. Here, too, with practice comes increasing differentiation in the number and type of figures and in the spatial arrangements on two or three levels as well as an effort to organize figures into subunits.

The complexity of a composition tends to increase with practice. Progress can be seen in the use of more subtle and complex forms of symmetry that maintain spatial order and meaning with more varied items and whose organization no longer demands a strict one-to-one numerical or figural correspondence. Such forms of symmetry that do not

exactly duplicate the two sides of an array are usually found among the older and more talented children. In these cases, a symmetry of weights is maintained in the balanced placement of figures rather than in their actual identity (Figures 32a–b; 33, see color insert). In more complex symmetrical arrangements, individual figures no longer maintain strict bilateral similarity of size, shape, and color, and a central figure may be flanked by a larger item on one side and two smaller ones on the other side, which may result in a fairly balanced composition.

The developmental progression I have briefly reviewed is a slow though orderly process that begins with drawings of isolated object-centered descriptions, in which each object is depicted as an independent unit. Next, objects or figures show some degree of interdependence and affect each other. Only at the height of artistic development does the structure of the whole determine all the elements of a composition. Thus, development proceeds from multiple local graphic solutions, through partially coordinated mixed views, to a more unitary conception that dominates the composition. The latter is rarely achieved by children or adolescents (Golomb, 1992b).

This section has documented the hallmarks of the so-called child art style that is characteristic of the drawings of normally developing children. They

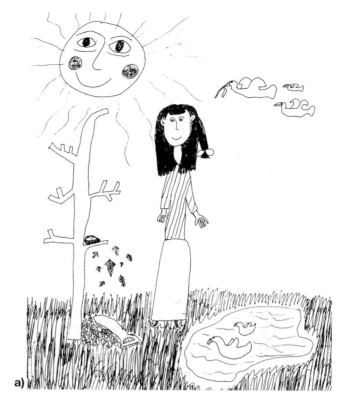

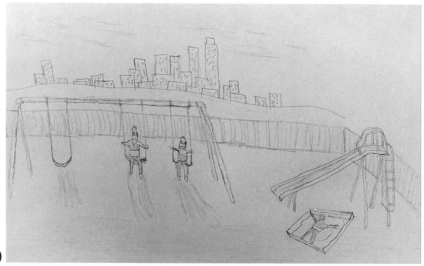

FIGURE 29. **Thematic unity. a. Landscape. Created by girl, age 7 years. b. City playground. Created by boy, age 12 years, 3 months.**

are flat, two-dimensional renderings of objects and scenes in the preferred frontal orientation. This style, with its disregard for true proportions and sizes, continues well into middle childhood and beyond. It often reaches an expressive and aesthetic high-point in its own mode of representation around age 9 years (Figure 34, see color insert). If we go be-

yond the late childhood years and well into adolescence, we note enduring preferences for canonical orientations and orthographic views, and we find only few examples of children drawing in perspective or using other three-dimensional pictorial devices.

I have highlighted general developmental trends

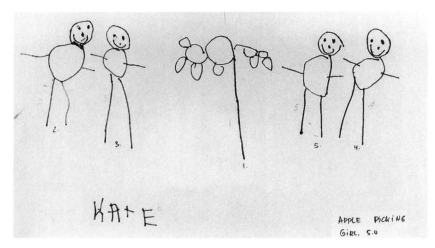

FIGURE 30. Simple forms of symmetry. Apple picking. Created by girl, age 5 years, 0 months.

a)

b)

FIGURE 31. More intricate forms of symmetry. a. Created by girl, age 8 years. b. Created by boy, age 12 years.

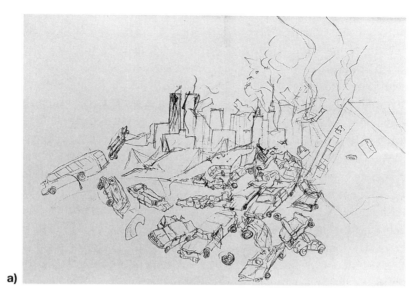

a)

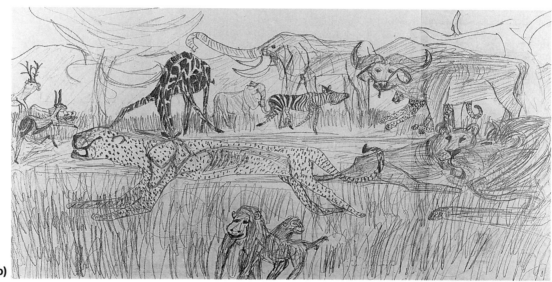

b)

FIGURE 32. Complex forms of symmetry. a. Tornado. Created by Eitan, age 6 years, 8 months. b. Animals in the wild. Created by Eitan, age 7 to 8 years.

in artistic development and the lawfulness of the progression from simple forms and their arrangements to more differentiated and complex compositions. Looking for laws and rules that underlie behavior comes at the risk of neglecting the individual characteristics of each work and its maker. As the illustrations amply indicate, there are significant individual differences in the themes children portray, in the style of their work, and in the emotions they intend to express.

Giftedness

The concept of talent or giftedness is a cultural construct and reflects the dominant values of a particular period (Korzenik, 1995). A child who at a very early age masters three-dimensional techniques of representation and uses lines that capture the contours of human and animal forms in a naturalistic style is commonly identified as gifted. In more recent years, the conception of giftedness has been broadened to include children who show an early aware-

ness of artistic form and originality in their vision that imposes an order on the composition reminiscent of primitive or folk art. In this case, the aesthetic quality resides totally within the style of child art.

Case studies of artistically gifted children (Beck, 1928; Goldsmith, 1992; Golomb, 1992a, 1992b, 1995; Milbrath, 1995, 1998; Paine, 1981; Pariser, 1995a; Warner, 1981; Winner, 1996; Zimmerman, 1995), especially of precociously gifted "realists," reveal that they pass through the same stages of development as ordinary children, but much faster. Milbrath (1998) called attention to what she considered their qualitatively different developmental trajectory, their early sensitivity to the function of lines and planes, and their ability to see the object in terms of its spatial–figurative characteristics rather than its objective meaning-based quality. According to this view, talented children are able to see the shapes and visual surface features of a display rather than focusing on rendering the object as it is known. In general, however, the development of artistically gifted children provides additional evidence for the universality of the early stages of drawing development, a finding that is supported by cross-cultural research.

Gifted children are best defined in terms of their individuality and even uniqueness, but they share some characteristics. They are incessant drawers, seemingly compelled to translate their experiences into graphic form. Thus, in addition to their natural talent and intrinsic motivation, they gain skills immensely from the constant interaction with their chosen medium, that is, from the ongoing problem seeing and solving they engage in (Winner, 1996). The differences among them are also significant; some gifted children, enthralled by the visual appearances of interesting objects and sights, desire to capture the essence of those sights with fidelity and singularity of purpose. These children will teach themselves many, if not most, of the techniques necessary to depict the three-dimensional character of objects and scenes.

The drawings of Eitan provide an excellent example of a precociously gifted child who discovered, on his own, all the major projective drawing systems (Golomb, 1992a, 1995). He began drawing at age 2 in the manner of all young children, namely, with

topological shapes that yield tadpoles and other simple global figures. But very quickly he went beyond these early forms and, having barely outgrown the toddler years, he taught himself the basic projective drawing systems that capture the volume and dimensions of the vehicles and other objects he was interested in. By the time Eitan was age 4, he had mastered horizontal and vertical oblique drawing systems that incorporate additional faces in his orthographic views, divergent and isometric projection, and he began to experiment with convergent perspective (Figures 35a–b, 36a–c, 37a–b, 38a–b, 39a–b, 32a; see also Figure 19b by Eitan). Eitan's development clearly indicates that this gifted child did not skip stages. For Eitan, to draw is to know and to understand, and it is quite breathtaking to

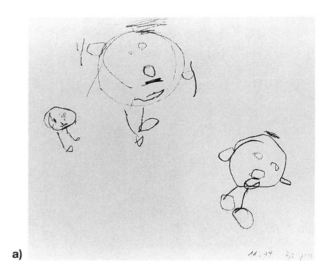

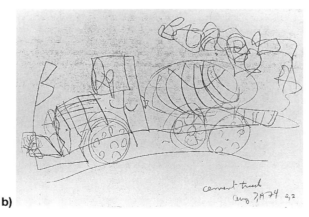

FIGURE 35. Drawings by Eitan at age 2 years. a. Family, drawn at age 2 years, 2 months. b. Cement truck, drawn at age 2 years, 7 months.

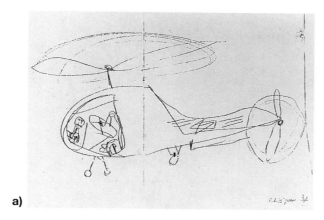

a)

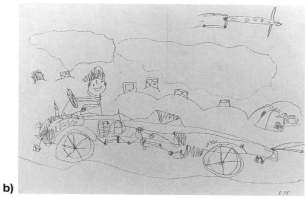

b)

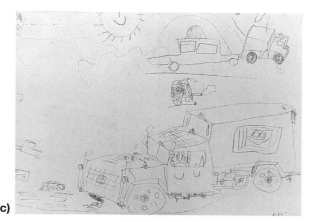

c)

FIGURE 36. Drawings by Eitan at age 3 years. a. Helicopter, drawn at age 3 years, 2 months. b. Desert landscape, drawn at age 3 years, 7 months. c. Truck in isometric (parallel oblique) perspective, drawn at age 3 years, 7 months.

see how he transformed the simple drawing systems until they suited his purpose. The different drawing systems he invented illustrate visual thinking in the graphic medium, a problem-solving mental activity in this three- to four-year-old boy. Eitan's vision did not change; the change was in his representational

conceptions that became more effective. These conceptions come about in an orderly, rule-governed fashion, and their adoption follows in broad outlines the developmental progression delineated by Arnheim (1974, 1986) and provides empirical support for his theoretical analysis. With this effective problem solving comes an enhanced understanding of the medium and, most likely, of the object.

A word about the role of culture: Although I have stressed the self-directed and autonomous development of this gifted child, Eitan is growing up in a Western culture where three-dimensional images are displayed in books and posters, and we might surmise that he has abstracted some of the more advanced projective rule systems, which he invented on his own, from such drawings.

The remarkable achievement of three- and four-year-old Eitan ought to make researchers wary of facile generalizations across different intellectual domains. Eitan, a thoughtful and intelligent child, was in most respects a typical preschooler and not a child in the concrete operational stage approaching the formal operations stage. Such findings challenge Piaget and his followers' stage conception and the hypothesized correspondence between logical–spatial reasoning and pictorial representation.

Other gifted children are colorists. By their very nature and inclination they tend to use dramatic rather than naturalistic forms, and they relish the expressive and decorative attributes of color, texture, and design. Their colorful and richly ornamental works are strikingly appealing and reminiscent of various forms of folk art (see color insert for Figures 22a–b, 23a–b, 24a–b, 25, 40). Their aesthetic is of a different order than that of the realists, as can be seen in figures drawn without regard for anatomically correct proportions, colors used expressively rather than naturalistically, and the flat composition. In the eyes of the modern beholder, their appeal is as powerful as the drawings of the young realists. It is not the precocity that is appealing in these works but the sincerity, directness, and expressiveness of the paintings. In contrast to the earlier mentioned appearance-based orientation, children such as Varda tend to express their inner psychological world rather than the perceptual experience of the more realistically inclined children. Of course, both types

FIGURE 37. Drawings by Eitan at age 4 years. a. Jerusalem, drawn at age 4 years, 2 months. b. Cement truck, drawn at age 4 years, 4 months.

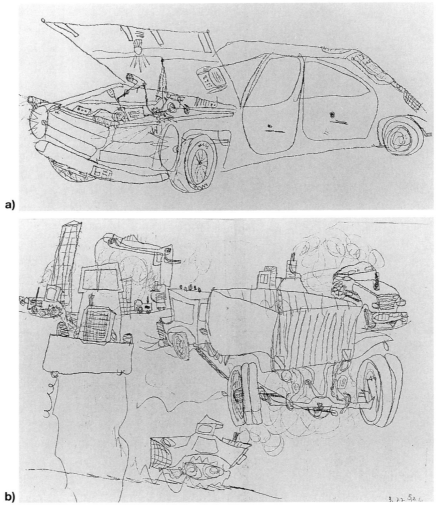

FIGURE 38. Drawings by Eitan at age 5 years. a. Car with open hood, drawn at age 5 years, 0 months. b. Construction scene, drawn at age 5 years, 2 months.

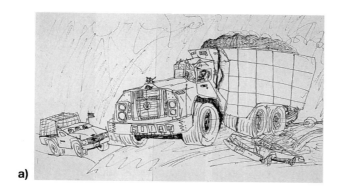

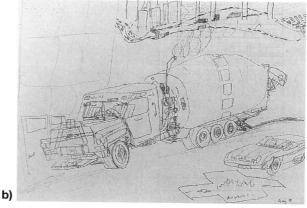

FIGURE 39. Drawings by Eitan at age 6 years. a. Near accident, drawn at age 6 years, 6 months. b. Cement mixer and fragment of parking lot, drawn at age 6 years, 7 months. (See also Figures 19b and 35a.)

FIGURE 32. Complex forms of symmetry: a. Tornado. Created by Eitan, age 6 years, 8 months.

of gifted child artists are engaged in visual thinking, in constructing their own pictorial world; both prize their autonomy and pursue their own agenda as they come to know and control their world in privileged ways. Thus, different routes of artistic developments can be pursued, and the two modes I have outlined are not exhaustive ones. Talent or giftedness in the arts may need to be further specified in terms of the domains in which they seem to excel. For example, Kárpáti (1997) found that gifted adolescents who create highly original three-dimensional constructions are undistinguished drawers who do not show any special aptitude for drawing in perspective.

Pictorial representation is, of course, also influenced by the available cultural norms, models, and the prevalence of such tools as ink, brushes, pencils, crayons, and paper. These are issues I take up when I discuss sociocultural influences.

DRAWINGS OF INDIVIDUALS WITH AUTISM AND MENTAL RETARDATION

In the past, psychologists have widely accepted the notion that intelligence is positively correlated with drawing ability. This thesis underlies the early tests of children's drawings as measures of mental devel-

opment (Burt, 1921; Sully, 1896; Thorndike, 1913), it motivated Florence Goodenough to develop her widely used Draw-A-Man Test (1926), and some assessment of drawing ability continues to be part of most current tests of intelligence.

In line with the presumed linkage between intelligence and drawing ability, it is held that people with mental retardation draw at their delayed or arrested developmental level. Several studies have documented that children with mental retardation draw like normally developed children of matched mental age (Cox & Bragal, 1985; Golomb & Barr-Grossman, 1977). These studies address cognitive aspects defined in terms of linguistic and mathematical competence and examine their relationship to representational development in children. Studies published by Henry Schaefer-Simmern (1948), however, indicate that this is not the whole story. Schaefer-Simmern showed that institutionalized adults with mental retardation with an IQ range from 49 to 79 could generate drawings, paintings, and tapestries of exquisite beauty, an indication that the aesthetic dimen-

sions of art making are not necessarily related to the artist's IQ or mental age. In recent times, Max Kläger (1992, 1993, 1996, 1997) documented the artistic development of several individuals with Down syndrome who, within the framework of a supportive workshop, create paintings of expressive power. The work of these adult artists has received considerable attention, most noticeably in several European exhibitions; it has won prizes and awards and has been purchased by museums and private collectors. Despite many significant individual variations, these paintings share certain stylistic qualities: They are reminiscent of folk art and of the fully developed child art style (Figure 41a, see color insert; 41b).

In general, the compositions are well structured, with a strong tendency toward symmetry, the use of bold contrasting colors, and ornamental features in the design. Figures, most commonly depicted in frontal orientation, are strikingly disproportionate and occupy a flat pictorial space. These works reveal the dedication of the artist and the seriousness and concentration with which the project is pursued,

FIGURE 41. Paintings by Willibald Lassenberger, an artist with Down syndrome, age of artist 32–34. b. Farm with pigs. *Note.* From *Die Bilderwelt des Willibald Lassenberger*, frontispiece and p. 56, by Max Kläger, 1992. Hohengehren: Schneider Verlag. Reprinted with permission.

a)

b)

FIGURE 42. a–b. Remarkable drawings by Nadia, a child with mental retardation and autism, at ages 3 years, 6 months and 5 years, 6 months. *Note.* From *Nadia, a Case of Extraordinary Drawing Ability in an Autistic Child* (pp. 3, 24), by L. Selfe, 1977, London: Academic Press. Copyright 1977 by Academic Press. Reprinted with permission.

and one can see development within the individual's exploration of form, content, and style. A videotape made by Max Kläger of the creation of a painting by Willibald Lassenberger documents how, over many hours of concentrated work, the artist expresses his intention to paint a mask. He consistently guides his composition through all the phases of his work and sustains the original intention despite the modifications he undertakes.

These findings challenge the singular attention to conventionally defined cognitive factors in artistic creation. Although there may not yet be a satisfactory explanation for the artistic productions of individuals with mental retardation, I note that the aesthetic dimension is relatively independent of IQ.

A further challenge to the linkage between IQ as a measure of linguistic and conceptual reasoning and artistic achievement appeared in the publications of the drawings of children with mental retardation and autism. Since the publication of Lorna Selfe's monograph on Nadia Chomyn (1977), a spectacularly artistically gifted child with autism and mental retardation (Figure 42a–b), and additional case studies of savant artists, researchers have wrestled with the question of how to account for the lack of correspondence between intelligence (verbal

and performance IQs) and artistic giftedness (Becker, 1980; Buck, 1991; Buck, Kardeman, & Goldstein, 1985; Morishima & Brown, 1977; Sachs, 1985, 1995; Selfe, 1995; Treffert, 1989; Wiltshire, 1987, 1989, 1991; Winner, 1996). The term *savant* refers to persons with serious mental handicaps who have a spectacular island of ability that stands in marked contrast to their handicap of mental retardation, autism, or both. Savant artistic skills are far in advance of those displayed by ordinary normally developing individuals. The most informed set of studies designed to explore this relationship comes from the laboratory of Hermelin and O'Connor at the University of London. In a series of studies that matched savants with mental retardation with normally developing, talented adolescents, the investigators found that the graphic talent of the children with mental delays and autism was indistinguishable from that of the normally developing children, and they concluded that artistic talent (above a certain IQ range, usually 40–70) is independent of intelligence and independent of the autistic syndrome (Hermelin & O'Connor, 1990; Hermelin, Pring, Buhler, Wolff, & Heaton, 1999; O'Connor & Hermelin, 1987a, 1987b, 1990; Pring & Hermelin, 1993; Pring, Hermelin, & Heavey, 1995). Such findings highlight the

specificity of artistic thinking and creating, and they provide some support for a modular view of the mind (H. Gardner, 1983).

Of course, this view of selected aspects of the nature of artistic giftedness does not address other symptoms of the autistic syndrome and of the specific cognitive and social deficits associated with it. In a study that examined the drawing and copying strategies of children with mental retardation and autism (not savants) matched on mental age with children with mental retardation only, my colleague and I found no significant differences between the two groups on diverse drawing tasks, although the children with autism performed better on the copying tasks (Golomb & Schmeling, 1996).

SOCIOCULTURAL INFLUENCES ON CHILDREN'S DRAWINGS

The question of universals in drawing development and the influence exerted by the cultural milieu has motivated investigators to study drawings from many diverse cultural settings. One of the earliest collections (Paget, 1932) included 60,000 drawings made mostly by children from the non-Western world. The drawings were collected by numerous collaborators and, despite the lack of optimal standardization, they are interesting because they highlight significant variations in the style of the drawings and also call attention to graphic models that seem characteristic of certain ethnic groups of children. Regarding the diverse stylistic renderings of the human figure, G.W. Paget (1932) considered them all as problem-solving strategies that successfully represent their object. He also identified certain local conventions noticed among African children such as a frequently occurring drawing of a human composed of a tiny head and an elongated body. He interpreted these local conventions as graphic inventions that are passed on from one generation of children to the next. Thus, children create their own traditions and regulate the transmission of their graphic styles.

This interpretation fits in well with an observation by Ricci (1887) of the graffiti made by Italian children at the end of the 19th century. The drawings of the oldest children occupied the upper parts of a wall: Those of the younger children occupied the lower areas. This kind of division encouraged inspection of the work of the older and more experienced children and facilitated transmission of their particular version of the child art style to their peers. Considering both the variety of graphic styles and the local conventions, Paget proposed a two-factor theory: Children spontaneously invent representationally equivalent forms for the human figure, and they transmit their inventions to the next generation of children. Thus, childhood drawing styles develop independently from adult models and represent universal and meaningful problem-solving strategies of children.

Paget's illustrations demonstrate the diversity of graphic models that can be found among preliterate children: stick figures; tiny heads; contourless heads and bodies; square, oval, and scribble trunks; hourglass triangular trunks; and similar variations on the depiction of facial features (Figure 43). These graphic models are typical examples of childhood art, and they can be found in any large collection of children's drawings, including Kerschensteiner's, collected at the beginning of the 20th century, and my own, dating from the 1960s to today (Golomb, 1992b). Such drawings are found in many times, places, and cultures. They are quite similar to 2,000-year-old rock carvings in the Camunian valley of northern Italy (Anati, 1967), to American Indian rock carvings in southern Utah (Schaafsma, 1980), and to Polynesian rock carvings on the islands of Hawaii (McBride, 1986). They attest to a universal factor in the creation of graphic equivalents at early stages of artistic development.

The same underlying graphic logic generates the diversity of early models, which are all based on principles of structural equivalence. No single graphic model represents, exclusively, child art at a particular developmental phase. Rather, within a certain structural range, graphic solutions are tried out, and models are perfected, transformed, or discarded. The inventiveness of children and the constraints on early child art find full expression in the diverse examples discussed by Paget and later investigators (Belo, 1955; Dennis, 1957; Fortes, 1940, 1981; Havighurst, Gunther, & Pratt, 1946; Jahoda, 1981; Sundberg & Ballinger, 1968; Wilson & Wilson,

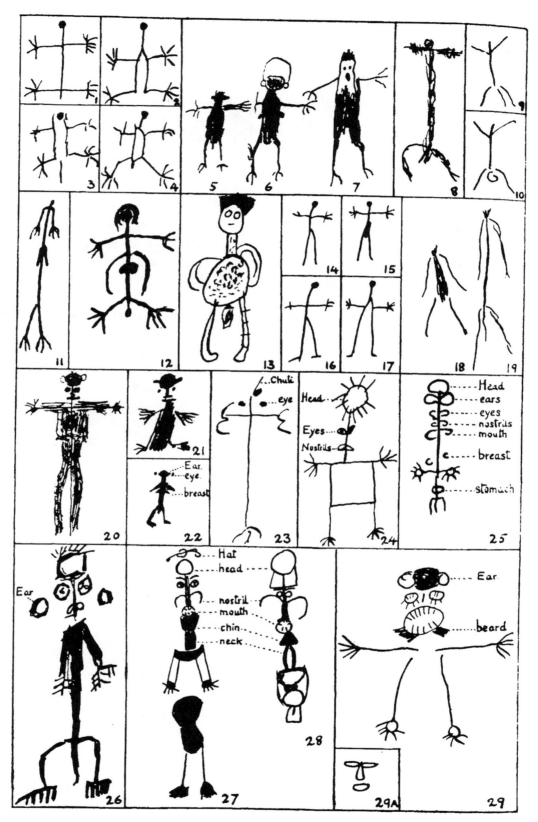

FIGURE 43. Human figure drawings from diverse cross-cultural sources. *Note.* From the collection of Paget. Some drawings of men and women made by children of certain non-European races, *Journal of the Royal Anthropological Institute, 62, 127–144. Copyright 1932. Reprinted with permission.*

1984). In recent years, the drive to eradicate illiteracy and the emphasis on schooling has brought Western models of drawing to many countries in Africa. The search for totally naive subjects who have never been exposed to paper and pencils has become more difficult (Andersson, 1995a, 1995b, Andersson & Andersson, 1997; Court, 1981, 1989, 1992), and it is not easy to tease apart the effects of schooling from established local traditions.

The emphasis on child art as a relatively autonomous development of a pictorial language should not obscure the impact of the larger culture on children's productions. The tools that are provided (paper, pencils, crayons, markers, paints, and brushes) have a decisive influence on children's experimentation with the medium. Thick brushes and runny paints yield different outcomes than crayons, a more controlled medium. The models provided by the culture, the teaching strategies used, and the expectations of teachers and parents can have a notable impact on the art children produce. Thus, for example, in China, which has a long artistic tradition, children are taught the exact steps they have to take to represent goldfish, shrimp, birds, and flowers. These steps are modeled by the teacher and closely followed by the children. Not surprisingly, these children show an early competence in the artistic style that is explicitly taught and practiced.

This kind of training can also affect the drawing of unfamiliar objects, as Ellen Winner has demonstrated. Observing a class of first graders following the carefully sequenced instructions of their teacher, she placed a stroller on the podium, and asked the class to draw it (Winner, 1989). To the consternation of the teacher whose teaching technique did not include such improvisation, and to the delight of Winner, the children reproduced the stroller with considerable competence, indicating its three-dimensional shape. In China, children's training in the arts is based on a nationally adopted curriculum that begins in kindergarten and extends through all the grades. Its implementation indicates that training can be effective and that a measure of graphic literacy can be attained by carefully graded instruction, as in this case, the imitation of steps modeled by the teacher.

The impact of cultural conventions is particularly noteworthy in the paintings of Yani, a precociously gifted child artist (Zsensun & Low, 1991). She is the daughter of a painter and, given free access to her father's studio, she soon began to experiment with the effects of charcoal, brush, pigments, and ink on rice paper, the traditional tools of Chinese painters. Throughout the history of Chinese paintings, the brushstroke has been the central focus, and the use of washes a fundamental element of painting. With brush and ink, the three-year-old Yani created at first single figures, for example, a tadpole-like kitten. By the time she was ages 4 to 5, Yani had mastered several basic brush strokes and could differentiate between lighter and darker strokes and between the effects of the different sides of the brush, and she could handle light and dark ink washes. Her favorite themes are monkeys, whom she depicted in mostly child-like activities as they engaged in a variety of actions and poses that create lively and aesthetically pleasing compositions (Figure 44a–b).

Even at this early age, the theme of Yani's art and its style of representation are clearly defined in terms of the cultural traditions of her environment and its long artistic history. Thematically, the choice of monkeys continues an old Chinese tradition in the visual arts and in narrative form; stylistically, she adopted the formulas that determine the order and form of the parts to be drawn with the use of brush, ink, and rice paper. Although highly gifted, and most likely trained by her father, Yani's early work displays many of the characteristics of the child art style in which figures are mostly arranged side by side, and her paintings of children, a less frequently chosen theme, are quite typical of the work of ordinary children. One can see in the work of this precociously gifted and highly motivated child some of the same developmental trends and constraints previously discussed. In many ways, they are typical childhood paintings conceived within the cultural traditions of China.

In Japan, artistic education also starts early, in the preschool years, with the teacher specifying theme, colors, and size of paper and demonstrating procedures. In the more traditional Buddhist preschools, children receive predrawn figures that need to be colored in, with an emphasis on neatness. Under the teacher's guidance, children begin with a

a)
b)

FIGURE 44. a. Let Me Smell the Flower. Created by Yani, age 4 years. b. I Am Not Scared (inoculation scene). Created by Yani, age 5 years. *Note.* From *Yani, the Brush of Innocence* (pp. 69, 70), by Wai-Ching Ho (Ed.), 1989, New York: Hudson Hills Press. Copyright 2001 by Byron Preiss Visual Publications. Reprinted with permission.

crayon drawing over which watercolor is applied, a technique taught in all preschools. Children often have a portfolio of drawings made during the school year, most commonly representing assigned themes. The artistic conception and convention that underlies this teaching method tends to encourage sensitivity to the medium, especially in terms of color use. Once again, certain stylistic features tend to characterize Japanese children's drawings of animals and humans; one can identify commonalities in the manner heads are drawn, but overall their work stays within the idiom of child art and its constraints.

Thus, although cultural models and teaching methods have a distinct impact on children's drawings and paintings, they do not change the basic structural similarities of child art, which are easily detected despite changes in time and space.

MOTIVATION AND THE MAKING OF MEANING

Drawing creates an imaginative representation of an aspect of the child's world. The child who discovers the magic power he or she can wield over the blank page engages in a uniquely human activity that transforms his or her ordinary experience of the world and represents it on a new and perhaps mythical plane of action and thought.

Leaving a mark, making a form, and creating an image are all means of exploring the object that is drawn. The young child is motivated to create forms that bear a likeness to the object. With increasing maturity and exposure to the medium, new problems are set and new solutions are found. The act of drawing confers the power to make and to unmake, to know the object and oneself more intimately, and children are quite passionate about their art making. To a large extent, children's involvement with art making is inner directed and propelled toward increasingly greater articulation. Drawing and painting are expressive statements about what one knows, feels, and wants to understand. Such expression is a dialogue with oneself and, as all meaning, intrinsically affective. It is a problem-solving activity that is often imbued with intense emotions, with concerns that are close to the heart of the artist and not merely an investigation of the medium and the skill needed to master it. That art making can be an in-

FIGURE 49. **Nightmare of Terrorist Attack. Created by boy, age 12 years.** *Note.* **From the collection of Malka Haas.**

tensely felt experience for a young artist can be gleaned from the comments of Varda as she reflects as an adult on her childhood work (Figure 45, see color insert):

> *I see myself standing in front of a big white sheet of paper attached to the wall with special thumbtacks . . . and I begin to work. I take a wide brush, dip it into paint, and on the white paper arises the large figure of a big black woman, and I quickly run out of space. Malka notices and attaches another sheet of paper. The black woman grows, surrounded by decorative ornaments and symbols of great beauty. Below her feet, at the bottom of the page, I add a little grave with the name of the child who died, over which the black woman weeps. How did she get onto my paper? Over whom did I grieve when I was 10 years old? What feelings were stirred up in me that here appear in my painting? (Gering, 1998, p. 90; see also Golomb, 1995)*

In general, we can discern two trends in children's intention and motivation for art making: a narrative tendency and an expressive tendency, both of which are influenced by the cultural context in which the art is being produced. The narrative tendency is motivated by the desire to tell a story—to convey information about the nature and function of objects, the layout of a scene, and the actions and intentions of protagonists (see color insert for Figures 46, 47). It drives the desire for narrative competence, for differentiating and coordinating the various elements of the composition to effectively convey the message. The expressive tendency manifests itself in the selection of forms and colors that convey an affective message, often by exaggerating the size and color of body parts, and in the aesthetic delight children find in ornamentation. At times we may discern a tension between the desire to create a better likeness, with its demands for the kind of competence that yields a naturalistic depiction, and the playful tendency to use expression for its own sake, as can be seen in the drawings of large, decorated, and masklike faces. These tendencies lead to the development of different styles of representation and yield their artists different kinds of satisfaction (Figures 47, 48, see color insert; 49).

The themes children portray reflect their experiences, joys, interests, and sorrows, hopes, fears,

struggles, victories, and defeats. However, children do not live and create in isolation. They are part of a larger community, and events that affect all of its members are depicted: holidays, birthdays, birth and death in the family, earthquakes, and many more. In some cases, illness and the fear of dying can lead to astonishing expressions, even in young children. Such drawings can afford insights into the inner world of children's experience and reveal the artistic means by which they attempt to order their world.

During the elementary school years, there is a gradual decline in the spontaneous productions of children, and the work of most children seems to reach a plateau that signals the end of a very creative and productive period in child art. There are likely to be diverse reasons and competing interests that lead to this decline of artistic activity. Above all, alternative outlets for self-expression can be found in the widening horizons of middle childhood that afford access to sports and music, chess and computer games, and the opportunity for social activities. For some children, the technical problems associated with more advanced pictorial strategies spell the end of their pictorial explorations. In some cases, the arts are taken up again in late adulthood as a hobby or even serious endeavor.

SUMMARY AND ASSESSMENT OF CURRENT FINDINGS

We are faced with a set of seemingly contradictory findings. Between ages 5 and 10 years, there is a modest-to-good correlation between children's drawings of the human figure and their IQ scores. As the child develops, the drawings improve in the level of graphic skill, the number of parts drawn, and their relative proportions. Although a single drawing at one time cannot reliably indicate an individual child's representational competence, age norms on the Goodenough–Harris Draw-a-Person Test (Harris, 1963) reflect general developmental trends in graphic differentiation until approximately ages 8 to 10. The increase in differentiation scores indicates the school child's improved attention span, the development of routinized schemas, a better understanding of the examiner's expectations, practice in planning a drawing, and a more critical stance to-

ward the product. There is no indication, however, that human figure drawing measures conceptual understanding, and a broader sampling of children's drawing skills reveals considerable inter- and intra-individual differences depending on the nature of the task or theme and the child's motivation (Cox, 1993; Freeman, 1980; Golomb, 1974, 1992b; Thomas & Silk, 1990). After ages 8 to 10, there is a leveling-off effect (Dennis, 1991; Golomb, 1992b; Milbrath, 1998) in the drawings of the majority of children living in the Western industrialized world that occurs despite significant linguistic and mathematical achievements during these years. This finding applies to the drawings of ordinary children who show no special talent or motivation in this domain, do not receive instruction, and perhaps lack a supportive environment that encourages continued exploration.

The data on precociously gifted, normally developing children—for example, the drawings of Eitan (Golomb, 1992a, 1992b, 1995) and of such highly talented children as Duzzi (Beck, 1928), Landseer (Ormond, 1981), Millais (Warner, 1981), and Toulouse-Lautrec (Pariser, 1995a), who became artists in adulthood—highlight the décalage (i.e., unevenness or significant gap) between their conceptual development and drawing achievements. This finding is further amplified in the artwork of autistic savants such as Nadia Chomyn (Selfe, 1995), Stephen Wiltshire (1991), Stephen Wawro (Becker, 1980; Treffert, 1989), and Yamamoto (Morishima & Brown, 1977), whose mental and chronological ages are highly discrepant.

Thus, talent emerges as a significant variable, and the hypothesized relationship between artistic achievement and IQ becomes more tenuous. In the case of the autistic savants, especially those with severe language deficits, their artwork seems independent of linguistic–conceptual intelligence. The visual–spatial abilities of the savants with mental retardation seem to be intact and even heightened and when linked with pictorial talent may create aesthetically pleasing works of art. Given the uneven profile of scores on the subcategories of tests of intelligence, as measured on the Wechsler Intelligence Test (Wechsler, 1974), the savants with autism are probably limited in the development of their gift. Integra-

tion of the diverse and uneven levels of their mental and artistic abilities is not likely to be achieved. Drawing and painting are highly developed skills, and their acquisition requires sustained effort, experimentation, and awareness of artistic styles, past and present. Art making does not occur in a cultural vacuum, and artists actively relate to the art world of their time. Artistic intelligence draws on the diverse sources of human concerns, aspirations, and the capacity for reflection. From this perspective, the art of people with mental retardation or savants with autism is "outsider art" (Kläger, 1992, 1993; Winner, 1996), unconcerned with the artistic conceptions of the times and the particular challenges that their normally developed contemporaries face.

The data from diverse sources clearly support a developmental analysis in terms of an orderly sequence in the acquisition of graphic representational skills. This holds true for ordinary children across diverse cultures, for gifted children, for children with mental retardation, and most likely for savants with autism, although our longitudinal records are less complete for this population. These findings support the position of a general and seemingly universal developmental progression in drawing competence. However, without specific training, children's interest in their own drawings tends to decline in the late childhood years, and most do not go beyond the fully developed child art style. In countries where art education is taken seriously and instruction is regularly provided as part of the school curriculum, children continue to develop effective graphic schemas and procedures for specific topics (e.g., in China for birds, fish, shrimp, and flowers).

Psychologists may have used the term *realism* and its associated developmental trajectory in an unduly simplified manner. Luquet (1913, 1927) used the term to refer to the child's intention to represent a real item or event. But reality is a complex referent and can be represented from different perspectives, including the inner world, the outer world, or a mixture of both in very different styles. Even the tendency toward ornamentation creates a pictorial reality to behold, to enjoy, to reflect on. The tradition, by now well established, that differentiates object- and view-centered depictions is not a very apt characterization of child art. Drawings of the human figure are easily recognized even in the early stages of tadpoles and open trunk figures, although neither label captures the essence of these simple structural equivalents for the human figure. In my view, they are neither more nor less "symbolic" forms than later, more differentiated versions, all of which are symbolic representations in the pictorial medium.

We have seen that photographic realism is neither a universally acquired representational competence nor the goal of every gifted child. Basing our analysis on a supposed progression toward optical realism is not justified by the data, nor is it supported by art historical analyses or by the contemporary art scene. Projective realism is a cultural achievement and represents the values ascribed to the inventions of the Renaissance artists. Although it is only one of many possible styles of depiction, realism colors people's perceptions so that we mistake a style valued by our culture for an intrinsic phase of human graphic development (see also Pariser, 1995b, 1999, and Kindler & Darras, 1997a, 1997b, 1998). From my reading of the literature and review of the data, I argue that there is no simple one-to-one correspondence between Piaget's stages of cognitive development and the stages of graphic artistic development and that the hypothesized linkage between conceptual maturity and artistry has to be reassessed. Furthermore, the developmental progression from a stage of so-called object-centered depiction to a view-centered description, which has found wide support, is highly problematical on theoretical as well as empirical grounds, as my previous comments have indicated.

Pictorial representation involves perception and cognition; it is a problem-solving mental activity and as such presents a cognitive achievement, but it does not find a satisfactory explanation in Piaget's framework or even in a revised version of it (Case, 1991; Dennis, 1991; Lange-Küttner & Reith, 1995; Milbrath, 1998). By now, there is a broad consensus that Piaget underestimated the preoperational child's competence in several domains, including perspective taking, communicative ability, the distinction between mental and physical events, the child's theory of mind, and symbolic play. Although I argue against a close correspondence across intellectual domains and reject the forced search for similar mental

achievements at specific developmental stages, symbolic competence at some fundamental level is broadly congruent across several domains when one carefully considers the nature of the medium, complexity of mental computation, talent, motivation, practice, and cultural models. For example, what is acceptable to the child in the drawing of a tadpole or armless figure is not acceptable in a form puzzle, picture completion task, or selection of best picture task (Golomb, 1973); the identification of embedded figures in compositions designed to hide them calls on different competencies and standards of adequacy than the drawing of a figure. The changes we can observe in the work of some ardent six- or seven-year-old child can be seen as the result of thoughtful reflection, the desire to learn the tricks of the trade, and the intention to revise the drawing. Progress in the differentiation of figures and their composition is due to the desire to eliminate ambiguity, to achieve greater articulation of ideas and expression of feelings, to motivational, attentional, and aesthetic factors, as well as to the cognitive reversibility (the ability to mentally return to a starting point and coordinate actions) that characterizes the concrete operational period.

I have contrasted two general theories of drawing development, Arnheim's theory of representation and Piaget's theory, which has had widespread acceptance among developmental psychologists both in its original version and later revisions. Arnheim's theory provides a very general conceptual framework for studying artistic development, and the findings I have reported are based largely on my own empirical investigations. These developmental studies of form, space, composition, color, and preferences have been profoundly influenced by Arnheim's philosophical and psychological positions, which I have found productive for the formulations of the problems I wished to investigate. In general, my findings are quite congruent with Arnheim's theory of the psychology of the visual arts, and they extend his conceptions into the realm of child art. My work has led me to a rather critical position of the relevance of cognitive stages to artistic development, and in some ways I have modified and extended Arnheim's theory as it can be fruitfully applied to child art.

Arnheim's conceptions of development and the principle of differentiation as underlying all forms of mental activity, including artistic development, do not yield specific age-related predictions or predictions that can be neatly tied to conceptual development. As I previously implied, ages are merely convenient markers, and skill level, talent, motivation, practice, persistence, and the ability as well as the inclination to improve on one's creation affect the timing of certain pictorial achievements. There is no fixed timetable, although the process of differentiation as a largely self-generated representational activity can be outlined in very general terms of developmental phases characteristic of drawing development.

I have compared Arnheim's approach to artistic development with Piaget's theory. As I mentioned, Piaget was not specifically interested in the visual arts, but his position on drawing has been very influential and continues to be so (Dennis, 1991; Lange-Küttner & Reith, 1995; Milbrath, 1998; Morra, 1995). Serious authors who search for the congruence between drawing achievement and the stages of cognitive development outlined by Piaget have to account for the discrepancies I have identified. Thus, for example, Milbrath acknowledged that in the artistic development of ordinary children there is no clear relationship between children's drawings and their cognitive achievement of concrete operational reasoning. The less talented children who were enrolled in art classes did not show the anticipated three-dimensional skills that underlie drawing in perspective. In contrast, her sample of talented children did show the predicted relationship, albeit at different ages. In Milbrath' view, this finding supports Piaget's theory, although it is limited to the gifted children. She distinguished between the drawings of the younger talented children, whose work is based on perceptual–figurative processes, and those of the older talented children, whose perceptions undergo the transformations engendered by operative intelligence and conceptual analysis.

This position is difficult to sustain when we consider that Piaget's theory was conceived as a *general theory of intelligence*, which did not deal with individual differences, a theory that has been restricted by Milbrath to account only for talented children. Altogether, Milbrath argued that ordinary children, those not particularly talented in the visual arts, are

handicapped in their artistic development by their reliance on concepts rather than percepts (or figurative thought), a contention for which I do not find much evidence.

On the basis of the empirical findings reported by different investigators, one has to reject a unilinear view of a developmental progression toward realism in artistic development. Art comprises a special domain. In drawing and painting, the nature of the two-dimensional medium plays a significant role in determining what and how things can be represented. Most important, the artist's goal is to create a pictorial world imbued with meaning and feelings, to interpret some aspect of reality rather than to construct a faithful replica of it. Despite their diverse philosophical orientations toward the arts, Arnheim (1974), Belting (1987), Bernheimer (1961), Gombrich (1969), Goodman (1968), and Wollheim (1987, 1993) rejected the notion that art is concerned with making duplicates. In their various ways they stressed the representational and interpretive function of art, and they rejected the notion of a singular, unidirectional process.

Art making in childhood is a spontaneous, playful, and deeply satisfying activity, a creative enterprise that puts the child in charge of the small pictorial universe he or she can create. It is a passion for most young children, and the compulsion to create continues to be a powerful motivator for adult artists. Realism in art is, of course, a pictorial form highly valued in Western society, and exposure to its models will affect the goals young artists set themselves as they become aware of artistic traditions and standards.

The role of talent and motivation in artistic development warrants more attention than it has received. The concept of talent or giftedness is highly dependent on the cultural milieu, and in the Western world a child who draws in a naturalistic style is most likely identified as "gifted." However, under the influence of the Romantic vision of Rousseau and the artistic movement, which at the end of the 19th century rejected the naturalistic traditions of art, childhood art was seen as an expression of authenticity, inspiration, and truth. The modern artists who praised the naiveté of the child and lauded its freshness of vision saw in the art of childhood the

true mainspring of all creativity. This vision of childhood led to innovations in the teaching of children and to the first exhibits of their work alongside the works of adult artists (Fineberg, 1995, 1997; Viola, 1936). The art educator Cizek and his followers fostered the child art style, and child art became valued for its distinctive features, its deviation from realistic conventions, and its freshness of expression. This development also led to a new conception of childhood artistic giftedness, namely, the ability to use the child art style expressively in a manner that appealed to the aesthetic sense of the adult artist. The contrasting developmental trajectories of children such as Eitan, who strive to depict objects realistically, and those who, like Varda, pursue the expressive and ornamental aspects of the child art style, personify these two forms of artistic giftedness. Yani exemplifies the precocious use of the medium by a very young child whose originality of themes and vitality of composition extend beyond cultural conventions. The art of Eitan and Yani strikes a particular chord because of the young age of these children and the precocity of their craftsmanship, in addition to the aesthetic qualities that mark their work early on. Varda, in contrast, develops the child art style to the fullest; it is not technical precocity that appeals to us in her work but the originality of her composition and the sincerity, directness, and expressiveness of her paintings. These characteristics set the works of these child artists apart from that of their young contemporaries who also love to draw and paint. Theirs is a passion to create, to set themselves problems and to solve them; art making is for them a daily activity.

A further point needs to be made concerning the distinction between spontaneous, self-initiated art making and the rules that govern its transformation, and the controlled (and thus constrained) experimental investigations of recent decades. The latter contribute much to our understanding of the effects of instruction, task specificity, training, and the provision of a model, to mention a few variables. They have highlighted unsuspected competencies and also constraints on children's abilities, and they may be useful for developing a better understanding of what can be taught and how it is to be done. They do not tell us much about artistic development. (See also

Costall, 1995, for a criticism of modern experimental research that questions its ecological validity.)

Finally, some thoughts about the relationship between what appear to be domain-specific skills and aptitudes and more broadly conceived mental processes: In the normally developed individual, especially one who pursues an artistic vocation, all mental capacities are involved in the selection of themes and styles of representation, in their relationship to the artist's previous work, to the larger artistic community, and to the world of art critics and curators. The capacity to revise, to diversify, to experiment, and to critically assess one's work calls on all human capacities, a gift that is denied savant artists with mental retardation and that develops gradually over time in normally developing children.

My review of children's artistic development focused on the strategies children invent to deal with the specific constraints and possibilities of the two-dimensional medium. Drawing is a potentially expressive medium that affords the artist great latitude in the choice of forms and colors and their arrangement. The major constraint of this medium is the impossibility of directly representing volume, depth, distance, and multiple sides, and the necessity of learning the tricks of the trade to create the illusion of a three-dimensional object in space.

I next explore representational development in a three-dimensional medium and its effect on children's representation. Because there are few systematic studies of sculpture, the discourse is relatively limited to reporting on my own work in this field. This makes for a different kind of presentation, a more detailed account of data and method of collection.

CHAPTER 3

THE DEVELOPMENT OF SCULPTURE

The study of children's representation in a three-dimensional medium such as clay or a similar material has so far received very little attention. Unlike drawing, which has been studied extensively to assess children's representational concepts and, to a lesser degree, their aesthetic sensibilities, very few questions have been raised about children's approach to a three-dimensional medium such as clay, "play-dough," or plasticine.

In chapter 2 I noted that child art is characteristically flat, focused on a single, frontal view of the human figure and other objects. Figures, especially animals, are often represented in mixed views, with bodies depicted in side view and the head rotated into the frontal plane. These characteristics of childhood drawings have been interpreted as signs of conceptual immaturity, indicating a deficient perspective-taking ability rather than the novice's limited technical skills in the two-dimensional medium. In this view, cognitive limitations are only gradually overcome as children develop more advanced conceptual skills that lead to more veridical three-dimensional depictions of objects and scenes. Thus, the interpretation of the nature of child art and its two-dimensional character is grounded in the study of the two-dimensional medium. However, without a comparison of children's work in two- and three-dimensional media, one cannot tease apart the effects of the two-dimensional medium from those that might be attributed to conceptual deficiencies and, once again, the issue concerns the status of the underlying conceptual schemas. Does a uniform concept override the properties of the medium, or

does it respond selectively to its possibilities and constraints?

Modeling with clay, unlike drawing, allows the child to explore the multiple sides of an object and to add to or subtract from the mass in what is essentially a *reversible* medium. A closer examination of children's approaches to modeling human and animal figures in clay can provide new data that either support or challenge the conceptual deficit interpretations. Thus, findings from the three-dimensional study of representation are also likely to shed light on the meaning of children's drawing strategies. But beyond its relationship to drawing, the study of the development of modeling is interesting in its own right and can answer fundamental questions about an art form that has played an important role in the cultural life of humans since Paleolithic times.

It is something of a paradox that drawing, rather than a three-dimensional medium, has been the major focus of research. Drawing is a medium that requires technical skills to create the illusion of volume and of multiple sides and thus presents a special problem for examining the development of three-dimensional concepts. In the domain of drawing, considerable efforts have been made to map children's abilities to represent three-dimensional objects, with researchers generally delineating a slow progression from a flat, two-dimensional depiction drawn in orthographic projection to the representation of additional sides suggestive of the volumetric properties of objects and their multiple sides.

Researchers have focused on drawing rather than clay because clay is a technically difficult and some-

what messy medium to work with, and clay figures handled by inexperienced children tend to fall apart. The collection of clay figures, their transport, preservation, and storage present considerable problems and require much time and effort on the part of the investigator. By comparison, the study of children's drawings does not face these difficulties, hence the many extensive collections of children's drawings and the continued investigation of this domain. However, as long as students of child art limit their studies to the two-dimensional medium, their interpretations of the determinants of the particular form of children's drawings remain somewhat speculative.

In drawing, one might conceive of the developmental progression as proceeding from one-dimensional lines to two-dimensional geometric shapes and culminating in three-dimensional lines that represent the sides of objects receding into depth. On the basis of his analysis of prehistoric sculptures, Arnheim (1974) hypothesized that the development of sculpture might begin with the use of one-dimensional sticks, progress to a two-dimensional representation composed of sticks and slabs arranged within one plane, and finally culminate in patterns in more than one plane that represent the cubic body in the third dimension.

If this view of the historical antecedents of sculpture was transposed to the developmental domain, one might conceive of the sticks and snakelike shapes children roll with dough or clay as equivalents of one-dimensional lines, the pounded or flattened thin layers as equivalents of two-dimensional regions on a page, and modeling all sides of cubic objects as a three-dimensional approach to sculpture.

In the past, some authors have distinguished between the methods used by artists who work in stone and those who work with clay, wax, or plaster. According to the Renaissance artist and writer Leone Battista Alberti, the sculptor uses his tools to take away from the stone, and the modeler adds as well as takes away from the clay. This distinction has not been sustained over time; great sculptors made clay "sketches" before transferring their model to stone or delegating the transfer to specialized craftsmen (Wittkower, 1977). In the context of this chapter, I do not distinguish between these terms and use both to describe children's work with clay or play-dough.

Of course, it would be futile to expect children's sculpture to meet the stringent requirement of modeling in the round—a sophisticated approach developed in Greece around 400 BC to conceive of the emerging figure from all its sides. Modeling in the round requires that the sculptor considers all potential views as he or she works on a particular aspect or side. It is possible, however, to consider more elementary aspects of three-dimensional representation, for example, the upright standing posture of a figure, and the child's intention to represent more than a single frontal side. Such a conception of three-dimensional representation in sculpture raises a new set of questions not previously addressed.

In the beginning of the 20th century, several students of child art reported their findings on children's modeling of the human figure, but these studies lacked the necessary experimental and statistical controls (Bergemann-Konitzer, 1930; Märtin, 1932a; Matz, 1912, 1915; Potpeschnigg, 1912; Wulff, 1927). Since that time, relatively few relevant publications have appeared, and their focus is on ways to enhance creative and expressive ways of thinking (Burton, 1981; Edwards, Gandini, & Forman, 1993; Grossman, 1980; Haas, 1998; Haas & Gavich, 2000; Hagen, Lewis, & Smilansky, 1988; Hoag, 1959; Löwenfeld, 1939; Sherman, Landau, & Pechter, 1977), with some authors listing the number and type of body parts that are modeled at different ages (Brown, 1975, 1984). With few exceptions (Golomb, 1972, 1973, 1974), studies devoted to modeling have not been concerned with the three-dimensional conceptions that underlie children's work with clay, conceptions that are at the core of children's sculpture. I now turn to a report on two studies that closely examined young children's representation in playdough and clay, studies designed to delineate the development of representational conceptions and the discovery of modeling techniques.

The first study focused on early phases that mark the transition from a nonrepresentational attitude of sensory–motor actions to the emergence of representational conceptions and the evolution of effective "models." It provides insights into the mental pro-

cesses that undergird the child's modeling. The second study provides a more detailed exposition of the role of models and task effects, with a special emphasis on the variables that affect the three-dimensional treatment of diverse objects.

The subject of the first study is the human figure modeled by 300 American and Israeli children enrolled in preschools, kindergarten, and first grade (Golomb, 1972, 1974). Their ages ranged from 2 to 7 years. Children were seen individually and given a standard portion of playdough with the request to make a doll, a mommy, and a daddy. Following the modeling tasks, each child was also asked to make a drawing of a mommy and a daddy. These data and the extensive protocols that record each child's behavior during the session provide a fairly clear picture of the emergence of representational concepts in this medium.

PREREPRESENTATIONAL INTERPRETATIONS

To explore the transition from a prerepresentational attitude to a genuinely representational conception of the modeling task, I included two-year-olds in this study. Their behavior demonstrated that they lack an awareness of the representational possibilities of this medium. The very youngest among them, those between ages 2 years and 2 years and 8 months, hold the material passively, turn it aimlessly, or hit the table with it.

At times, the playdough is used in conjunction with other toys, sticking it on blocks, cars, and the like. A few months later, between ages 2 years, 8 months and 3 years, 2 months, the child tends to handle the material more actively; the dough is fingered, pounded, stretched, pulled apart and joined together, or hammered on the table. Other actions include patting, stretching, folding, squeezing, lengthening, poking, pinching, and flattening the dough with the palm of the hand. The material is handled mainly for the pleasure of playing with this soft and pliable medium, actions that are devoid of representational intentions and are best characterized as *prerepresentational actions*. Finally, the child discovers the rolling motion, rolling the dough back and forth on the tabletop, which yields the first visually coherent and pleasing unit. Without apparent

planning, the child has created his or her first articulate shape in this medium: the snake. Further practice leads to more expressive forms that capture children's attention, and they now take a closer look at their creations. A new attitude can be noted, a dawning awareness of forms and of the possibility to make things. As discussed in chapter 1, and similar to an early phase in drawing, this discovery sets the stage for *romancing*, the telling of stories to explain what one has made. Romancing is a kind of forced interpretation of an accidentally produced formation; the narrative develops quite independently of form quality and is not yet tied to a perceptual likeness.

The three-dimensional medium tends to foster interpretations that derive from *imitative actions*: bouncing a piece of rounded dough in imitation of a ball; moving a blob across the table like a train, a car, or an animal walking; and flattening lumps of dough in imitation of meat patties or pancakes. These are actions in lieu of or as an aid to representation. They are not performed to create a perceptual likeness of the dough shape to the object but instead to imply the object by imitating one of its functions.

Romancing and imitative actions serve as substitutes for representation proper; they are pseudorepresentational devices that meet the demands of the task. They mark a transitional stage of development, when the request to make something is only vaguely understood and the child does not yet know how to proceed. He or she knows only that some people, an older sibling or a parent, can "make" things and, although the child has an inkling of representational possibilities, he or she lacks functional representational concepts and models. When pressured to "explain" what he or she has made, the child tends to resort to romancing while maintaining some order in the spatial identification of parts. This interpretation usually takes the form of locating the head in the top part and the legs somewhere at the bottom. On the whole, romancing as an interpretive act seems typical of a brief transitional phase, a fleeting moment in the developmental sequence and, like action imitation, is fairly soon replaced by more adequate representational means.

Further along in development, we find the somewhat more advanced forms of reading off and verbal

designation. *Reading off* is an effort to read the hidden meaning of the dough blob. It is based on an incidental discovery of perceptual similarity between the blob and a real object. Because it relates to the "looks" of the product, reading off is more advanced and less arbitrary and fanciful than romancing.

Among the most advanced pseudorepresentational devices invented by the child is *verbal designation*, a useful aid to representation in that the parts, although not yet modeled, are verbally identified. In this case, the verbal identification of parts no longer depends on the dough form's chance appearance, and the figure, although still crude and minimally differentiated, is made to conform to the original intention. The distinction between the earlier developmental form of reading off and verbal designation is quite important. In the case of verbal designation, the parts are interpreted according to some principle such as location on a vertical axis: Top is head, center is tummy, bottom is legs. Designation requires the notion of correspondence, and the discovery that the top of the bulky structure can stand for the upper part of a person is a significant step on which further representational development depends.

In the process of exploring dough shapes, the prerepresentational child has developed a growing awareness that the modeled piece can look like something, in fact can contain forms and meaning. As long as children lack representational tools, they avail themselves of pseudorepresentational tactics and rely mainly on verbal aids to interpret their creations. Verbal means, however, will not satisfy children's representational urges for long, and they will search for better means of representation and invent more suitable forms.

REPRESENTATIONAL BEGINNINGS: THE HUMAN FIGURE

The passage from a prerepresentational attitude to the first attempts to model a human involves a radical transformation in outlook and competence. Most commonly, age 3 years marks a turning point in the development of representation. Children show an eagerness to explore the media and a capacity for fast learning. Children move relatively quickly from prerepresentational interpretations to the discovery of similarities and the invention of simple forms of equivalence. Because the human figure is a favorite subject for most children, at least in the Western world, I begin with a description of children's efforts to create the human form.

Early Representational Models in Playdough

Modeling the human figure begins with the undifferentiated blob of dough from which crude, nonsymmetrical structures evolve. Three models emerge as the first representations of the human: the upright standing column; the ball or slab of dough with facial features; and the layout model composed of an array of separate parts, mostly facial features and occasionally a tummy and limbs (Figure 50a–c).

Upright column. The most common model of a person is a lengthened blob of dough, crudely shaped, held up in the air or placed erect on the table. It is a primitive upright column with little modeling of its parts, which are often verbally designated. Holding up the dough figure emphasizes its verticality and primitive likeness to the intended human object and circumvents the difficulty of making a standing, well-balanced figure. The representational concepts of verticality and erectness seem to determine this model, which has no counterpart in drawing (Figure 50a). With his or her first three-dimensional model of a person, the child crosses the threshold to representation proper. The figure is still crude and undifferentiated, determined by position and height of the blob. To provide the characteristics of the human figure, the child "completes" the sculpture verbally. The designation of parts usually reveals that the child has a clear perceptual concept of what a man or woman looks like, what is the top, middle, and bottom of the figure. The poorly modeled figure is interpreted in terms of the human's basic visual characteristics. At this early stage, there is a considerable gap between children's modeling skills and their desire to invent adequate forms. The outcome of these early modeling efforts is a global figure, the child's first step in the modeling of a person.

With experience and the motivation to create a better likeness, the upright standing column develops into a figure consisting of a basic unit with

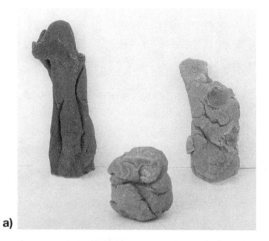

a)

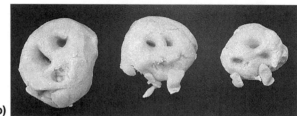

b)

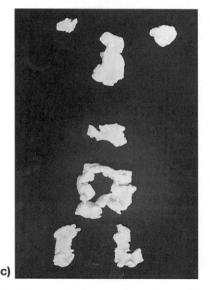

c)

FIGURE 50. First sculpting models. Created by artists ages 4 to 6 years. a. Column. b. Sphere with facial features. c. Layout model.

some internal subdivision of individual parts. The head is usually pulled out or shaped by pressing the fingers around the top section, arms and legs are pinched out, and the facial features are minimally represented or left out altogether. With the exception of the symmetrical and upright standing column, there is little observable effort at precise work-

manship, and the details of the figure are barely indicated (Figure 51). Although the sculptures are crudely modeled, they signify progress; the child no longer needs to rely on verbal designation of parts or on mere verticality to create a basic likeness to the object.

The majority of these one-unit models are erect standing sculptures, although occasionally a flattened and horizontally placed figure appears. A variation on this model can be seen in sculptures composed of a column and a head or a global body with a separately formed head.

Evolution of the tadpole figure. A second frequently used model is a ball or flattened blob of dough, most commonly with the facial features scratched on its surface, poked out, or separately formed and attached to the global structure. Although this figure lacks the determinants of verticality and upright posture, modeling the facial features provides some of the distinctive characteristics of the human figure. For the young modeler, the global form represents the head as well as the entire body (Figure 50b). Occasionally all of the major body parts, eyes, nose, mouth, tummy, and legs, are inscribed on a slab of dough. Such a figure bears a striking resemblance to the drawings of young children that differentiate the major body parts inside the drawn contour. Indeed, it is a graphic model imposed on a three-dimensional medium.

With additional experience, the global ball or slab of dough differentiates into a two-unit model,

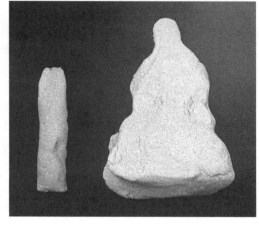

FIGURE 51. Minimally modeled figure. Created by child, age 4 years, 7 months.

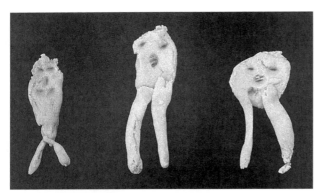

FIGURE 52. Tadpole: Disk or sphere with extensions for legs. Created by children, ages 3 years, 4 months to 5 years, 0 months.

and in modeling as in drawing the tadpole man gains prominence. In the three-dimensional medium this figure consists of a sphere and legs. Three-dimensional variations on the tadpole theme range from the large disk or sphere with short extensions for legs to the smaller disk with longer legs (Figure 52). At times we can follow, in a single session, the development of a tadpole figure from a global to a more differentiated tadpole. In Figure 52 the first tadpole consists of an oblong head–body and relatively short legs. In the next two tadpoles, the child shrinks the basal unit and lengthens the legs. The majority of the tadpole figures are placed horizontally on the table top, but approximately one third of them are held up or placed standing upright on the table.

The global head–body structure of the tadpole man usually varies from a sphere to a bulky but flattened piece of dough or a disk-shaped unit. A common working procedure consists of rolling the dough into a ball, flattening it with the palm of the hand, then adding separate pieces for legs. These may be rolled like sausages and attached to the global structure or put together in a piecemeal fashion. Some children paste tiny pieces together to make the legs and hair. In American preschools, children frequently comment, "Gotta make it flat," as though they meant to say, "Got to make it flat like paper." Unless it is flattened, the dough seems unworkable to them. Among Israeli children who, at the time of this study, were not used to playdough for the making of pretend cookies, such actions

were exceedingly rare, and the percentage of upright standing or upright held tadpoles was significantly higher than that of their American counterparts. Some children solve the problem of creating an upright standing tadpole figure that does not topple over by *reversing* the order in which they model the parts, beginning with the legs on which a rounded shape (head or head–body) is placed (Figure 53). Of course, when children hold the figure up, they do not have to grapple with the problem of how to balance an upright standing sculpture.

Once the dough form has been flattened, the facial features are scratched in, poked out, or separately formed and attached so that the features are raised. At times facial features are placed on the surface of the disk and pressed into the dough until they almost disappear in the soft background.

Graphic models and their antecedents. The third model in dough is a persistent though infrequently used representation of a person. It begins as a *layout model* and consists of an arrangement of facial features to which arms and legs can be added (Figure 50c). All the parts are formed separately and, although they lack an embracing contour or dough background, they are assembled in their correct spatial relations. Evidently, the surface on which the parts are laid out provides an adequate background that is implicitly incorporated into the representation. This is not a fragmented figure for the young modeler; it may even contain all the essentials of eyes, nose, mouth, tummy and legs (Figure 54). With further elaboration, this model becomes a full-fledged *graphic model*.

The graphic model in dough is an interesting

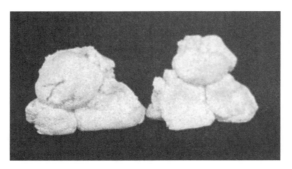

FIGURE 53. Upright standing tadpole. Created by child, age 5 years, 2 months.

line of development in this medium. Essentially it is a linear model that evolves from the representation of single features and parts, borrows concepts and procedures from drawing, and eventually becomes quite perfected. Unlike the typical modeling procedures already described, whereby a figure is constructed from several solid parts or modeled from one piece of dough, the graphic model uses two-dimensional representational concepts and procedures. One gets the impression that the child "draws" the dough figure, and indeed he or she does outline head and body contours with thin strips of dough. Figure 55a exemplifies the transposition of the graphic tadpole model to the three-dimensional medium. Figure 55b illustrates a slightly different version of the graphic model of a tadpole person and offers a glimpse of ongoing processes of differentiation. The figure on the left consists of a flattened but solid head with facial features and two extensions to represent the body outline. The figure on the right has been constructed similarly, but shows a clear improvement in that the body contour has been completed ("I'll close the doll") and a belly-button added for further differentiation. Figure 55c represents a good example of the graphic model in which facial features and buttons are placed inside the contours for head and body.

Another version of the graphic model is the stick figure in dough (Figure 56) and other variants that consist of an orderly array of pieces, some attached and some detached, laid out on the table like a puzzle assembly (Figure 57). These figures are reminiscent of "open-trunk" models in drawing (see Figures 3 and 4), but their construction is quite different. In

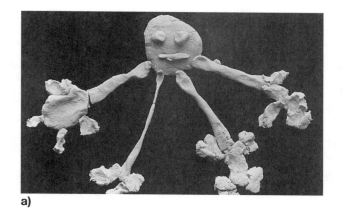

a)

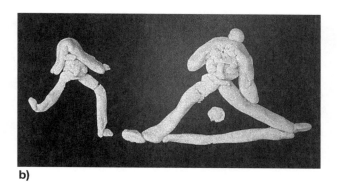

b)

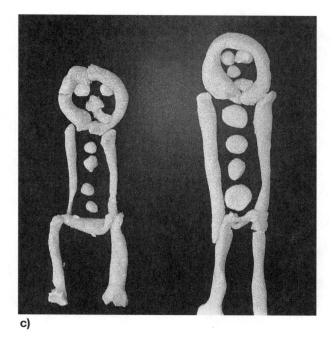

c)

FIGURE 55. Graphic models in dough: a. Tadpole figure. Created by child, age 4 years, 4 months. b. Tadpole figures. The figure on the right includes a bellybutton and a strip of dough to complete the body contour. Created by child, age 5 years, 0 months. c. Armless graphic models. Created by child, age 4 years, 7 months.

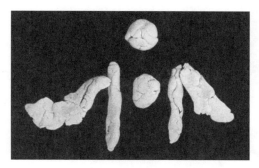

FIGURE 54. Layout model composed of head, facial features, arms, legs, and body. Created by child, age 3 years, 9 months.

FIGURE 56. Stick figures in dough. Created by children, ages 4 years, 7 months to 5 years, 4 months.

drawing, each part follows the other in a special order, from the top down or vice versa. In these figures, the "preparation of parts" seems to follow from the qualities of the three-dimensional medium, with all the parts modeled *before* they are assembled. With further practice, the detached forms are joined together, and soon the "puzzle" figure is transformed into a proper graphic model or it evolves into a more conventional sculpture consisting of solid parts.

Models are temporary solutions to a representational task, as can be seen in children's modeling of a snowman. Children who model a man as an array of detached parts construct a complete and erect standing snowman composed of two or three balls stacked on top of each other (Figure 58). The adoption of a model in dough does not imply its contin-

ued use. On the contrary, the child who spends a great deal of time with this medium tends to discard the less suitable model and invents other means of representation. This process can be seen in the graphic model in dough, which is unstable, cannot be lifted without serious dislocation of its parts, and requires patience and fine motor coordination. For these reasons it tends to be exchanged for models that are more suited to the task at hand. Above all, models should be considered as tentative solutions, temporary formulas for representation.

General Trends in Modeling the Human Figure

The great majority of one-unit column figures are constructed in a vertical, upright posture, whereas those created by joining separately formed parts are placed in a horizontal position. Making an upright standing figure, even the lumpiest of sculptures, involves special difficulties of balancing a figure that wobbles and tends to topple over; this is especially the case when its construction involves the joining of several parts. Making a standing sculpture can be very frustrating, and one solution is to place it horizontally on the table. The supine figure is thus determined by two factors: the graphic model and exasperation with making a standing one. The overall direction of this type of figure is vertical–horizontal, with the body constructed in the vertical plane and arms extended horizontally.

Compared with the drawn human figure, the trend in modeling is toward an earlier differentiation of the trunk as a separate structure. However, facial features and other details such as hair, ears, fingers, and toes that are prominent in drawings are less frequently represented. This rule does not apply to the graphic model because it derives from the two-dimensional medium and retains the distinct characteristics of representing details. As the three sculpting models indicate, there is no single template, and different figures can meet the criterion of basic structural equivalence.

In general, children concentrate on the frontal plane of the figure; they model facial features, belly-buttons, and occasionally hair. The young artists seem to follow the rule that the bare minimum necessary to achieve perceptual likeness will do. Simpli-

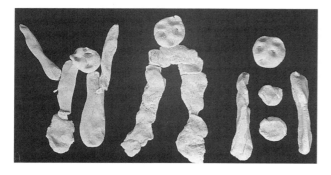

FIGURE 57. A variant of the stick figure in playdough. Created by child, age 6 years, 0 months.

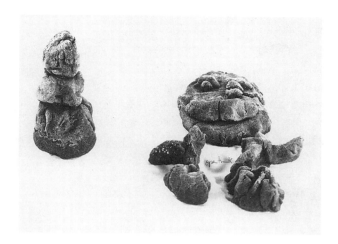

FIGURE 58. **Man and snowman. The man is modeled as an open-trunk figure lying down in contrast to the snowman, which boasts a body and is upright standing. Created by child, age 4 years, 4 months.**

fication does not imply ignorance of body parts, and children frankly express their awareness of features that they could represent but won't because the figure can do without this part. For example, "I won't add arms, it's too much . . . I am not going to make his hair, we'll pretend that it has hair" (girl, age 4 years, 11 months); "here is his little eye . . . I don't have to make the nose, no space" (boy, age 5 years, 2 months). The difficulty of modeling tends to reinforce the inclination toward economy and simplicity in representation, which is further enhanced by children's playful attitude and freedom to symbolize and transform the parts they have created. This playfulness permits the children to resign themselves to the imperfections of their sculpture, to rename, reinterpret, and to qualify the final product instead of reworking it. Examples of this attitude can be seen in a boy (age 4 years, 11 months) who modeled a solid head with facial features, an outline trunk, arms, and legs. On inspection, he reinterpreted his figure: "I cut out the insides of the giant so now he is dead." A playful narrative mode also characterizes the work of a girl who constructed an upright figure (a daddy) by pinching and pulling the mass. She interprets her work with a sense of humor and delight in its incongruity: "Don't like to make daddies. I like my daddy . . . He has a big stomach, having a baby, ha, ha, ha" (girl, age 4 years, 6 months).

Children are aware of the imperfections of their sculptures and indicate that they fall short of their intentions. For example, when the legs turn out to be unequal in length, children tend to explain this inequality rather than correcting it: "he broke his leg," "just came from the hospital," "got chopped off," or "his leg got shot." When the head is too small to hold all the major facial features, we note displacement (e.g., the mouth sinks down and comes to rest on the torso). Children readily comment on what they perceive as flaws, for example, "his hand turned out awfully big," "what a long finger I made," and "I won't make the fingers, you can do without them." Such statements indicate the young artist's resignation over the imperfect state of affairs and highlight the gap between competence and performance. An example of a girl's ongoing commentary on her efforts illustrates the difficulty she experiences and the comical ending: "Very hard for me to make; I have to do the tummy, and head and legs and shoes and arms and hands. Don't want to make hands, have to do the legs so he can stand up." The figure collapses, and she starts all over:

> First start with the head, little balls can make eyes . . . a big eye and a little eye . . . this is his ears. I want it to be a man, this is the chin, goes up here . . . he is an old man, some older men have some of the hair; tummy, I have to make his neck first, then tummy, then arms, long long arms; very hard to make the legs, he lost his legs, were running away from him. (girl, age 4 years, 6 months)

These and similar comments reveal that children are astute observers of their work, at times critical and dissatisfied but always ready to reinterpret the sculpture rather than search for an alternative method that would bring the figure closer to the adult's "realistic" conception. The four-year-old's interpretation of her work transforms the irregularity of the figure without abandoning her original representational intention. She does not accept the erratic, but instead of modifying her sculpture she eliminates the contradiction by playful and narrative tactics. In this manner, the child strikes a compromise between fact and fancy, and for the time being this solution satisfies. Thus, a dynamic balance is

maintained among representational intention, modeling efforts, and playful transformation. The older child, no longer satisfied with this kind of resolution, will attempt to fit the figure to his or her more exacting standard of correct representation.

In spite of the younger child's reliance on interpretation rather than correction, she has made tremendous progress in representation per se. Interpretations no longer serve as substitutes for modeling and are reduced to the status of corrective devices. The procedure of modeling with dough or clay is new and demanding and elicits many spontaneous and insightful comments. The naming of parts and thinking aloud about plans, procedures, and revisions reveal an ongoing problem-solving process that is at times quite humorous:

> *Put her face on, legs, whole body.* How to start off? *I think I know . . . leg and second leg. Then another piece, eyes, mouth, make her legs, her bum . . . How does it look? Good, I make everything, now neck. How about her earrings? Take this big [lump], roll it and then her arms. A big lady has long arm . . . needs to be up where her neck is.* (girl, age 4 years, 5 months)

From these early sculpting models we can infer the representational concepts that gave rise to them. As in drawing, they are characterized by generality, such that a global form can stand for another global entity, in this case a person. Verticality, uprightness, and facial features serve as defining attributes of the human figure. Genuine three-dimensional treatment of the human figure, although rare at this stage, can occasionally be observed, as in the case of a boy age 3 years, 10 months, who made a global man with facial features, turned the figure over, added some dough, and said, "Now his back on—that's all done."

Considering the characteristics of this material, the determination to create a specific object and the ability to sustain this intention while shaping, often unsuccessfully, a blob of dough is a significant achievement. It reveals the capacity to subordinate the modeling action, the appearance of the figure, and the child's verbal designation of parts to a central, dominant representational intention. Indeed, a profound distance exists between the prerepresentational child who merely acts on the medium and the child who makes a crude column–blob with designated parts. It is this distinction between mere sensory–motor action and representation that the child masters in the course of a few months, provided he or she is given the opportunity to explore the medium.

A note about individual differences in representing the human figure: They are pronounced, and we find some young three-year-olds who produce advanced sculptures, whereas some four- or even five-year-olds create relatively undifferentiated tadpoles. As in drawing, the overall trend is toward increasing complexity of representation with age, with differentiation of parts closely related to the figure's structural properties. As the child begins to pay more attention to detail, the figure improves in its structural organization. Mere representation of parts is rare if not absent and, given some experience with the medium, the child learns to arrange the parts into a coherent unit. If an older child persists in the arbitrary placement of parts despite continued practice and freedom to explore the medium, the behavior should be considered atypical and would merit a diagnostic assessment.

DIFFERENTIATION OF THE HUMAN FIGURE

Progress in modeling can be seen in the differentiation of the parts of the human figure that are now distinctly modeled. As the dough figure approaches "completion," there are continued developments in the three early models: the *upright standing* figure that is now composed of several solid parts, the *horizontal* figure constructed of solid rounded or flattened parts, and the *graphic outline* figure.

The primitive one-unit figure previously described splits apart. At the very least it now boasts a separately formed head placed on top of the body that includes legs, although it is frequently armless and faceless. The several parts are modeled successively, each part attached to the one preceding it. The usual construction sequence starts with the head or the legs, although occasionally a trunk is

modeled first. In modeling as well as in drawing are instances of self-reference, in which the artist touches his or her own body to help identify the parts to be modeled. The finished sculpture is held up or placed standing on the table (Figure 59a–b).

The horizontal figure composed of solid rounded or flattened parts represents a compromise formation between the three-dimensional upright standing figure and the flat two-dimensional model of graphic origin. Once the figure develops a differentiated trunk and legs, its appearance and overall workmanship varies from the crude, slightly lumpy, and unshapely construction of younger children to the skillfully finished and symmetrical composition of the more experienced children (Figures 60, 61, 62). The graphic model in dough, whose antecedents

were discussed earlier in the layout model and in the graphic tadpole figure, persists and is perfected (see models in drawing, Figures 5, 6, 9). Instead of working with solid masses and using the three-dimensional properties of the dough, children outline the figure with strips of dough, closely following the characteristics of the drawn line. The head is often modeled as a flattened rounded piece, but the trunk is always outlined and consists of circular or squarish forms. This model is adopted deliberately, accompanied by such remarks as "I'll make it like on paper" or "I'll make it like crayon."

Graphic models in dough vary from crude, clumsy versions to graceful, delicate ones exhibiting a taste for detail and precision. Almost all of the graphic models are equipped with distinctive features, and the majority were produced by girls. These figures demonstrate careful planning, measuring the length of the sides, choosing the quantities to be used, and attaining almost perfect symmetry. This work exhibits new constraints and is less playful than that of younger, inexperienced children; a more demanding standard of correct representation has been adopted by the older artists (Figure 63).

With the acquisition of arms, and the figure's subdivision into its major parts, the modeled human reaches a stage of formal completion. With the exception of the graphic model, the sculptures continue to be constructed with simplicity, stripped of

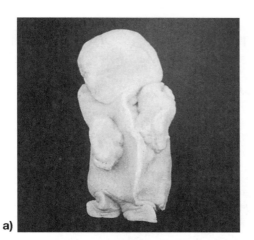

a)

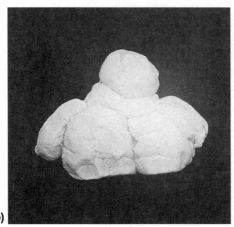

b)

**FIGURE 59. Upright models. The finished figure is held upright or placed standing on the table.
a. Created by child, age 5 years, 2 months. b. Created by child, age 6 years, 0 months.**

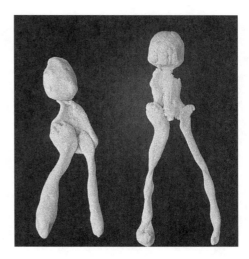

FIGURE 60. Horizontal armless figure. Created by child, age 4 years, 10 months.

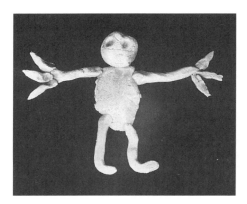

FIGURE 61. Differentiated figure with minimal facial features. Created by child, age 5 years, 9 months.

detail, and limited to bare essentials that ignore the relative proportion of parts. Most four- and five-year-olds create very similar models for the mommy and the daddy, but when asked whether there are any differences between them they insist that they are not the same, for example, "they have different parts inside, not the same blood" (boy, age 4 years, 9 months). There are also frequent references to *pretense* such as "can only make . . . we can pretend." In this domain, pretend is always a possibility and is significantly broader than just pretense play: It refers to trying out, playing with forms, thinking and imagining, a preliminary mode of experimentation that is not yet fixed or final.

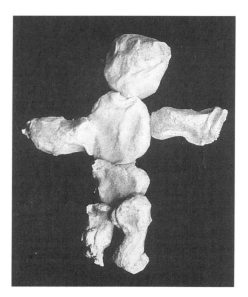

FIGURE 62. Horizontal faceless figure with two-part trunk. Created by child, age 5 years, 3 months.

The need for a visually intelligent subdivision of the figure into distinctive parts is the main concern at this stage of modeling, which eventually includes the distinction between the upper and the lower torso, inclusion of neck and clothing. When the arms are first endowed with fingers, their size is determined by the zest of creation and the need for symmetry rather than by realistic proportions. The modeled parts seem to increase in size as children proceed with their work. By the time they model the fingers, which is one of the last acts, they roll the dough with pleasure and gusto, carried away by the activity and enjoying it for its own sake. Most frequently, the sun–radial pattern is adopted for the hand, and its balanced structure seems to please children (Figures 64, 65). Thus, work habits and the dominance of preferred forms over accurate proportions determine the size of the hands, and emotional significance should not automatically be attributed to them. But of course, modeling a human can elicit positive and negative feelings, as the following examples suggest:

> *Head and then eyes, mouth. He is* mad.
> *Legs stick on, I know how to make*
> *daddies anyway, sometimes have ear-*
> *rings on, yes big earring; the last thing*
> *to put on—shoes—he is lying down,*
> *has to find a way to get them off. Looks*
> *like Mickey Mouse, his ears, no eyes,* I
> *don't want him to see.* No face, no
> mouth, can't talk. *(girl, age 4 years, 5*
> *months)*

A 7-year-old boy, who is small for his age, commented as he modeled a man: "The man is going to be a little bit smaller [than the woman] because the smaller he is, the smarter he is, and did you know that smaller men are great, and they don't even think they are" (boy, age 7 years, 11 months).

In each of the three sculpting models, the figure passed through a process of orderly differentiation determined by the properties of the medium and the specific model used. The main emphasis is on the differentiation of forms and the creation of balanced, symmetrical structures. Once this has been achieved, the overall proportions of the figure improve gradually. A note about frontality: In the case of the hu-

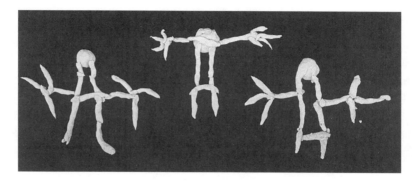

FIGURE 63. Highly symmetrical graphic models in playdough. Created by child, age 5 years, 9 months.

man body, the frontal aspects are the most important and informative ones; they define the character of the person, the gender, affect and intentionality, direction of movement, and social communication. In sculpture as in real life, humans relate most directly through their senses, which privilege what is in front of them, a tendency that favors the representation of the canonical frontal view. Up to age 5, children tend to work mostly on the frontal plane. Between 5 and 6 are some instances of turning the figure over and modeling the back lightly or offering recognition of its existence: "The other side is its back and neck." The dominant directions are vertical–horizontal, similar to those observed in drawing. Along with verbal interpretation of irregularities are now statements indicating the need for corrective actions: "Have to take some off; finger is too long."

This completes the first account of the early development of the human figure in playdough. Next I turn to a more comprehensive examination of representational development on a broader set of tasks.

CHILDREN'S REPRESENTATION OF INANIMATE, HUMAN, AND ANIMAL FIGURES IN CLAY

So far the discussion has been limited to modeling of the human figure in young children. The next task is to extend the inquiry to older children and to their modeling of additional objects. With these measures we are in a better position to map the evolution of sculpture in children and to identify the problem-solving strategies in a three-dimensional medium. A comparison of the child's performance on diverse tasks can aid in distinguishing among the effects of the medium, instruction, and the child's concept of the object. Of special interest is the developmental progression in sculpture: Does it follow

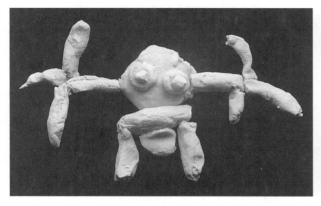

FIGURE 64. Horizontal model with arms extending from the head. Created by child, age 4 years, 9 months.

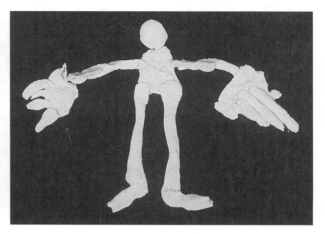

FIGURE 65. Symmetrical horizontal model with large hands. Created by child, age 5 years, 2 months.

the dimensional pattern established for drawing, from one- to two- to three-dimensional use of lines most commonly assumed (Lark-Horovitz, Lewis, & Luca, 1967), or does dimensionality play a different role in this medium?

In addition to helping us better understand children's emerging three-dimensional concepts in clay —a material that, unlike dough, is not associated with baking—the comparison with drawing can clarify the role of the medium in the form the representation takes. Thus, the aim of this expanded study is twofold: to determine the order in which representational concepts emerge in the medium of clay and to clarify the impact of selected task variables on the child's ability to represent objects three-dimensionally.

The question of order concerns the nature of the developmental progression. The order of stages in the development of three-dimensional representation is primarily addressed in terms of the *posture* of the figure (upright standing or placed horizontally on the table), the child's attention to *multiple sides* of the modeled object, and the manner in which the medium is used, for example, by hollowing out and creating protrusions, which suggests the inside as well as the outside of the figure. Succinctly stated, I wish to examine the hypothesis that three-dimensional development in sculpture, in analogy to drawing, follows the same progression established for drawing, namely, from one-dimensional lines to two-dimensional regions to a three-dimensional use of line or matter. Alternatively, I consider the hypothesis that, in modeling with clay, children exhibit, from the beginning, a basic three-dimensional representational conception of the object that undergoes differentiation and refinement with further development.

In my selection of task variables, I wished to go beyond the traditional subject matter of the human figure which, in the past, has led to the prediction that modeling with clay would follow the same linear development as observed in drawing. This interpretation ignores the uniquely difficult technical problem of representing the human figure in an upright fashion without recourse to an armature (a kind of wire scaffold). In contrast to the linear development position, I hypothesized that modeling the human figure as a horizontally placed object is a function of the nature of this particular task and does not reflect a limited two-dimensional conception.

With these hypotheses in mind, we selected the following variables for closer examination: complexity, symmetry, balance, and familiarity (Golomb & McCormick, 1995). Of these variables, *complexity* refers to the number and arrangement of differentiated elements that comprise an object, which can vary from a few simple to many diverse elements. *Symmetry* refers to the number of sides of the volumetric object that have the same or similar characteristics; these vary from complete symmetry of the six sides of a cube to the partial symmetry of a four-footed animal whose two long sides are nearly symmetrical, to the bilateral symmetry of the human figure whose front and back sides are distinctly different. *Balance,* a variable that is quite specific to the clay medium, refers to the construction of a free-standing sculpture, which requires some understanding of its mechanical properties and the technical difficulty of balancing an upright figure. *Familiarity* refers to knowledge of the object and the availability of practiced representational models. Thus, for example, familiarity with drawing might predispose a child who has not yet worked with clay to rely on a well-practiced graphic model and transpose it to the clay medium.

I predicted that simple and symmetrical objects would be the easiest to construct in an upright manner and that, as complexity increased and overall symmetry decreased, the physical balancing of a figure, as a free-standing object, would become harder. Familiarity, a necessary condition for any representational task, would yield more differentiated sculptures, also relying on pre-established models.

Thus, I chose eight tasks that vary along these dimensions (Golomb & McCormick, 1995). The tasks were modeling a Cup, Table, Man, Woman, Person Bending to Pick up a Ball, Dog, Cow, and Turtle. According to my analysis of potential task effects, objects that are familiar to the child, simple in construction, easily balanced, and have symmetry of sides, are the most likely candidates for successful three-dimensional modeling. These conditions apply most fully to the Cup and the Table, with the Table more complex in its construction than the Cup. The Cup can be modeled by turning the ball of clay, in-

denting its center, and flattening its bottom to make it stand. The Table requires more planning in the modeling of separate parts: flattening the lump of clay to serve as the table top, modeling four separate pieces to create the legs, and attaching the five pieces to yield a balanced, upright-standing structure.

Animals are more complex in structure than Cup or Table and comprise more differentiated parts that require skillful planning. They are, however, relatively stable in structure, with bodies resting on four legs placed perpendicular to the horizontal axis of the body, which facilitates an upright posture. In terms of the overall structure of the Dog and the Cow, the major parts include head, body with its two prominent (long) sides, four legs on which to balance the figure, and a tail. A similar set of conditions applies to the Turtle, which is composed of head, body, legs, tail, and shell. The relationship of the body inside or underneath the shell tends to make it a more complex object of representation.

Animals are also quite symmetrical, with the two major sides, or long sides, near duplicates of each other. Instead of a dominant canonical view that favors a single side, which is the case for the human, in four-footed animals there is a competition between frontal and side views (Golomb & Farmer, 1983; Ives & Rovet, 1979), which calls attention to more than a single side or view. To the extent that symmetry enhances three-dimensional representation, and in the absence of a single dominant frontal view that favors the horizontal position, one might expect a more comprehensive representation of sides in animals and, with equal distribution of weight on its four legs, a greater tendency to construct the object standing upright.

Among the animal figures, the Dog and the Cow vary somewhat in terms of familiarity. Most children have encountered real dogs and numerous pictures of this animal; cows may be less directly familiar to urban children and are mostly known from toys and picture books. Turtles, however, are well known to many young children who have handled them as pets. In light of these differences, I predicted that the most familiar animal would be represented in a more differentiated manner.

Finally, the human, although the most familiar object, is the most complex in this series of tasks.

Its structure is organized along the vertical axis, and its relatively disproportionate parts—head, neck, body, a set of arms and hands, legs and feet—make it difficult to balance. In contrast to animals, the human figure has marked differences between its front and back sides. The human body calls for the vertical alignment of a large torso with two long spindly legs, which creates problems of balance for a standing figure and thus favors the horizontal position. However, specification of a theme may facilitate uprightness and attention to multiple sides, as in the case of a human bending down, which makes posture more salient.

I ordered the requested objects in terms of simplicity–complexity, symmetry, balance, and familiarity. If indeed these variables affect children's productions, one might expect better performance on the Cup and the Table than on the animal and human figures because the Cup and the table meet the criteria of being simple in construction, symmetrical, balanced, and familiar. Considering the variables, animals should show more three-dimensional treatment than humans, and among the human figures, attention to posture and multiple sides should favor the Person Bending over the Man and Woman.

The participants in this study were 109 children ranging in age from 4 to 13 years. They were enrolled in preschool centers and elementary–junior high schools, kindergarten through seventh grade. Also included in the study was an adult sample of 18 liberal arts students who were enrolled at an urban university. Approximately one half of the students majored in the visual arts or took art courses; the others were students of psychology. Each participant was seen individually over one to two sessions and was provided with a ball of clay approximately 4 inches in diameter for each one of the tasks. On request, more clay was made available. A detailed record was made on all facets of the construction process, with careful attention to the modeler's actions and comments, which were also tape recorded. The sculptures were preserved for examination, analysis, and scoring.

Uprightness

The question of uprightness is of special significance because the horizontally placed sculptures of the hu-

man figure have been attributed to the artist's constricted two-dimensional conception of the task. My results challenge this interpretation with the finding that uprightness and attention to multiple sides can be seen even in the work of our youngest children, the four-year-olds. Almost without exception, the youngest children modeled a three-dimensional upright standing Cup; closely following this feat, they successfully modeled the Table. The Cup was rounded on the outside, hollowed out on the inside, and freestanding. Although the younger children modeled their object more crudely than the older children, they succeeded in portraying the three-dimensional character of the Cup. Because creating a standing table requires adjusting the size of the legs to sustain the top, much experimentation went on. Faced with the problem of collapsing legs, children invented various solutions from increasing the width of the legs to turning the table upside down "to let the clay dry," and reversing the position afterward, because "when it is dry and sturdy you can turn it upside down." Thus, on the first two tasks that were relatively simple in structure, familiar, symmetrical, and balanced, almost all the children created three-dimensional representations, with upright intention as one of the defining attributes of three-dimensionality (Figures 66, 67).

The great majority of the animal figures were also modeled in an upright stance and exceeded the number of upright standing humans. Among the human figures, the Person Bending to Pick Up a Ball was modeled more frequently in an upright standing posture than either the Man or the Woman sculptures. The *intention* to model an upright standing figure was already apparent among the youngest children. For the total sample of children, 57% at-

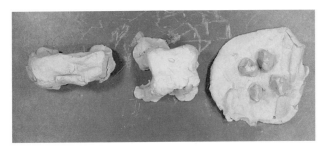

FIGURE 67. Tables modeled in clay. Created by children, ages 5 years, 7 months to 6 years, 1 month.

tempted to model the Man or Woman in an upright standing fashion, comparable to the 50% upright humans of adults. The number of children's upright standing figures increased to 76% for the Person Bending (adults 100%), and peaked at 83% for the animal tasks (adults 100%). When the results on the animate tasks are compiled for all subjects combined, there is a consistent increase in uprightness as a function of the nature of the task, which indicates children's sensitivity to the demand characteristics of the assignments, with close to 100% uprightness on the inanimate tasks of Cup and Table.

When considering the factor of age, an interesting pattern emerged. On the human figure tasks, upright intention *decreased* with age, and the preschoolers had the highest upright intention (71%), followed by the kindergartners (68%), with all others trailing far behind. Closer examination of the modeled figure reveals a significant relationship between upright posture in Man and Woman tasks and their degree of figural differentiation (complexity). As the figure increased in detail, children found it harder to make it standing and resorted to a horizontal posture. These findings suggest that at an

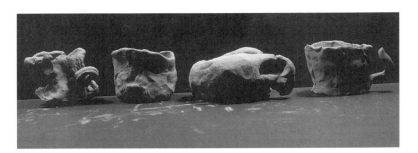

FIGURE 66. Cups modeled in clay. Created by children, ages 4 years, 4 months to 6 years, 5 months.

early stage in modeling, four- and five-year-olds use a primitive three-dimensional strategy that leads to crudely modeled upright humans. The older children who attempt to differentiate their figures and model more numerous and diverse parts face the difficulty of constructing complex figures that are difficult to balance. Complaints such as, "these legs aren't strong enough to hold it up; there, it's falling" (boy, age 6 years, 9 months); "hardest part is the legs . . . always fall apart" (boy, age 7 years, 0 months) are quite common. As this child explains, "Because I didn't know how to get them standing up. Like when I was putting the legs over there and then if I put on the body it wouldn't stand up . . . the legs are a little bit too thin" (girl, age 8 years, 3 months). For these children, horizontality is a compromise solution: The figure is more detailed in its construction but is resting on the table top, and children occasionally make a remark such as "It's night time and he is in bed, yeah" (girl, age 7 years, 10 months). In the Person Bending task, the inclination to place the figure horizontally is countered by the strong demands for verticality implied in the instruction, and upright intention increased with age. Children struggle with the technical difficulty of this task and attempt diverse solutions (e.g., seating the person in a chair or on the ground so that the figure can reach for the ball without toppling over, modeling the figure in a kneeling or bending-over posture with the figure resting on the arms and sometimes the head). One five-year-old instructed himself while modeling, "You need to give him legs so he can stand up good; you need to give him a neck so he can bend over, then the head and the hands" (boy, age 5 years, 11 months).

The adults in the sample also faced the technical problem of creating upright standing humans, as this comment indicates: "I can't get them to stand on those feet. I would rather have all those figures standing but I couldn't get the clay to work." The gap between intention and execution is well expressed by this adult student: "I don't perceive them lying down when I am making them . . . It's like when you draw them, and they are flat, but not lying down. It's the same thing."

On the animal tasks, the child's upright intention is more easily expressed because these figures can be balanced on four legs that provide a stable base for the horizontally placed body. In some cases the animal is equipped with four legs placed underneath the body but turned on its back "to let the clay dry" (boy, age 6 years, 10 months).

These findings clearly indicate that upright intention has to contend with the skill level required for the modeling of diverse objects, as this boy so poignantly states on his Person Bending task:

> All I have to do now . . . I hope he stands up. I hope he stands. He's gonna have to stand up, so I have to put more . . . Oh, oh, I need more clay . . . Please can you stand up straight . . . I can't stand him up. Big legs won't help you stand up. I'll have to use all of this clay to make you stand up. Please, please, stand to the ground. I can't make him stand up, I wonder what I can do to make him stand up. I think he has more legs down here at the bottom than up here at the top [chest]. I guess I have to add more up here [chest]. I'm gonna make you stand up if it's the last thing I do. *Please, can we go on to the next thing.* (boy, age 7 years, 4 months)

Clearly, the problem is of a technical and not of a conceptual nature.

Modeling of Sides and Dimensionality Scores

My second measure of dimensionality concerned modeling of sides, and the extent to which, unlike in drawing, children consider more than a single aspect of an object. The findings from the different human and animal tasks indicate that even the youngest children in this study, the four-year-olds, were inclined to consider more than a single side of the object, especially in the case of the animals. Overall, the tendency was to create an upright standing animal, its head and body orientation clearly differentiated such that the head was modeled in a frontal orientation and the body in side view. During modeling, children paid some attention to the underside of the body and the shaping of front and hind legs. They worked attentively on up

to six sides of an animal, turning it upside down and to the side as they modeled the different parts.

Dimensionality scores assess the extent to which the figure is modeled three-dimensionally. It is a composite measure that includes number of sides modeled, uprightness, and the adoption of procedures that are unique to the three-dimensional medium, such as hollowing out, creating protrusions, and indicating parts located inside the body (open mouth, teeth, protruding tongue, earlobes) or underneath clothing. In general, dimensionality scores increased with age and showed a strong task effect. Of special interest is the finding that on the animal tasks, the number of sides modeled by the four-year-olds increased to more than twice the number of sides modeled on their human figure sculptures. Likewise, their dimensionality scores on the animal tasks increased significantly when compared with their human figures, a finding that held for all age groups and indicates a strong task effect.

As is to be expected, dimensionality scores also increased with age, with animal figures gaining higher scores than humans, and the Person Bending yielding higher scores than the Man and Woman figures. This age effect tends to level off around 8 or 9 years, but scores again increased for the adult sample. Although the dimensionality scores tend to level off during middle childhood, differences were noted in the approach of the older children, predominantly the seventh graders. Often their modeling skills were not much better than those of third or fourth graders, but they differed in the persistence with which they attempted to revise the figure, often three or four times, and in their efforts to smooth the appearance of the clay figure. At times, they created "compositions," providing the dog with a ball and two bowls for water and food, or hay for the cow.

The increase in scores from the youngest to the oldest children does not signify an absence of dimensional characteristics in the figures of the preschoolers. Some attributes of three-dimensionality, for example, uprightness and attention to multiple sides, are understood early on, and even the youngest children in this study were inclined to consider more than a single side of the object. The following examples are drawn from the protocols of four- and five-year-olds modeling the human figure. One pre-schooler adopted a tadpole model for her figure of a Woman. Holding the figure up, she turned it, indented the eyes, and spontaneously identified both back and front of her sculpture. The figure is crudely modeled, but the act of turning and conceiving of the figure's front and back sides reveals a differentiated conception of the human body and an attempt to model it (girl, age 4 years, 2 months). Interestingly, her identification of the figure begins with the back, a finding observed several times in this age group. Another girl modeled her Person Bending as a global entity with short legs and remarked, "Big nose like elephant and big long eyes . . . feet in the *back*, one foot broke down, she is bending down" (girl, age 4 years, 4 months). Figures are often faceless, which was also the case for one kindergartner. Her faceless humans are lying down, but the Woman is endowed with six strips of hair that stick out from the back of her head and a seventh hair that extends from the top.

In the case of animals, the upright posture is common, with head and body orientation clearly differentiated and some attention given to the underside of the body and its legs. Examples from the animal tasks provide an even clearer demonstration of an incipient three-dimensional conception. Many children turn their figures as they model, inspecting all sides, especially underneath when modeling fore and hind legs. One girl, while modeling her Dog, pulled out the four legs and commented,

> One foot, two foot, three foot, four foot . . . make it over, looks kind of messy . . . one eye, two eye, mouth looks like a pumpkin. I just made a pumpkin, Over [turns figure on its back] one foot in the back, one foot right here, four feet in the back . . . See, it can even stand up! I made the mouth, one nose. (girl age 4 years, 4 months)

Her modeling style and method of sculpting are crude, but the basic representational conception is three-dimensional, a simple version of working in the round. Another preschooler composed her Dog of lumpy, shapeless parts. The body is an elongated horizontally oriented piece of clay, two eyes are attached frontally, and a tail at the opposite end: "tail, body, eyes on, forgot to put the feet on." She added

four feet underneath the body and turns the figure upside down to secure the legs. This animal figure is organized along both horizontal and vertical axes and stands upright (girl, age 4 years, 2 months). In a similar manner, a kindergartner created a lumpy body for his Dog sculpture; pulled off pieces to represent ears, nose, mouth, and eyes; lifted the mass to attach legs underneath; and indented the back of his animal with "spots." He adopted a similar procedure for the turtle, indenting its shell to show its markings (boy, age 5 years, 2 months).

I found few so-called mixed views that align head and body on a single side or plane (Figure 68). An interesting example comes from a kindergartner who worked very methodically, paid attention to detail and guided each of her actions, including corrections. Her humans are two-dimensional constructions that closely follow a graphic model. The same model is used for the Dog, which is also modeled in some detail, with its head turned toward the viewer so that the body and head align in the same plane. In contrast, the Turtle and Cow are standing upright on legs that are attached underneath the body, with head and facial features in frontal orientation and the body in side view, with indentations on the back of the cow and on the shell of the Turtle. Thus, multiple sides are worked on: front, sides, top, and bottom (girl, age 5 years, 3 months). This example shows us that children's representational conceptions are quite flexible, that different representational models can coexist and tend be used on different tasks. It also demonstrates the ability to benefit from experience and to modify representational models accordingly (Figure 69).

In general, children's comments indicate their intention to make an upright, standing animal and highlight the logic that underlies the adoption of diverse dimensional strategies. These strategies are more skillfully applied by the somewhat older children, who create better forms and manage to balance the figures more competently.

Figural Differentiation and Representational Models

As was the case in the first study, figural differentiation was mostly age related. Just like drawing, the early figures were global and undifferentiated representations. With increasing age and practice figures attained greater articulation of form, and the number of clearly modeled parts increased. With but one exception, I did not find any truly one-dimensional models composed of unconnected lumps or snake-shaped pieces of clay. Only a single example of unattached snakelike parts fell into this category. Stick figures that, in analogy to one-dimensional line drawings, could be characterized as one-dimensional clay figures were also rare and were mostly modeled by third-grade and older children (Figure 70). Sev-

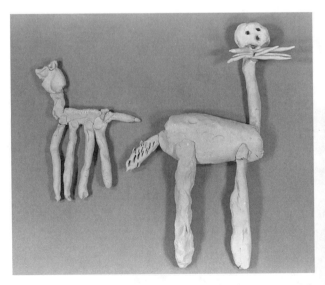

FIGURE 68. Mixed view of an animal. The mixture of frontal and side views is common in drawing and relatively rare in sculpture. Created by child, age 7 years, 11 months.

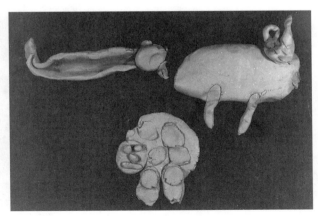

FIGURE 69. Distinctly different animal models. Created by child, age 5 years, 7 months.

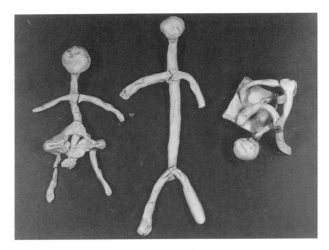

FIGURE 70. **Stick figures modeled in clay. The figures are constructed from one-dimensional sticks that create, in the case of the Man and the Woman, a two-dimensional pattern in space, and in the case of the Person Bending, a three-dimensional pattern. Created by child, age 8 years, 8 months.**

eral children who modeled their humans as stick figures placed horizontally on the table constructed their animals as three-dimensional upright, standing sculptures (Figures 71a–b, 72a–b). One boy who consistently applied the stick figure model to all his sculptures noted that his Person bending is in profile, with one eye and one arm (Figure 73).

A two-dimensional graphic "outline" model com-

posed of thin strips of clay appeared infrequently and was mostly limited to preschoolers and children in kindergarten. A solidly shaped but flattened figure was used more frequently (10–26% of the figures), but no clear age trends of this model could be discerned (Figure 74a–b). The majority of participants created three-dimensional models that were held upright, freestanding, or standing with some support (Figures 75a–c, 76a–b). A somewhat unusual model was adopted by a seven-year-old whose animals were placed horizontally. He adopted a view-specific posture: "I'm only making two feet [on the cow] because they just stand there, you can only see two feet, and that's how they usually stand like that . . . I'll flip it over so that they can look the other way" (boy, age 7 years, 11 months). Despite this rather sophisticated, view-specific report, his figures are crudely modeled and exemplify the general observation of a significant gap between children's intention and their primitive modeling skills, between competence and performance. Without extensive practice, children's representational intention and understanding by far exceed their ability to adequately express their vision.

Variability in style and degree of differentiation was common in each of the age groups I studied and also characterizes children's performance across the different tasks. Thus, for example, children who

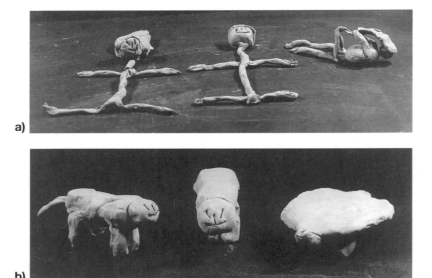

FIGURE 71. **a–b. Differentiated human and animal models. Humans are modeled as stick figures, animals are modeled three-dimensionally, standing upright. Created by child, age 9 years, 7 months.**

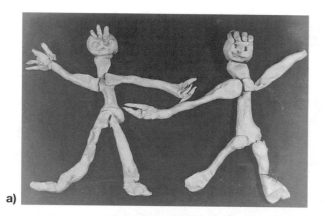

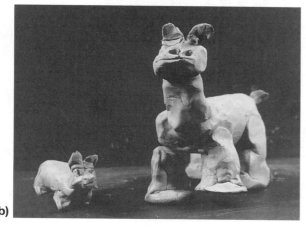

FIGURE 72. a–b. Diverse human and animal models. Created by child, age 10 years, 2 months.

used a graphic model on the human sculpture switched to solidly shaped upright standing animals, and different strategies might be used on the three animal tasks, which suggests the exploratory and experimental nature of children's approach to modeling rather than the manifestation of an underlying conceptual model (Figure 77, see also 71a–b, 72a–b, 74a–b). For example, one kindergartener used three-dimensional models for the Cup and the Table, sculpted two-dimensional humans lying down, and discovered a three-dimensional method for her animals: "You have to make it *standing up*. Now I got it, is going to be easy now, now I get it." To avoid the legs collapsing under the weight of its body, she placed the animal on its back, a solution also adopted by older children: "A dog with its paws up in the air" (girl, age 5 years, 6 months).

Regardless of the model used, differentiation is the hallmark of development, and with experience

children create more detailed figures, introduce measurement, guide their own progress, make corrections, and tend to gain greater satisfaction from the end result. In the case of the human figure, there were more differentiated torsos, shoulders, and the inclusion of a neck and clothing such as shirts with sleeves; flaring skirts or pants; and occasionally, ties, hats, belts, earrings, mustaches or beards, zippers, shoe laces, and heels (Figures 78a–b, 79a–b).

As the human figure gains in detail, it is mostly placed horizontally with an occasional justification: "He is overweight. Let's leave it like that for now. He is sleeping" (girl, age 10 years, 11 months). Although the sculptures continue to be modeled quite crudely, older children attempt to introduce motion and gesture, attend to proportions, and convey more information. This self-guidance and learning from a single trial can be seen in modeling a woman holding a baby:

> *Needs to be a little fatter, the part that attaches the arms, she is holding the baby. The second arm has to go like that, otherwise will fall off when you pick it up . . . I tried it before when I moved it up the board.* (girl, age 6 years, 9 months)

A brief segment from an older child's record on Person Bending shows extensive planning, self-guidance, reflection, and revision as she proceeds with modeling:

> *I add a little more clay because I remember I needed a little longer hand to reach for the ball. I pick up the hand and place it with the rest of the pieces. I look at all the parts. I start to put together the guy and see that the bottom part is a lot bigger than the top. I carve away some of the parts and measure and still need a little more off. I see that it fits and start adding the feet to the man. I make the feet and put them on. The man is lopsided . . . I put the head on the man and I realize he has too much pants, they are too big . . .* (girl, age 12 years, 11 months)

Although the technique of the older children is often not better than that of the younger ones, the se-

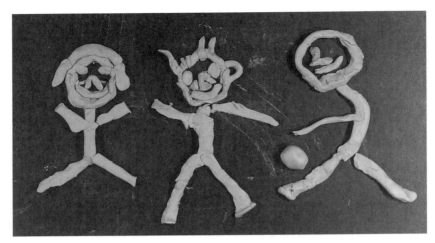

FIGURE 73. Consistent application of the stick figure model across tasks. The figure of the Person Bending is in profile. Created by child, age 9 years, 6 months.

rious reflection and concentrated time devoted to the effort distinguishes them.

One of the main differences in the work of the children and adults concerns the sexual differentiation of the human figure. In the case of children, it was rare to find sexually distinctly modeled humans, but in the adult sample those differences became very marked by the inclusion of breasts, penis, and buttocks; broader shoulders for the man; and thinner waists and broader hips for the women (Figures 80–84). The adult's conception of the human as a gendered being is clearly captured in the words of a male art student: "I'm thinking of the overall image. Takes time to come up with it . . . breast . . . when I

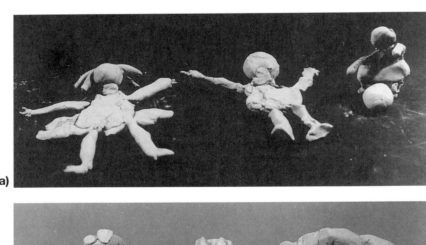

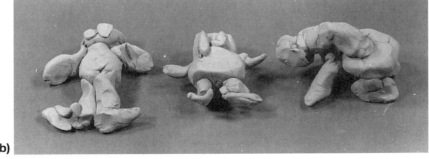

FIGURE 74. Solidly modeled flattened figures. a. Created by child, age 9 years, 8 months. b. Created by child, age 5 years, 11 months.

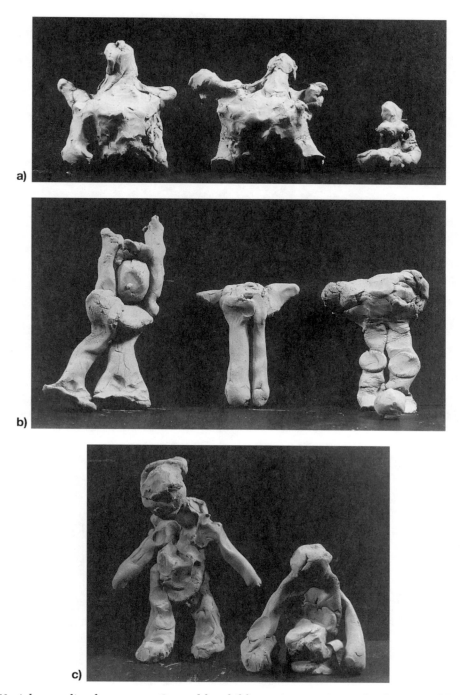

FIGURE 75. Upright standing humans. a. Created by child, age 4 years, 8 months. b. Created by child, age 4 years, 9 months. c. Created by child, age 7 years, 6 months.

think of a woman's shape, it's more round, and man's shape as long and stick-like, more harder kind of shape" (Figure 84).

In terms of the animal models, differentiation can be seen in collars on the dog and bells on the cow,

along with horns, spots, and udders. There is also more attention to size differences, with the dog smaller than the cow, and attempts to introduce action such as "I'll make the mouth open, he is about to eat something" (boy, age 7 years, 4 months); "his

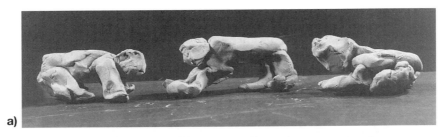

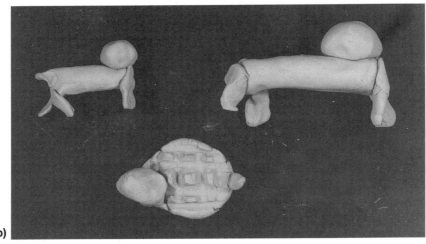

FIGURE 76. Upright standing animals. a. Created by child, age 5 years, 11 months. b. Created by child, age 6 years, 8 months.

mouth is open, he is barking" (boy, age 7 years, 11 months); "I'm trying to make a tongue . . ." (girl, age 10 years, 9 months).

Along with planning and increased skill comes a more critical awareness and negative evaluation of the final product: "All my people come out deformed" (girl, age 12 years, 3 months); "that's the awfullest thing I ever made . . . it looks more like a creature from outer space, this is going to look awfully stupid" (girl, age 10 years, 10 months).

Lack of representational skill can lead to seem-

ingly immature constructions. After several unsuccessful attempts to make an upright standing table, one child ended up with a fold-out model, a flattened table top and four legs extending two-dimensionally, that is, at right angles from the four corners of the table top (boy, age 12 years, 8 months); a similar procedure characterizes the modeling of the legs of a cow (girl, age 8 years, 8 months) and some turtles. Even adults, at times, adopt such a fold-out pattern as seen in the modeling of a Dog by one of the adults in our study.

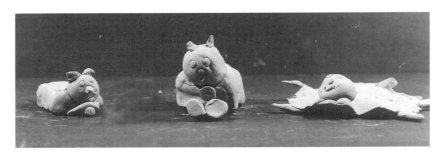

FIGURE 77. Diverse animal models. Created by child, age 8 years, 11 months.

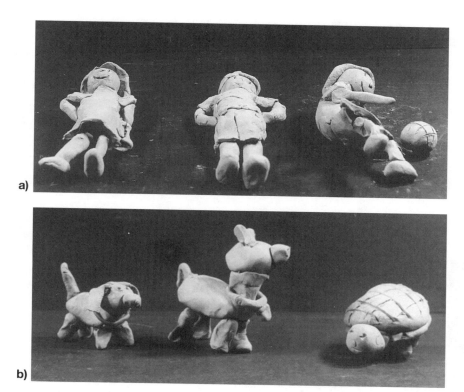

FIGURE 78. a–b. Greater differentiation in human and animal figures. Note clothing and accessories. Created by child, age 10 years, 10 months.

These examples of older children and some adults demonstrate the fallacy of linking specific representational procedures with conceptual development.

Construction style, that is, the manner in which figures are composed, involves two strategies: internal subdivision of the lump of clay by pinching, pulling, and subtracting clay from a single unit or addition of separately modeled parts. The additive method was more frequently used by all our participants, a preference which was not age related; no clear age trends emerged in terms of a preferred construction style. Differentiation of the figure was independent of the construction style. Regarding the ordering of parts, the majority of humans were constructed in a top-to-bottom sequence. Next came the inverse order of bottom-to-top that in many cases facilitated the figure's upright stance, followed by a sequence that began with modeling the body first. However, in a majority of animal figures, the body was the first part to be modeled. Overall, figures in clay were constructed with utmost simplicity, devoid of detail and adornment, often faceless but most commonly including the trunk.

Although facial features are rarely omitted in the drawn human figure and seem to constitute a defining characteristic of a person, the prevalence of faceless humans in clay is high, with approximately one third of the humans lacking facial features (Figures 59a–b, 60, 62, 65). In animal figures the omission of facial features reached 40%. Despite this omission, the orientation of head and body is most commonly well differentiated and, although facial features may be lacking, ears are frequently modeled and indicate the direction of the head. Mixed views, a common occurrence in drawing, are infrequent in clay modeling and seem to be limited to figures that are flattened, placed horizontally, with legs lined up side by side, reminiscent of two-dimensional drawings (Figures 68, 69). These mixed views are most likely borrowed from the graphic medium. The finding that not a single preschooler modeled an animal in a mixed view suggests that this strategy is derived from the graphic medium, with which the older children are more familiar. It is a transient phenomenon and disappears as children develop more effective strategies of working in clay.

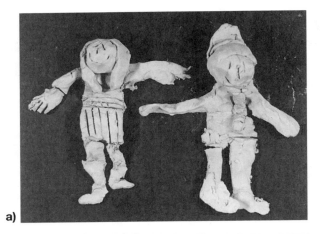

a)

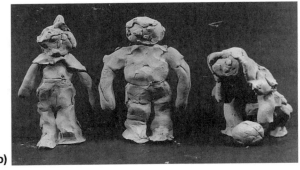

b)

FIGURE 79. **Differentiated but crudely modeled figures. a. Created by child, age 10 years, 3 months. b. Created by child, age 10 years, 9 months.**

CONCLUDING COMMENTS

My major questions concerned the development of three-dimensional concepts in modeling with clay and the order in which dimensional strategies emerge. My findings indicate that when children become representational in this medium, approximately during age 4, they exhibit some basic three-dimensional understanding, as indicated by their attention to multiple sides, volume, and upright stance of a figure. The flattened, horizontally placed human figures appear to be a somewhat later development, a function of familiarity with this difficult medium and the ambition to create a more complex and differentiated figure. Even then, the tendency to work horizontally on the figure's frontal side is counteracted in the Person Bending and Animal tasks. It is most striking to observe the differential treatment that the same child applies to the different tasks (Figures 69, 71a–b, 72a–b, 74a–b, 78a–b). Thus, the previously held notion that the singular

attention to frontal aspects of the human figure represents the child's conceptual limitation regarding dimensionality no longer seems tenable.

When children develop graphic and plastic representational concepts, three-dimensional modeling in clay appears not to follow the hypothesized linear progression from one- to two-dimensional and finally three-dimensional representation. Instead, they begin with an incipiently three-dimensional conception that is gradually refined and differentiated, provided the child is exposed to this medium and experiments with various tasks and possibilities. When their ambition to create greater likeness and complexity militates against the use of an upright posture, children use what appear to be two-dimensional strategies and models. Overall, the findings demonstrate the effects of complexity, symmetry, balance, and familiarity on the child's modeling of the items I selected, which indicates children's responsiveness to task demands.

It is perhaps surprising that the process of differentiation in modeling tends to level off beginning from, approximately, ages 8 or 9. Even the sculptures of our educated adult sample show this leveling-off effect, with 50% of the human figures placed horizontally on the table, and attention focused on the frontal region of the human figure (Figures 81, 82, 83). This leveling-off effect is similar to that found in drawing; only in cases of continued practice and the motivation to acquire new representational skills do the drawings of adolescents and adults show progression beyond the typical middle childhood drawings. These factors may well lead to a similar phenomenon in modeling with clay.

I found very little support for the view that the early and primitive representations are merely expressions of cognitive immaturity and much evidence that the young artist struggles with problems older children must also confront: how to create a satisfying representation in a medium that puts a premium on balance, uprightness, and the modeling of multiple sides, all of which require great skill and practice. Given children's limited experience with modeling in clay and their lack of knowledge of the cultural traditions and practices that prevail in this medium, their early, somewhat primitive constructions are to be expected. Early beginnings tend to-

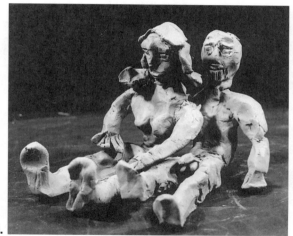

80.

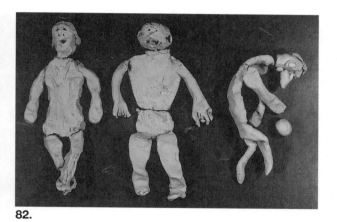

82.

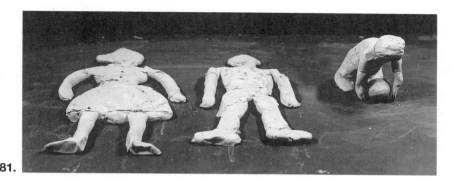

81.

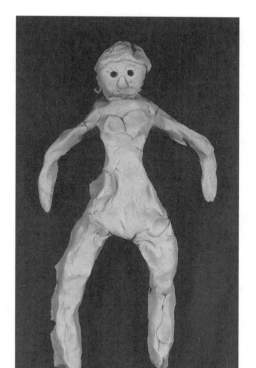

83.

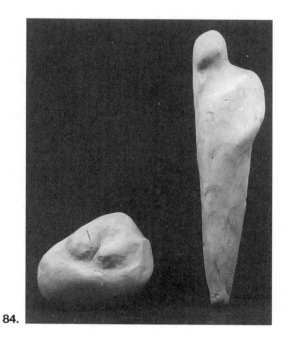

84.

FIGURES 80–84. Human figure modeled by college students. Created by students, ages 23 to 29 years.

ward simplicity and economy of forms that yield global representations.

Beyond a delineation of some of the principles that underlie representational development in the three-dimensional medium of clay, these findings suggest that the analysis of drawing can benefit from an understanding of development in modeling. The constraints of the graphic medium can best be understood when comparing a child's performance in two- and three-dimensional media and thus differentiating between medium-specific and conceptual constraints on the representation. For example, in the two-dimensional graphic medium, animal drawings often display mixed views. This juxtaposition of different views, most commonly interpreted as a sign of conceptual immaturity, occurs infrequently on the modeling tasks and calls into question the adequacy of its interpretation in drawing. Thus, in addition to mapping representational development in clay, the findings document some of the limitations inherent in the transposition of interpretive models from the domain of drawing to sculpture.

The application of a dimensional progression model derived from drawing to sculpture rests on a somewhat narrow application of the principle that development proceeds from simple to complex (Arnheim, 1974; Werner, 1957). The principle of simplicity may have different implications for different media and tasks. In the two-dimensional medium of drawing, the third dimension is missing; it cannot be represented in a direct way, which presents the pictorial medium with its unique problem. These restrictions do not apply to the three-dimensional medium, and the principle of simplicity can apply equally well to mass and uprightness. It is important, however, to keep in mind the distinction between working with mass and a three-dimensional conception of a figure that is to be modeled on all sides and placed vertically upright. Working in a three-dimensional medium does not by itself guarantee a three-dimensional conception and or production.

In this chapter I was concerned with the evolution of three-dimensional conceptions and their expression in clay on a set of different tasks. Analysis of representational development in both drawing and modeling can provide a more comprehensive account of the principles that underlie performance in each medium, an issue I take up in the next chapter.

REPRESENTATIONAL TRENDS IN DRAWING AND MODELING

As the previous chapters have indicated, a major issue in the study of artistic development concerns the models, schemas, or style of children's graphic and plastic representations; their changes over time; their relationship to conceptual development; and, of course, the impact of the medium and its specific properties. In drawing and painting, the mediums of paper, canvas, bark, silk, or other textiles present a two-dimensional surface to which ink, paint, charcoal, chalk, or crayons can be applied with brushes, pens, pencils, and the like. The two-dimensional medium affords the artist a range of actions and potential forms of representation but also constrains what can be done within its domain. In contrast to the painter's two-dimensional medium, clay, plaster, wood, and stone are three-dimensional materials that invite the artist to work on all facets of the sculpture. The tools of the sculptor, depending on the material he or she works with, include the chisel, punch, hammer, drill, and file (Rogers, 1969; Wittkower, 1977). Even though there is a vast distance between the conceptions and skills of the adult artist and the children studied, some of the fundamental properties of the two- and three-dimensional media also affect the work of children and the artistic languages they develop.

This chapter aspires to a more comprehensive review of drawing and sculpture than is usually the case and includes the representations of untrained children and adults from diverse cultures and historical periods. Such comparisons reveal the extent to which the early pictorial and plastic representations share a common language and how sociocultural variables affect their developmental course.

In the previous chapters I formulated a set of rules that governs the development of artistic activity in children, a development characterized by increasing differentiation across all dimensions of art making. How well do these principles account for artistic representation in other populations of untrained children and adults? Can the child art I have studied be generalized to the art of all beginners?

I begin my review with a comparison of the development of children's graphic and plastic models of human and animal figures described in the previous chapters and examine the manner in which the medium affects the nature of the child's representation. Next I consider cross-cultural findings of historical significance and focus on the rock art of the Anasazi culture, which spans more than 1,000 years in the American Southwest. The petroglyphs provide an illuminating example of the nature of basic graphic models and their continued usefulness for the expression of spiritual concerns. Finally, I report on more recent cross-cultural studies of the drawings and sculptures of unschooled, preliterate people. These cross-cultural studies reveal a limited set of models that are reminiscent of child art and are widely used by diverse sociocultural communities.

In the preceding chapters I highlighted differentiation of form as a fundamental principle that underlies development in the arts. In both two- and three-dimensional media, development begins with global undifferentiated forms that represent their object in a minimal and highly economical fashion. Progress can be charted, in general terms, along several dimensions that yield greater structural definition of

parts; inclusion of significant detail; and attention to orientation, posture, gesture, and movement.

Processes of differentiation mark development in both domains, but the specific forms that development takes are also influenced by the nature of the medium and available tools. The three-dimensional material available to the children was clay and play-dough, which they modeled while holding the mass in their hands, aided on occasion by a plastic knife and wooden chopstick. Handling the clay is, of course, very different from applying brushes, pencils, and markers to paper. Contact with clay provides a more intimate tactile experience of touching the malleable material, shaping it, pulling it apart, pressing and turning it, examining the emerging figure, and revising it. In contrast to modeling with clay, drawing and painting are based on gestures that yield expressive lines, shapes, and colors made with relative ease and finality. Keeping in mind the distinctive characteristics of the pictorial and plastic media, I examine children's drawings and sculptures more closely. I focus, primarily, on those aspects on which I can compare work in the two media, namely, figural differentiation, detail, dimension, proportion, posture, orientation, and gesture.

THE HUMAN FIGURE

Figural Differentiation and Representational Models

The representation of the human figure in the two media reveals similarities as well as differences. In both media the earliest representations are global figures, a model consisting of a basic unit with prominent facial features (Figures 1, 50b) that represents the whole person. In modeling there are additional solutions particularly suited to the medium, such as the upright standing column that lacks facial features and elicits them verbally (Figure 51). This model does not have a clear counterpart in drawing; it relies on verticality and verbal designation of its parts. In the early drawings of a large circle with facial features, the body is implicitly included within its confines, which may be akin to the verbal designation of the sculptures. In general, the two-dimensional medium elicits more depiction of detail and embellishment: The big circle demands some-

thing additional, and marks are made with relative ease. In modeling there is less emphasis on detail, and this continues to be the case when the figure develops, differentiates, and becomes a fully articulated representation of a human. In both media we find the single representation of features (the layout model), which appears in modeling as well as in drawing, although this model is used infrequently and is quickly modified or discarded (Figure 50c).

In very short succession, children differentiate the global one-unit model in drawing into the tadpole figure with its expressive facial features, the stick figure derived from experimentation with the straight line, the open-trunk figure, and a figure that includes a separately drawn torso. In sculpture there is the erect standing column composed of two parts (head and body), the elongated figure with head and limbs pulled out of the mass, the tadpole model composed of a single head–body unit and limbs, and the stick figure. Quite distinct from drawing, the modeled human is frequently represented as a faceless figure (in 33% of the sculptures I studied), but it often includes a trunk section (Figure 59a–b).

Similar to development in drawing, the modeled figure is composed of separately shaped parts, either by internal subdivision (which has no clear counterpart in the early drawings) or by the addition of separately modeled parts, but it differs in the order of its construction and degree of detail. In drawing, the sequence most commonly begins with the head and ends with the limbs; in contrast, in modeling, in an attempt to assure the stability of the upright standing figure, the sequence often begins with the legs or the torso. Unlike the drawings, which display many details and embellishments, the sculptures are composed with utmost simplicity, one might say with austerity. Finally, the graphic model in dough or clay presents a transposition of a drawn figure and, not surprisingly, is very similar to its original source. It is a model not very suitable to the three-dimensional medium and tends to be discarded, especially when the intention to produce an upright standing figure is paramount.

Representational models are not fixed schemas; they are tentative solutions that vary with the meaning of a task, practice, and the child's intention, which is nicely illustrated in one four-year-old boy's

model of a man and a snowman. The snowman is a faceless, upright standing figure composed of three balls of dough. His snowman is a very typical production of young children, who insist that it be upright and include the "tummy." The man has a flattened head, raised facial features that include eyes, eyebrows, nose, and mouth, an open trunk, legs, feet, and arms. As seen in this figure, the boy uses two distinct models and procedures for creating his figures (Figure 58).

Dimensions, Posture, and Orientation

The major differences in the representation of the drawn and sculpted human figure are in volume, attention to sides, orientation, posture, and degree of detail. In drawing as well as in modeling, children do not represent the human figure in its anatomically correct proportions, a finding that is especially striking in the early sculptures (Figures 61, 64, 65). The main emphasis is on the differentiation of forms and the creation of balanced structures. Once this has been achieved, the overall proportions of the figure improve gradually.

The progression in drawing proceeds from one-dimensional lines to two-dimensional enclosed areas or regions, with some late attempts to depict the third dimension by the use of oblique lines, shading, hidden line elimination, foreshortening, and other devices. As shown in chapter 1, without receiving special training, very few adolescents are able to portray the depth dimension and the volume of a figure, and only artistically gifted children are the exception to this rule. Most commonly, childhood drawings are flat two-dimensional portrayals, with humans depicted in frontal orientation. The early humans are organized along the vertical and horizontal axes of the page, with the body differentiated along the vertical dimension and the arms extended at right angles from the body. With the intention to portray actions such as reaching, holding, bending, and running, the strictly vertical–horizontal organization is modified as arms are angled and legs bent; the vertically aligned torso remains stable and unchanged for a long time. When the theme demands it, figures can also be presented in profile and from the back, but there is a marked tendency to adhere to the preferred (canonical) frontal orientation, which leads to interesting mixed views with the body in frontal orientation and the head in profile, or the arms aligned to one side of the body as if reaching in one direction while the head is turned frontally. These graphic solutions do not simply reflect the child's ignorance of "views" or his or her indifference to the incomplete rendering of the figure as can be seen in this young three-year-old's comments as he draws a rabbit (his choice). He begins with the eyes drawn in the center of the page and lists the parts, one by one, as he draws them: eyes, nose, mouth, whiskers, ears, legs, head (circle around the facial features). Next, he draws a circle around the whole configuration and proclaims that this is the body, and "you can't see the tail cause the body is so fat" (boy, age 3 years, 0 months).

In modeling, even with the strong pull of the frontal aspect of the human figure, young children, despite their limited modeling skills, tend to pay some attention to the multiple sides of their sculpture. There is also an earlier attempt to present action by bending the figure's torso to model it kneeling or seated as indicated on the Figure Bending task. Overall, there is considerable flexibility in changing a model as the different responses to the Woman or Man and Figure Bending tasks indicate (Figures 71a, 74a–b, 75a–c).

ANIMAL FIGURES

Figural Differentiation and Representational Models

The drawing of animal figures begins with minimally differentiated all-purpose forms of circle and straight line. The early forms do not clearly differentiate between the various animate creatures that look much alike. Animals, especially mammals, at first resemble the tadpole creatures that represent humans; soon they are equipped with features that distinguish them from people: ears that extend from the top of the head, a tail, whiskers, a long neck and spots on a giraffe and, thereafter, a horizontally aligned animal body. At first, one-dimensional lines are used to depict the body, followed somewhat later by the two-dimensional lines of the closed shape. The transition from a vertically extended body (the tadpole or the humanoid figure with trunk and legs)

FIGURE 85. Early animate models in drawing. Variations on the human tadpole figure. Created by boy, age 4 years, 2 months.

to a horizontal one represents a major transformation in the graphic model (Figures 85, 86, 87, 88), and it is noteworthy that the depiction of the body in animals precedes its representation in the human figure (Figure 89). In general, right-angular relations dominate, with two to four legs drawn perpendicular to the horizontal body. Gradually, the right-angular relation of body and limbs yields to a more dynamic

FIGURE 86. First animal models. One-dimensional lines represent body and limbs. Created by girl, age 4 years, 2 months.

depiction of slanted legs, suggesting an animal in motion.

In modeling there is a fairly quick transition from shaping a global figure and poking out its facial features, to forming a bulky creature horizontally aligned and standing on its legs. Although most children attempt to model an upright standing animal, I also found somewhat flattened although still bulky animal models lying down. As with the human figure, the animals are modeled sparingly (40% lack facial features). The emphasis is on creating the major parts in their correct orientation with the head facing frontally, body sideways, legs perpendicular to the body, and the tail at the opposite end of the head. Ears are generally included on the Dog, horns frequently on the Cow, and spots are scratched in or indented on the shell of the Turtle. The older children include more identifying marks: a pointed and somewhat triangular head, floppy ears, and a collar for the Dog; a squarish head, bell, and udders for the Cow; and a shell that curves over the body for the Turtle. In terms of the construction sequence, the body is almost always modeled first, followed by head and tail, and lastly the legs.

Dimensions, Posture, and Orientation

The most striking difference between drawing and modeling is in the dimensional treatment of the ani-

FIGURE 11. a–b. Figures embedded in ornamental designs. These designs tend to override figure–ground differentiation. Created by Varda, age 5 years. *Note.* From the collection of Malka Haas.

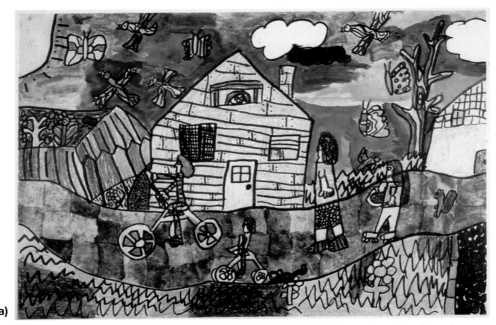

a)

FIGURE 19. Oblique lines are useful in the representation of more than a single side of an object. a. Holiday. The side view of the house is masked by clouds, but note the fence. Created by girl, age 7 years.

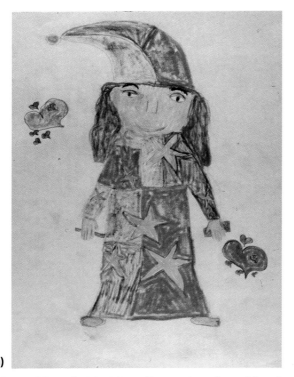

a)

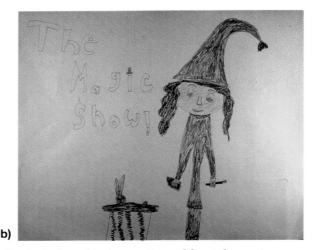

b)

FIGURE 21. a–b. Magicians. Decorative play with color in the depiction of a theme. Created by girl, age 6 years.

FIGURE 22. a–b. Primary colors and the exaggeration of facial features yield expressive portrayals of the human figure. Created by girls, age 5 years.

FIGURE 23. a–b. Animals on land and sea. The theme is embedded in colorful designs. Created by girl, age 7 years.

FIGURE 24. a–b. Still life and sunset. Color as a dominant organizing principle. Collage and oil pastels. Created by girl, age 7 years.

FIGURE 25. Portrait. Color as a dominant organizing principle. Drawn in oil pastels and watercolor by Varda, age 12 years. *Note.* From the collection of Malka Haas.

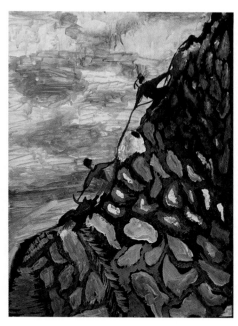

FIGURE 33. Rock climbers. The young artist uses the diagonal to divide the landscape in two equal parts, which creates a more dynamic form of symmetry. Created by boy, age 10 years. *Note.* From the collection of Malka Haas.

FIGURE 34. Highlights of the child art style. Created by Varda, age 8 years. *Note.* From the collection of Malka Haas.

FIGURE 40. Portrait. A colorful depiction that achieves a balance between figurative and ornamental tendencies. Created by Varda, age 6 years. *Note.* From the collection of Malka Haas.

a)

FIGURE 41. Paintings by Willibald Lassenberger, an artist with Down syndrome, age of artist 32–34.
a. Krampus, the devil in hell (a popular figure in alpine mythology). *Note.* From *Die Bilderwelt des Willibald Lassenberger*, frontispiece and p. 56, by Max Kläger, 1992. Hohengehren: Schneider Verlag. Reprinted with permission.

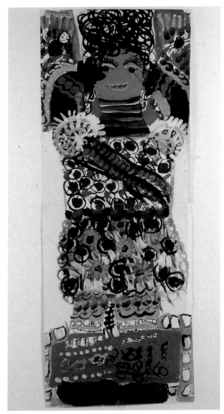

FIGURE 45. The Black Woman and the Grave. Created by Varda, age 10 years. *Note.* From the collection of Malka Haas.

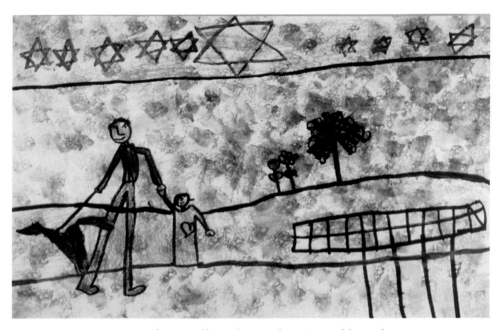

FIGURE 46. Going for a Walk With Grandpa. Created by girl, age 5 years.

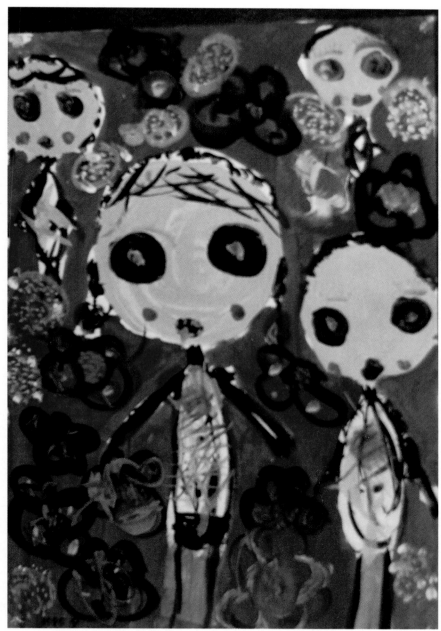

FIGURE 47. The Starving Children of Biafra. Created by Varda, age 9 years. *Note.* From the collection of Malka Haas.

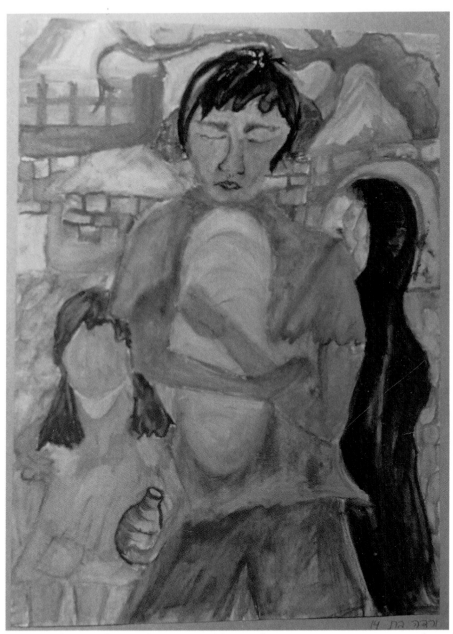

FIGURE 48. Vietnamese Fleeing Their Village. Created by Varda, age 13 years. *Note.* From the collection of Malka Haas.

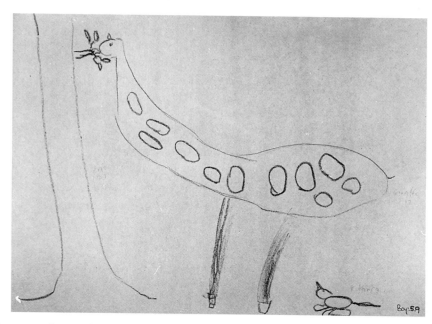

FIGURE 87. **Differentiated animal model. Two-dimensional depiction of body and legs. Created by boy, age 5 years, 9 months.**

mal figures. As previously mentioned, the great majority are upright standing figures or sculptures intended to stand with or without some support, and even young children paid attention to the different sides of their evolving animal. Figures were turned upside down to attach the legs and sideways to model the tail, and they were turned to inspect the sides and to frontally attach the facial features. Although these efforts were not always successful and the outcome was often crude, the child's actions indicated that he or she was thinking about the animal as a three-dimensional creature with multiple sides to work on. Interestingly, the mixed model so prevalent in drawing was infrequent in this medium

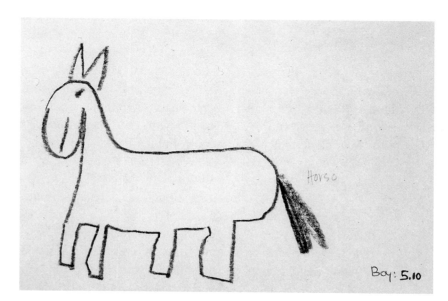

FIGURE 88. **Differentiated animal model. A single contour outlines head, body, and limbs. Created by boy, age 5 years, 10 months.**

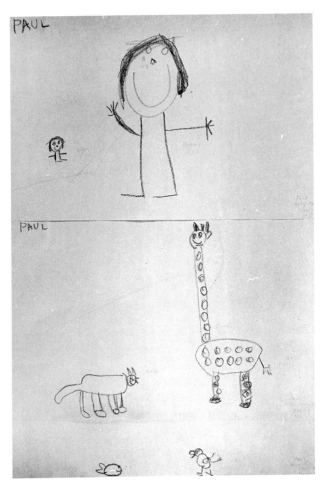

FIGURE 89. Comparison of drawn human and animal figures. The humans are depicted with an open-trunk and one-dimensional arms and feet, the cat and the giraffe with two-dimensional lines. Created by boy, age 6 years, 5 months.

among the younger children. The same logic seems to underlie the use of the graphic model, which was deemed suitable for the depiction of humans but was rarely used for animal figures.

Thus, one- and two-dimensional outline models were not deemed useful on the animal tasks, and most animals were presented three-dimensionally and standing; examples of changes in posture were limited to a few animals seated or lying down, perhaps suggesting motion but at the same time circumventing the problem of sustaining the weight of the body on the legs.

BRIEF SUMMARY OF MY COMPARISON OF DRAWING AND MODELING

My comparisons of the effects of the two media on our human and animal tasks highlight the diverse models children invent and the orderly changes in their representational thinking and competence. The representational diversity in the choice of models and the internal ordering of their parts militates against a notion of a single underlying mental image or schema and provides evidence for considerable flexibility in the child's creation of two- and three-dimensional figures. Two-dimensional drawings, mixed models, omission of features and body parts, emphasis on frontality, and many other so-called faults in children's drawings need not indicate conceptual immaturity, confusion, or intellectual realism as has often been claimed. Omission of the trunk in drawing but its inclusion in modeling cannot indicate conceptual confusion or memory constraints in the one case and competence in the other. The same logic ought to apply to inclusion of the trunk in animal drawings and its so-called omission in the drawn human figure. The answer is to be found in the evolution of artistic thinking, which involves sensitivity to the possibilities and demands of each medium and the spontaneous awareness that a representation is not a literal imitation of an object.

Of special significance is the finding that even preschoolers model their figures with an incipiently three-dimensional conception of the task, an indication that their two-dimensional representation in drawing is the result of limited technical skills rather than conceptual deficits. Of course, this understand-

that enabled the young artist to represent the characteristic and informative (canonical) side view of the body as well as the canonical frontal view of the head. These competing views of the animal can be successfully represented in the three-dimensional medium, whereas in drawing animals are depicted in side view with the head rotated into the frontal plane.

On the animal tasks, I found few stick figures that, in analogy to the one-dimensional lines in drawing, might be characterized as one-dimensional in clay. In the few cases where such a classification seemed applicable, the sculptures were made by older children, from the third grade on. In drawing, there were more examples of stick figures, especially

ing is far from perfect; it gradually becomes refined and differentiated provided the child is exposed to the medium and experiments with various tasks and possibilities.

The practice of focusing on a single task, namely, the human figure, can provide only limited information on children's representational conceptions. In the case of humans, the frontal aspect is the most important and revealing one; it defines the character of a person, gender, affect, and intentionality. In drawing and sculpture, as in real life, humans relate most directly through their senses, which favor what is in front of them, the canonical frontal view. This view provides the most characteristic information about its subject and has found many adherents in the long history of art; witness, for example, the Egyptian practice of presenting the human body in frontal view and its head in profile.

My comparison across two- and three-dimensional media and several different tasks reveals that children have a more intelligent understanding of the nature of the object to be portrayed than was previously assumed, but it also highlights the technical difficulty that the novice faces. To be initiated into the cultural conventions of representation takes time, interest, motivation, practice, and instruction as well as mental maturity as the study of our young participants and those of other cultures indicates.

To explore the impact of cultural models, I turn to a historical review of the rock art of a preliterate people, the Anasazi of the American Southwest, for whom a continuous record of art making exists. Overall, there is a striking kinship between the Anasazi petroglyphs, made over centuries, and what we have learned from child art. Their flat depictions, frontal views, disproportionate bodies, and the abstract character of their art are reminiscent of the child art style.

A HISTORICAL RECORD: ART OF THE ANASAZI

We are fortunate that an archeological record of Native American rock carvings and cave paintings from the American Southwest has been preserved that provide fairly continuous representations extending over at least 3000 years (Schaafsma, 1980). Accord-

ing to Schaafsma, the earliest level of pictorial representation is associated with a hunter–gatherer culture, also called the Archaic period, and consists of abstract designs and patterns. From the beginning of the Horticultural period, with the cultivation of crops and a more settled lifestyle for members of a family or clan, one can follow the development of representational figures among, for example, the Anasazi, who were part-time farmers and hunters in the higher elevations of New Mexico, Arizona, and Utah. Schaafsma dated the cultural beginnings of Anasazi rock art to around 1 AD, a period termed Basketmaker II. According to Schaafsma, the Anasazi were painters and skilled craftsmen, as testified by their baskets, sandals, woven string bags, robes, and dog-hair sashes. Their personal adornments included complex hairstyles, head ornaments, necklaces, pendants, earrings, seashells, and polished stones. Many of these items are illustrated in the rock art of this period.

Schaafsma identified two major artistic traditions: the Glen Canyon linear style of mostly two-dimensional outline figures and the San Juan and Rosa anthropomorphic style with its large, broad-shouldered humans, mostly painted in solid color, usually white, depicted in rows or pairs (Figure 90a–b). Over the next few centuries, during the period labeled Basketmaker III to the Early Pueblo II (approximately 400–900 AD), the large anthropomorphic figures shrink in size, become more numerous, and undergo changes, especially in the manner of the torso. In the early anthropomorphic figures, the body is trapezoidal or rectangular, with a small head, exaggerated neck, thin and short limbs, and usually no hands or feet. Gradually triangular torsos appear and become the dominant mode. The triangular bodied figures are often represented in rows, holding hands. For the first time small stick figures are seen walking, running, and sitting, in stark contrast to the large, somewhat static anthropomorphs.

At the same time, the earliest humpback flute players appear, and these figures continue to be represented in the Anasazi petroglyphs and cave art through the late Pueblo II and III periods (900–1300 AD). During this period larger villages are established, and the cliff villages of the Mesa Verde (1050–1150 AD) multiply and prosper. This is a

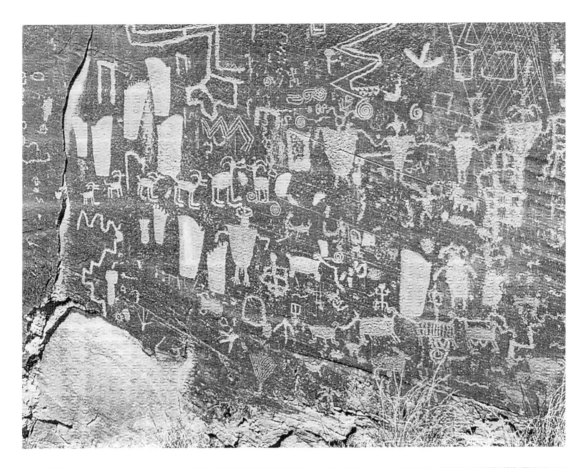

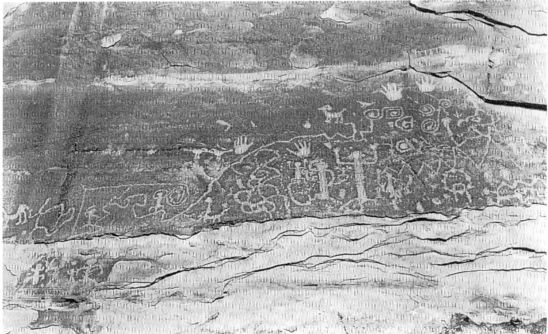

FIGURE 90. Anasazi rock carvings and paintings. a. Kayenta representational style and earlier Anasazi work, Smith Fork Bar, Glen Canyon, AZ. *Note.* From Scott Files, Peabody Museum, Harvard University. Photograph reprinted with permission. b. Late Anasazi petroglyphs. Pictograph Point, Mesa Verde National Park. *Note.* From Scott Files, Peabody Museum, Harvard University. Photograph reprinted with permission.

highly creative time that produces sophisticated pottery and ingenious architectural constructions and continues the Anasazi traditions of rock art. Prominent are the highly formalized rectilinear stick figures with arms held up or down that characterize the late Anasazi tradition.

Altogether, the enduring and prolific Anasazi rock art and cave painting of the Colorado plateau embraces about 1,300 years of Southwestern American history. Several simple models seem to have co-existed, perhaps serving different functions. One can, of course, emphasize stylistic differences in, for example, the depiction of the torso from the broad-shouldered trapezoidal figure to the rectangular shape, the reduction in size, and the more numerous stick figures engaged in lively activities. Examining differences that characterize a period and its people is meaningful and valuable, but the differences in formats and in the meaning they were meant to convey can also be seen as stylistic variants on basic representational models, recognizable and useful, and relatively stable in their configuration over time. Most likely, some of the stylistic modifications reflect changes in cultural conventions and are related to the lifestyle of the painters and their community. But there also are continuities, for example, in the figure of the humpback flute player that has survived from about 400 AD to modern times, apparently a very satisfying model that continues to be meaningful to successive generations.

For the student of child art, the petroglyphs of the Anasazi represent the familiar vocabulary expected in children's drawings, and the similarity among basic human and animal figures is quite striking. From the archeological record of a people, I turn to more recent studies of drawing and sculptures made by preliterate children and adults and collected mostly by Western scholars.

CROSS-CULTURAL FINDINGS OF DRAWING AND MODELING

The search for untrained, spontaneous beginnings of art making has led investigators to collect drawings from many parts of the world, with an emphasis on the drawings of children and adults from preliterate societies. For example, the anthropologist A. C.

Haddon (1895, 1904) collected drawings from preliterate Papuans and commented on their "very rudimentary power of delineation" and their similarity to the drawings of Central Brazilian tribes. One of the most ambitious projects was undertaken by G. W. Paget (1932), who collected drawings that were sent to him from different parts of Africa, the Middle East, Asia, New Zealand, Australia, Jamaica, and British New Guinea. Given the Western emphasis on the representation of the human figure, children from diverse cultures and races, mostly between ages 5 and 9, were asked to draw a man, a woman, a man riding a familiar animal, and a human head. Altogether, some 60,000 drawings comprising 200 collections were assembled. Although the conditions under which the drawings were requested varied from village to village—drawings were obtained mostly from unschooled children but included some who were attending school—the results are nevertheless instructive.

Most of the drawings show some of the familiar characteristics of child art, although local traditions appear to have a significant impact on figural qualities (Figure 43). Scrutinizing the graphic examples provided by Paget, one encounters familiar graphic models: the stick figure endowed with a linearly drawn trunk, the tadpole figure lacking a separately drawn torso, open-trunk figures, and contourless faces and contourless bodies. In those examples in which a child produced several drawings in short succession, the sequence from one-dimensional lines (the stick figure) to the open-trunk figure and finally to the separately formed two-dimensional body of the human figure recalls the familiar and well-documented efforts of Western children as they begin their early exploration of paper and crayon (Golomb, 1992b). Paget also commented on local traditions of S-shaped and hourglass bodies, of facial features drawn outside a closed but concave-shaped contour into which the features are neatly inserted. But the dominant impression is of a universal graphic language clearly recognizable to the student of child art, a language whose basic grammar allows for variations on a common underlying structure.

Paget's report on the drawings of children from widely ranging sociocultural and racial settings gave further impetus to cross-cultural research in this area

(Alland, 1983; Anastasi & Foley, 1936, 1938; Andersson, 1995a, 1995b; Andersson & Andersson, 1997; Belo, 1955; Court, 1989, 1994; Dennis, 1957, 1960; Deregowski, 1978; Fortes, 1940, 1981; Harris, 1971; Havighurst, Gunther, & Pratt, 1946; Jahoda, 1981; Martlew & Connolly, 1996; Meili-Dworetzky, 1981, 1982; Schubert, 1930; Sundberg & Ballinger, 1968; Wilson & Wilson, 1984, 1985). The ensuing studies vary significantly in their methodology, with drawing tasks often restricted to a single theme and a single trial, for example, drawing the human figure. In most studies the assignments were administered in a group session, which does not control for the impact of peers, and in a majority of studies children had received some kind of formal schooling, which likely affected drawing style.

There are, however, some studies whose participants were true novices in the realm of drawing, most notably a study reported by the anthropologist Meyer Fortes. During 1934–1937, in collaboration with his wife, Fortes collected drawings in Northern Ghana from unschooled Tallensi children and adolescents (Fortes, 1940, 1981). He described a tribal culture that is devoid of pictorial traditions and only marginally influenced by the outside world. Children were normally nude until the beginning of puberty, and until their first pregnancy girls remained nude except for a cloth or leather "back flap" hung on a waist cord over the buttocks. The sample was small and at first comprised 12 illiterate bush children between ages 6 and 16, which expanded somewhat to include late adolescents and some young men in their early 20s, none of whom had ever drawn with paper or pencil.

Fortes invited the children to his house, sat down in their midst and, using a colored pencil, drew an animal on a sheet of paper. Next he offered a pencil to one of the older boys, a 12-year-old who produced small shapes consisting of open and closed lines distributed all over the paper; other children followed with similar scribbles. One of the boys produced a stick figure for a human that became the standard schema for most of the children. Most commonly, the stick figure was placed vertically, in the middle of the page, with scribbles filling in the rest of the paper. Male figures were drawn

with a penis, female figures with breasts. On the second day, the children continued to fill the whole paper space with scribbles, interspersing them with animal and human stick figures. The propensity to fill the whole page persisted. Although most figures were spindly matchstick models with tiny heads, variations of this model consisted of a filled-in body with lines thickened to represent its volume, a sign of learning from limited experimentation with the medium.

When adults were given paper and pencils, they too used the same graphic model developed by the children, with the addition of radial hands and feet. Essentially the same graphic model was used by both children and adults whose culture, according to Fortes, was completely devoid of representational graphic art (Figure 91).

Fortes compared the stick figures produced by the illiterate bush children with drawings solicited from school children who came from the same tribe and were boarders at a middle school. The drawing style of the latter, based on two-dimensional forms, followed the conventions typical of Western children. Several decades later, in 1970, Fortes returned to Ghana and once again collected drawings from Tallensi children, this time those enrolled in a local primary school. Their figures were two-dimensional profile drawings, in the style of what Fortes described as the Western graphic tradition. The three groups of Tallensi children—the bush children, the boarders, and the local school children—differed in their use of color. The bush children picked colors randomly, the boarders chose colors according to a set of personal preferences, whereas the local school children chose colors in a more conventional manner, adhering more closely to the object's true characteristics.

Fortes considered the Tale drawings as an ideogram rather than a picture, with body proportions symbolizing the relative functional importance of the various parts. In his view, the drawings are functional diagrams projecting in an abstract formula the relative positions and spatial relationships of the significant parts of the object. The matchstick models of humans and animals perform their function of conveying the minimally indispensable visual information needed to recognize objects and respond ap-

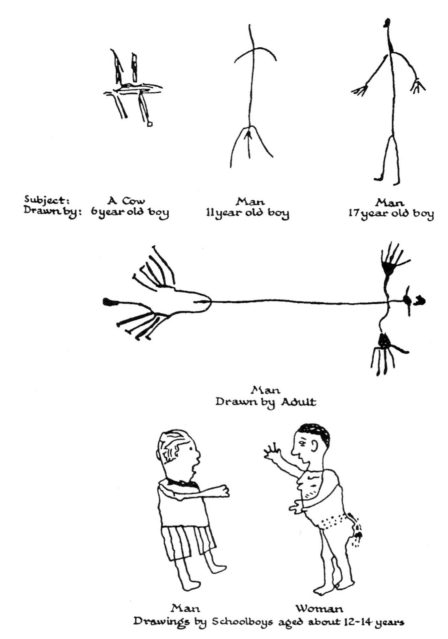

Subject: A Cow
Drawn by: 6 year old boy

Man
11 year old boy

Man
17 year old boy

Man
Drawn by Adult

Man Woman
Drawings by Schoolboys aged about 12-14 years

FIGURE 91. Fortes's drawings by unschooled and schooled Tallensi children and adults.

propriately to them. Fortes seemed to imply that this so-called ideogrammatic representation is a developmentally primary form and that the familiar schemas of European children are the result of cultural influences. He based his interpretation on his findings from the schooled Tallensi children, whose drawings are variants of child art in Western traditions (Fortes, 1981).

Thus, Fortes interpreted his findings in terms of a culture-dependent convention, a view shared by Deregowsky (1978), who further expanded the notion of the primacy of the ideographic style by proposing that young European children suppress this early stage in their development. European researchers of child art (Kellogg, 1959; Freeman, 1977), according to this view, may have failed to observe this

very early phase because of pervasive cultural influences that suppress the emergence of ideographic representations in favor of the more "realistic" style.

This suppression theory is at odds with the finding that the stick figure representing a human is one of a series of early models that Western children invent spontaneously, especially in two-dimensional media. In cultures where children have ample access to paper and pencils and where they can experiment freely, this stick figure model is usually transformed into a two-dimensional representation until it reappears later as an abbreviated formula that is useful for narrative accounts. The fact that Tallensi children as well as adults used the same graphic model suggests that it is an easily recognized and meaningful figure for which there is general approval. Such drawings are found in many times, places, and cultures and are not limited to the work of children. They are quite similar to rock carvings found on the island of Hawaii, in southwestern North America, and in the Camunian valley of northern Italy and, of course, are closely related to the pinhead figures described by Paget. Models that are easy to produce and that capture a basic likeness to the human figure are good candidates for cultural transmission, and the question is perhaps more general: namely, how a particular style develops among children and adults and is maintained over a prolonged period.

More recent studies have continued to focus on the drawings of preliterate people. Gustave Jahoda (1981) examined drawings of schooled and unschooled Ghanaian adults and found very few differences between them. Because the unschooled adults were able to draw as well as their more literate Ghanaian counterparts and produced drawings that were quite similar to those of English elementary school children, one wonders whether they were totally unfamiliar with this medium.

Among the few published longitudinal studies, a case study reported by Dale Harris (1971) can shed some light on the earliest representational beginnings. He provided two four- and five-year-old children living in a remote and isolated area of the South American Andes with paper and pencil, which they had never seen before. Over a 7-week period, he encouraged them to draw a man, and he reported on their first marks in the form of scribble

lines, the emergence of closed shapes and tadpoles, and their transformation into a graphically differentiated human figure. A similar finding has been reported by Malka Haas on the drawings of illiterate bedouins from the Sinai Peninsula, who never before had access to paper and pencil (M. Haas, personal communication, 1978). After initial scribble patterns, the children as well as the adults evolved the human figure in the steps we have previously outlined (see chapter 1). When children were provided with paper and pencil, a first in their lives, five- and six-year-olds progressed in a single session from scribbles to a radial shape, followed by a human with an oval trunk. Once this generic model of a human had evolved, the children tried to depict the characteristic appearance of members of their tribe by drawing the women in a triangular shape, the contour filled in, leaving only a slit in the top part for the eyes. Such drawings represent the traditional outfit of Moslem women who expose neither body nor faces to strangers.

This finding is quite compatible with Wayne Dennis's (1960) report on the drawings of illiterate Syrian bedouins. These people often omit the facial features, shade the facial area, or draw it very small. These cases show how cultural factors modify an early representational model to suit local demands and thus codetermine the appearance of the graphic model.

These findings largely support the notion of a universal representational process in children as well as untrained adults that yields very similar basic configurations in early stages of graphic development. This thesis of a universal representational process predicts structural similarity but not strict identity of patterns, which are influenced by the sociocultural milieu and by significant individual differences among the drawers. The extensive findings of Paget are congruent with this theoretical perspective and compatible with studies that examine the influence of the social environment.

An early study by Jane Belo (1955) of unschooled children from Bali illustrated the general developmental principles of the emergence and differentiation of early forms and the impact of peers and cultural models. She described the rich cultural artistic traditions of the Balinese, who celebrate their

temple festivals with dramatic performances. She especially noted the shadow play performances, which children enthusiastically attend. The shadow play is a form of visual story telling; it takes place at night and, behind a white screen illuminated from behind by an oil-burning lamp, puppet figures appear as shadows on the screen and enact the play. Highly stylized figures represent the heroes of Hindu mythology, and the children who routinely attend performances learn to distinguish among the different characters of demons, spirits, and heroes.

With this background, Belo in the early 1930s selected a group of 20 children who never before had access to paper and pencils. The children, who ranged in age from 3 to 10, came to her house for 3 months and drew in the company of other children. On her walls Belo displayed their drawings, made in the traditional style of Balinese artists, of the well-known mythological themes portrayed by the puppets in the shadow play. According to Belo, the three- and four-year-olds drew round heads and lumpy bodies with stick legs, which are typical examples of early child art. Between ages 5 and 7, a marked change was observed, as children began to draw in the culturally dictated manner of a head in profile, with the characteristically long nose and slanting eye of the wayang puppet shadow play. She noted that the children did not copy adult graphic models but were interested in each others' work and learned new techniques demonstrated by their more experienced peers. Belo commented on the reciprocal influences between the children that produced a "style" to which new members of the group tended to conform. Lacking access to paper and pencils, the children were used to drawing with charcoal on walls, apparently gaining extensive experience with the culturally appropriate models. These findings illustrate both the early rule-governed beginnings of pictorial representation and its deliberate transformation along cultural conventional forms. That many children could master the appearance, posture, gesture, and movement of the shadow puppets attests to the power of their motivation, their intense practice, and their talent to go beyond the early generic forms to the artistic formats of their community.

Studies by Brent and Marjory Wilson (1979, 1984, 1985) elaborated on cultural influences of stylistic features that are passed on from one generation of children to the next. They highlighted characteristics that differentiate the drawings of Egyptian village youngsters and their urban peers, and they noted the sophistication of Japanese children's drawings, which are modeled on characters familiar from their comic books. The interaction between "organismic" factors and the sociocultural environment finds further documentation in the work of Elsbeth Court and Sven Andersson.

Court has done extensive research on the development of drawing in Kenyan children and documented both the general forms this development takes and some of the specific characteristics of the cultures she has studied. In an early study (1981) she reported on preliterate Kenyan children and adults who, on first trials and within the same drawing, produced circles and zigzag patterns that developed into simple humans, cows, and houses. The familiar drawing patterns evolved very quickly, without prior experience with paper and pencil.

In a later study (1989, 1994) that specifically addressed the impact of the sociocultural milieu, Court examined the drawings of Kenyan school children from three rural cultures: the Kamba, Luo, and Samburu. These communities have distinct traditions in the visual arts, but none include drawing on paper. The participants in this study were 699 school children, ages 6 to 18, most of whom are the first in their families to attend school. Since 1985, drawing is a required subject that is taught in all grades, and teacher certification requires some competence in this field. The drawing tasks were group administered and included the following topics: Cow, Person, House; Myself Eating; a Table With Some Items; and Free Choice Drawing.

Court focused her preliminary report (1989) on two major findings, the role of the person (self) in relation to others and the drawing of tables. On the first task, the Cow, Person, House drawing, animals and houses are prominently displayed, and humans are either absent or play a subordinate role, a finding that seems also to characterize the Free Choice Drawing. On the latter assignment, only 25% of the Luo and Samburu children depicted humans. The Luo, who are fishermen, emphasized boats, and the Samburu, who are herders, drew animals. The ma-

jority of the Kamba, who come from a farming community, drew people within a social setting, which was the case for all the children on the Myself Eating assignment, in which they drew themselves in the company of others seated at a table.

Court remarked that the table symbolizes progress and wealth and does not always indicate the drawer's personal experience. The dwellings of the Samburu, for example, are too small to house a table, but their children depicted themselves eating seated at a table. Of equal interest is the high percentage of tables drawn in inverted or divergent perspective, in which lines, instead of receding and converging in the background, diverge. In all grades, with the exception of the first grade, approximately 20% of the tables were drawn in this format, which increased with school experience. This formula for tables is widespread in East Africa; it is regularly seen on chalkboards and word charts and in the depiction of buildings. It also functions as a test on teachers' exams. This projective drawing system, which does not correspond to a particular "view" and does not aim for photographic realism, provides a satisfying solution to the problem of displaying items on a table surface, and its model is transmitted as a culturally acceptable representation.

Cross-cultural studies that investigate drawing as well as modeling are extremely scarce. Among the first to report on the differences between drawing and modeling in clay was Fortes (1981), who noted that children's favorite pastime was modeling small clay figures of people, horses, cattle, and other animals 3–6 inches in height. Boys and girls played extensively with their clay figures, which varied in quality, but the best among them were realistic representations, endowed with facial features but lacking ears. The human figures clearly indicated sex differences: women were modeled with breasts, an occasionally enlarged belly signifying pregnancy, and a slit between the legs to indicate the vulva, which was decorated with a tuft of hair snipped from the artist's head. The figures of men were not given genitals; however, an enlarged scrotum was occasionally represented. Figures of chiefs mounted on horses were always dressed in bits of cloth and equipped with a hat modeled from clay. Cattle were modeled with horns, and bulls and stallions with scrota.

Fortes commented on the three-dimensional nature of the figures: "These figures do suggest that these children had a clear grasp of three-dimensional objects in space. Tallensi culture, I should add, was at that time markedly lacking in any form of art or developed decorative products" (p. 47). Although he noticed the discrepancies between children's one-dimensional stick figure drawings and their three-dimensional models in clay, Fortes did not delve any further into the potential significance of this finding for a theory of drawing development.

In a recent attempt to broaden the cross-cultural investigation of representational development, Sven Andersson collected drawings from Tanzanian children (Andersson, 1995a, 1995b). In a study designed to test the Piagetian stage conception of intellectual and visual realism in graphic representation, he compared the drawings of Tanzanian and Swedish children, ages 9 to 12, on two themes: When I Am Working in My Classroom and My Future Family. Although Swedish children benefit from a culturally enriched schooling environment, the Tanzanian children's drawings were superior in their use of projective systems. Overall, Andersson challenged the Piagetian stage conception because the Tanzanian children seemed to use intellectually realistic devices, for example X-ray drawings, as well as visually realistic strategies based on oblique projection and, in a few cases, on linear perspective.

In a further study conducted in 1997, Sven and Ingrid Andersson requested drawings as well as sculptures from children and adolescents living in a remote area of Northern Namibia near Ruacana and the Epupa Falls at the Kunene River. The youngsters, members of the Himba tribe, did not attend school and had no previous access to paper and pencils. In a video (Andersson & Andersson, 1997) that documented the actions of their participants, the young women wore their hair in an elaborate and highly ornamental style and adorned their necks and bare chests with decorative pendants and necklaces and their wrists with bracelets, evidence of a developed aesthetic sense. The video captured the behavior of the first group of eight youngsters and documented the somewhat gingerly pencil movements that left a light imprint as the pencil created small circles, wave-like patterns, and S shapes dis-

persed over the page, interspersed with single, verti-
cally placed lines and two sets of shorter lines
drawn perpendicular to the vertical. Patiently and
slowly they filled up the page with these marks as
well as shapes that might resemble a stick figure, a
tree, or a flower, all composed of line and circle.

Once the page was filled, Sven Andersson, with
the help of an interpreter, queried the drawers on
the meaning of the figures and their parts. Slowly
and hesitatingly, they answered cow, rat, flower,
goat. As children and adolescents gathered around
the table, the next person, a young man, began his
explorations with paper and pencil. Stick figures
emerged that were later identified as man, crocodile,
donkey, snake, and elephant. The figures were
drawn in an inverted orientation to the drawer.
Next, in response to Andersson's request that the
young man draw himself, he began with an elon-
gated oblong shape (body), added one-dimensional
arms and legs and finally a head with two eyes. A
two-dimensional drawing of an animal's head and

body with one-dimensional legs came next, followed
by a two-dimensional homestead, lizard, and croco-
dile, all drawn in an inverted orientation to the
drawer's position. Others took their turn with paper
and pencil, creating stick figures, tadpoles, open
trunk figures, and two-dimensional, closed-trunk fig-
ures with or without arms, and circular enclosures
for house and animal shed; one even drew a head in
profile. Most participants drew with intense concen-
tration, taking their time as they created the simple
variants of the basic human and animal figures
found in children's drawings as well as in the draw-
ings of other preliterate societies (Figure 92).

The second set of data was collected from mem-
bers of the Himba tribe living at the Epupa Falls. In
the study (1997), the Anderssons first supplied their
participants with clay and asked them to model a
person or an animal. All of the participants held the
clay in their hands as they modeled and shaped
their sculpture in the round—turning, pulling,
pushing, rounding, pinching the material to create

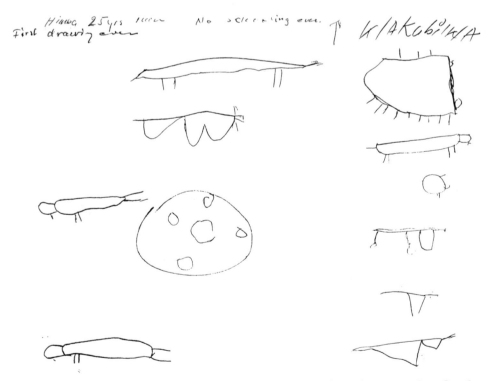

FIGURE 92. First drawings of a member of the Himba tribe from Namibia. The artist identifies: homestead,
person (the artist), lizard, crocodile, hippopotamus and a wooden fence that surrounds the houses and the stone
fireplace, and where the cattle is kept during the night. Created by man, age 25. *Note.* From the collection of
Sven and Ingrid Andersson. Reprinted with permission.

an upright, standing, naturalistic-looking three-dimensional figure. Some created quickly and very competently an animal consisting of head, body, four legs, ears, and curled-up tail. The object was modeled by internal subdivision of its parts, and the animal is standing. The adolescent girls in this group tended to model their humans with long necks and breasts, emphasizing hairdo and buttocks, and in an upright posture. The ease and confidence with which this modeling occurs suggests that the artists have some familiarity with clay modeling. Talent and individual differences also play a role that can be seen in comparing the work of highly adept modelers with others who are less skillful and create more crudely shaped figures.

Following modeling with clay, the participants were provided with paper and pencils and asked to draw. The forms, figures, and configurations that emerged are very similar to the ones drawn by the first group of participants. By comparison with their ease in modeling clay figures, the youngsters appeared deeply immersed in their drawing efforts, seemed less relaxed, and experienced more difficulty. The differences between the drawn and sculpted models of humans and animals highlight the importance of the medium of representation; the abstract linear quality of line drawing and the three-dimensional opportunities provided by clay that afford a more naturalistic representation and yield such different constructions on the same theme. The different strategies are ingenious problem-solving approaches to the problem of representation and reflect an early and very likely universal capacity for the languages of the visual arts.

SUMMARY AND CONCLUDING COMMENTS

This chapter began with a comparison of the drawings and sculptures of children, followed by a review of archeological and cross-cultural research that focused on the representations of preliterate people. What is the connection between these sections, and what is their relationship to the theme of development in the visual arts?

In chapters 1–3, I discussed the drawing development of contemporary children growing up in an artistically rich environment. I questioned whether,

by limiting the investigation to the two-dimensional medium of drawing, a systematic bias affected the interpretation of children's work that could have masked their underlying representational competence. To better grasp the nature of the representational processes in the visual arts, I reviewed the development of drawing as well as modeling and then compared children's performance in the two media. I noted similarities as well as significant differences in the representation of the same object, an indication that differentiation of form can occur along diverse lines, all of which can capture the basic structure of the intended object. Above all, work in clay demonstrates that even young children can have a three-dimensional conception of the object and of the representational task but that the manner in which this is expressed is profoundly affected by the nature of the medium.

Our analysis of the rule-governed processes that underlie the development of artistic representation points to a universal factor in the evolution of the early stages of pictorial languages. To more fully explore this hypothesis, I reported on the rock art of the Anasazi and on cross-cultural studies. My analysis of the Anasazi petroglyphs provides further evidence for these assumptions and, moreover, calls attention to the relative stability of basic patterns over many centuries. This finding suggests that once a basic level of graphic differentiation has been achieved, representational activities do not inevitably lead to further differentiation and change. In cultures where paper and pencils are plentiful and readily available and where experimentation and developmental change is valued and expected, the early graphic forms of the typical child art style are further developed and, by the end of childhood, the youngster's art activities are either channeled into progressively more complicated patterns that fall within the culture's norms and expectations or are discarded in the sense that children stop drawing.

This review of cross-cultural studies of drawing has documented considerable stylistic diversity in the invention of graphic models. These models represent the different forms the principle of creating structural equivalences for the human figure can take, emphasizing the length dimension of the body and the facial features to indicate its humanity.

These drawn forms are never exact copies of the object but embody the artist's experience, understanding, and expression within the graphic medium. These findings highlight universal features while also demonstrating the impact of the cultural milieu and its most common models, provided they are within reach of the artist's graphic comprehension and competence. Drawing is not a simple act of imitation, and rarely is central perspective found in the artwork of children and adults who live in a world where photographs, realistic art reproductions, and advertisements model three-dimensional systems of representation. When models are within reach of the child's skill level and visual understanding, they tend to be adopted and perpetuated—witness the child art style of different decades and venues.

Without cultural supports, pictorial competence is arrested at an early stage in visual thinking. An example of a culture that sustained and conserved early models of representation is that of the Anasazi, whose rock art retained many of its early characteristics; changes in their art occurred at a relatively basic level of orthographic depiction. This artwork does not reflect on their overall cultural achievements and adaptive intelligence; witness their ability to develop crops, architectural competence, skillful and aesthetically pleasing pottery, and their survival under the difficult social and natural conditions in which warfare and an arid climate presented major threats to the individual and the community. The petroglyphs, whatever their ultimate symbolic meaning might have been, seemed to have fulfilled their function of representing the spiritual world; apparently no need was felt to introduce major changes toward a more naturalistic depiction.

There are, of course, other cultures that value stability of representational patterns, as seen, for example, in Orthodox art, the Christian religious art of the Byzantine Empire that began in 330 AD and ended with the occupation of Constantinople by the Turks in 1453, and thereafter was continued in the icon paintings of the Russian Orthodox church. Thus, over 1,000 years, a similar pictorial system was used in Byzantine and Russian art (Willats, 1997). According to Willats, Orthodox art demanded a form of depiction that referred to the religious world as distinct from the real world of naturalistic art. Icons depict a spiritual world, and the techniques used by the icon artists fulfilled this function well, thus assuring that this form persisted with relatively little change for over 1,000 years.

From the perspectives of 20th-century art and its history, there are many diverse languages of pictorial art, although their developmental origins can be found in the simple beginnings I have reviewed. Pictorial representation is a uniquely human endeavor, and its early steps are based on a universal language of visual representation in two- and three-dimensional media. The beginnings are essentially self-taught patterns that can represent an object in a very simple and abstract manner by creating equivalences, not copies, in the particular medium that is available. The differences between drawing and sculpture reflect the inherently abstract form of graphic representation and that to search for a literal copy of the object in a child's drawing is to misunderstand the nature of representation and its basis in the creation of equivalences in a particular medium.

My comparison of representation in two different media, of the work of children and untrained preliterate adults, has provided insights into some of the basic forms of artistic creation. I now turn to an account of the earliest known beginnings of this symbolic process in the visual arts.

DEVELOPMENTAL PERSPECTIVES ON PREHISTORIC ART

In the previous chapter I explored the early phases in the acquisition of a graphic and plastic vocabulary, focusing on such naive beginners as young children and untrained illiterate adults. I examined the development of representational concepts and skills in individuals of diverse cultural backgrounds and found structural similarities with the art of the Anasazi which, over 1,300 years, used simple representational models.

To understand the language of child art, we need to inquire into its origins—that is, the roots of this symbolic activity—and chart its course of development ontogenetically, phylogenetically, and culturally. In my quest for a deeper and ecologically valid understanding of the beginnings of art, I now extend my inquiry further back into historical time to search for the earliest record of art practiced by our human ancestors. Are the historical and ontogenetic processes of artistic representation alike and, if so, can a recapitulation theory of child art enhance the understanding of prehistoric art? If, however, there are significant differences in the style and the level of differentiation of these art forms, such a finding would hold significant implications for the conception of child art and its developmental trajectory.

My inquiry is designed to situate child art in a comparative and historical perspective that will illuminate the role of universal processes, of culture, and of cognitive constraints. Like language, art making is at the core of human culture and perhaps represents our unique ability to create symbols and to convey increasingly complex meanings to members of our community; a young child who creates a simple recognizable figure also shows this ability.

This chapter begins with an inquiry into early forms of artistic activity by nonhuman primates and briefly reviews findings of what might be considered antecedents of an aesthetic sense and of representational capacities. I then describe modern humans in Europe, including their hunter–gatherer lifestyle and their cave art. A review of findings gathered over the last century and continuing with recent discoveries highlights efforts to date the cave art by style and radiocarbon techniques. It also shows a considerable debate about the meaning of prehistoric art, its relation to the perceptual and cognitive capacities of the artists and their community, and the relation to child art. The issue of ontogeny recapitulates phylogeny is discussed in its relevance to prehistoric people and children, and an examination of the similarities and differences between the two aids in the clarification of issues that pertain to both.

PHYLOGENETIC ANTECEDENTS

The search for artistic beginnings in our phylogenetic past has focused on nonhuman primates, monkeys and great apes, and their ability to create recognizable images. In the wild, spontaneous mark making that carries representational intent has not been observed. However, investigators who have studied drawings and paintings by some of the great apes reared in captivity and in close interaction with humans reported that these animals show an interest and sometimes pleasure in mark making, filling in blank spaces and showing some evidence of patterning tendencies. Schiller (1951) and Morris (1962) reported that their subjects tended to complete pre-

formed stimulus patterns and showed a preference for completion, balance, and symmetry, findings that have not been replicated by other researchers (D. Smith, 1973). For example, Boysen, Berntson, and Prentice (1987) found that chimpanzees tended to mark the center of a page regardless of the stimulus pattern with which they were presented.

Given this interest in mark making, what kind of development in the creation of forms has been recorded? Although the data are sparse, some investigators have reported on a progression in markings, in the case of Congo, a young female chimpanzee at the London Zoo who, from ages 1 to 4 years, advanced from scribbles to the production of circular shapes and crosses (Morris, 1962). A similar development has been noted in the case of a sign-language-trained orangutan, Chantek, who progressed from scribbles to the drawing of open and closed shapes at age 4 but who showed no further development (Miles, 1990). In terms of copying from a drawn model, Chantek has been reported to draw lines and circles (Miles, Mitchell, & Harper, 1996), and two captive female chimpanzees have been successful in copying a model of straight lines using an electronic finger-painting device (Iverson & Matsuzawa, 1996, 1997).

Because symbol-trained great apes can recognize drawings and photographs of people and objects (Antinucci, 1989; Gardner & Gardner, 1989; Itakura, 1994; Parker & McKinney, 2000; Patterson & Linden, 1981), can they progress from the recognition of line drawings to the production of representational drawings? The reported findings are ambiguous and suggest that some language-trained apes attribute meaning to their drawn configurations. For example, the Gardners reported that Moya, a chimpanzee who created somewhat controlled and simplified forms, labeled her productions "bird," "flower," and "berry" (Gardner & Gardner, 1978). A similar finding has been reported for the signing gorilla Koko, who also labeled her drawings via sign language (Patterson & Linden, 1981). It is unclear to what extent this labeling reflects an intention to produce a particular object or whether it is more akin to "reading off," depending on the "looks" of the drawn configuration. Being raised in a human sociocultural environment and language trained appears to affect primate social learning and communication. Thus, extensive training in sign language and repeated experience with paints and paper may reveal not only an aesthetic sensitivity in these apes but perhaps also an activity that borders on graphic representation.

Data that compare an ape's painting with modeling in clay have not been published as of this writing. However, data on nonhuman primates' modeling with clay come from a recent series of studies that provided Capuchin monkeys, noted for their skillful tool use, with clay spheres, leaves, paint, and stones and, in a second condition, also with sticks (Westergaard & Suomi, 1997). Observers recorded the extent and number of times that a subject reshaped and painted the clay, as well as other modifications of the array of items. Of the 10 subjects, 7 modified the clay manually by squeezing, tearing, and rolling the mass and by striking it against the cage. The monkeys incorporated leaves into their clay mass, rubbing the clay with leaves and striking it with stones. These 7 Capuchins also engaged in painting activities such as dipping their hands into a paint well and rubbing their dripping hands over clay forms and by dropping the clay into the paint well. It is of interest that 4 of these monkeys used leaves as paint brushes and applied paint to the cage structures.

In a second experiment, a clay slab was attached to the floor of the cage, and the same subjects were provided with sticks and stones. The Capuchins used sticks or stones as marking tools on the clay slab. In this condition, 9 Capuchins marked the clay manually by drawing their hands across the surfaces of the clay slab, and 8 used stones or sticks as engraving tools. Their mark making produced at least one set of parallel lines across the surfaces of each form, which the authors characterize as nonfigurative. They interpret the Capuchins' clay modifications in terms of their general propensities for tool making and use, and not yet as a sign of symbolic thought.

The prolonged exposure of trained apes to drawing and painting implements has yielded ambiguous evidence regarding their capacity for symbolic representation in this medium. The generally negative findings highlight the amazing achievements of young children who, without training or great effort,

evolve their first basic representational shapes, name them, and expect others to recognize them. In this symbolic realm, there are clear discontinuities between apes and human children. So far the evidence suggests that the search for the beginnings of graphic representation has to focus on humans.

ARTISTIC BEGINNINGS

For the beginnings of representational activity in drawing, painting, and modeling I turn to human prehistory and a review of the socioeconomic and cultural conditions under which this art was created. A series of very fortunate discoveries made at the end of the 19th century and continuing into the present shows cave art that stems from the beginnings of Cro-Magnon man in Europe, approximately 40,000 BC. That a hunter–fisher–gatherer culture of small groups of *Homo sapiens* could create, in addition to tools vital for physical survival, images modeled in clay and carved in stone and ivory, and engravings and paintings on walls is, of course, a striking testament to humans' desire to leave a record of themselves, to create and communicate meaning. Unlike the spoken word, which in the world of preliterate communities leaves no trace other than the recipient's memory of it, art—whether portable or stationary on walls—provides a more lasting document of the values and concerns of the people to which it is addressed.

Multiple questions arise about art's earliest beginnings; its form and function; whether it is similar to what has been learned from our research on children and naive adults; its course of development; and what it can explain about the early humans, their concerns, rituals and, above all, their mental abilities.

This quest for the prehistoric beginnings of art focuses on the nature of the graphic and plastic arts at this early period in human cultural evolution and their role in the social organization of our remote human ancestors. It is useful to look for the earliest forms of this human artistic activity, the context for its emergence, and the course of its development over time. The issue of development is of central concern in the artwork of children and the early humans and, accordingly, its similarities and differences in style, composition, and meaning will be examined. An understanding of child art and its developmental course may heighten appreciation of the artistic achievements of our so-called primitive forebears, and their artistic accomplishments may aid in understanding the evolution of child art and its interpretation.

Answers to questions of origin can also address the recurrent and somewhat romantic conception of the *innocent eye*, which postulates the existence of an early phase of unspoiled superior vision in the child and the primitive adult, whose perception of reality is deemed to be acute, veridical, and closely linked to the ability to represent the world realistically. According to this view, the innocent eye succumbs to the later dominance of verbal–conceptual processes and cultural conventions that subvert and distort the original authentic vision (Bühler, 1930; Costall, 1995; Kellman, 1996, 1998). An alternative position posits a prolonged period of primitive and crude beginnings analogous to the early childhood years when simple and so-called distorted schemas—presumed indicators of the mental status of primitive man—dominate.

When turning to the record of human prehistory, we learn that such tools as hand axes had already been invented by *Homo erectus*, who used teardrop-shaped stones that fit snugly into the palm of the hand to cut, crush, cleave, or batter. At first such axes were crudely worked, but later they showed good craftsmanship. Polished stones and scratch marks on ivory and bone, found in southern France and dated 50,000 BC, are the earliest examples in Europe of "art products." Markings on tools such as spears and harpoons appear only with *Homo sapiens*.

Cro-Magnon or Modern humans spread over Europe in approximately 40,000 BC, during the Upper Paleolithic period. These people were able to adapt to the conditions of the Ice Age and lived in semi-permanent settlements of rock shelters and cave mouths, but mostly in open-air settlements of huts or tents. During harsh climatic conditions, they might have taken refuge inside caves. Game animals were vital for their survival, and the hunters followed the animals during their seasonal migrations and returned to warmer climates in the winter (Bahn & Vertut, 1988). They developed technologies well suited to the hunt and were skillful spear

throwers. According to Burenhult (1993), a skilled hunter could wound a deer from a distance of more than 30 meters and kill an animal at 15 meters. They engaged in large-scale hunting, and one of their methods was to drive herds over cliffs or into narrow gorges; they also developed fish spears for some regions. There were times that food was plentiful even close to glaciers, but some skeletons indicate slow growth caused by starvation or illness. Upper Paleolithic man lived on average to age 32, sometimes well over 50. According to Bahn, on the whole the people were fit and healthy.

From the tools Cro-Magnon developed, the portable art objects and the parietal art of rock carving and painting, the burial sites, body adornments, and clothing, most researchers assume that these people had a rich ceremonial life built on extensive rituals and religious belief systems (Burenhult, 1993; Leroi-Gourhan, 1982; Marshak, 1972; White, 1986a, 1993). Burial sites reveal highly decorative patterns of beads arranged on the corpse, which suggests that people felt a need to communicate with the spirit of the dead and developed abstract forms of communication by means of symbols (Burenhult, 1993; Marshak, 1972).

Paleolithic art covers all of Europe from Andalusia to the Ural Mountains. Today approximately 300 caves have been identified. In Europe parietal or wall art in caves and portable art overlap chronologically, although most commonly not in the same places. Portable art made from mammoth ivory, antler, bone, stone, and clay spread from the Atlantic to the Urals and from the Iberian Peninsula to Siberia, with concentrations in central and Eastern Europe. Large numbers of engraved and painted stone objects have been found with scores of decorated bones (Bahn & Vertut, 1988). Human figures, mostly female, have been discovered from Northern Spain to France, Germany, and the Baltics. Their characteristics vary; some are small and clearly three-dimensional. The most famous of the early sculptures are found in Central Europe, in the caves of Vogelherd, Geissen-Klosterle, and Hohlenstein-Stadel. The population was still sparse, and Burenhult estimates that by 20,000 BC the population in France was 2,000–3,000, and all of Europe included only 10,000 people.

The geographic distribution of parietal art in Europe differs from that of portable art. Paleolithic decorated caves are mostly concentrated in the Franco-Cantabrian regions of northern Spain and southern France; one is in Portugal. Other caves can be found along the Mediterranean in Italy and Sicily, Bosnia, Serbia, Romania, and Russia. These caves are 4000 km away from the main clusters of decorated caves in southwestern Europe. Experts generally agree that Paleolithic art, which extends over 25,000 years, shares certain features and represents a common Paleolithic style. Although there is no clear consensus on the stages of its internal evolution, which is discussed in the next section, there is agreement regarding the content of the parietal art, consisting predominantly of powerful animals and a small number of humans. Most authors stress the intrinsic unity of the art despite regional and temporal variations, which bears witness to a common state of mind during the prolonged period of the Ice Age.

PARIETAL CAVE ART

So far only the Upper Paleolithic has produced figurative designs, and they become abundant during the Magdalenian period (15,000 BC). Since the discovery of the Altamira Cave in 1879 and other caves in Spain and southern France, and with the illustrated publications of Abbé Henri Breuil, followed by André Leroi-Gourhan and others, people have marveled at the striking beauty of the naturalistically represented animals and pondered how our culturally and perhaps cognitively restricted forebears could have created engravings and paintings of great sophistication and vitality, depicting volume, texture, shading, partial overlapping, foreshortening, and 3/4 views.

Parietal (wall) artworks comprise engravings, bas-reliefs, and paintings. The most famous are the caves of Altamira, Lascaux, Niaux, Les Trois Frères, Pech Merle, Cougnac, and the recently discovered Cosquer and Chauvet caves. Images of large game animals predominate, some of which are now extinct or were present in southern France and northern Spain only during the Ice Age. They include the horse, bison, mammoth, aurochs (wild cattle), rhi-

noceros, lion, bear, reindeer, and ibex. Birds and fish are depicted less frequently. Stenciled hands appear in various periods and across a wide range of caves, in contrast to the sparse representation of humans and of figures with combined human and animal characteristics (perhaps sorcerers). Throughout the long Paleolithic period, marks such as dots, lines, and geometric figures appear interspersed with figurative art.

Animals often appear in pairs, for example, the bison and the horse, or in groupings. The figures are placed without regard for an explicitly presented baseline or ground plan, and they are frequently described as *floating* in space. The artist frequently used naturally protruding surfaces or cracks in the wall as an implicit grounding for the figures, or aligned the animals along an imaginary horizontal axis. At times, the images of the animals were superimposed on other figures, a technique of partial overlapping of forms that suggests the depth of three-dimensional space. Some of the superimposed figures represent earlier and later works, where the later images partially obliterate the earlier ones but, by and large, parietal art, whether engraved or painted, avoided superimposition of figures. Compositionally, different forms of symmetrical organization of figures have been described (Leroi-Gourhan, 1982): *mirror symmetry*, where two animals or animal herds are facing each other; *symmetry of mass*, where subject matter, such as signs, dots, or figures, is presented in a manner that maintains an equivalent mass on each side; and *oblique symmetry*, a grouping of figures with homologous points distributed on either side of an oblique axis. In general, the animals were drawn without concern for scale and nearly always in profile. Frontal and rear views were rare.

Methods of dating cave art include radiocarbon analysis, stratigraphic methods, and dating by style. The oldest parietal art has been identified by the radiocarbon method in the more recently discovered Chauvet cave, with a date of 32,000 BC. The most widely applied method of dating has been by style, beginning with Breuil's analysis that focused on the extent to which a depicted image was created from a consistently applied perspective or point of view or represented a mixture of views (Breuil, 1952). His

scheme emphasized the presence or absence of *twisted perspective* of an animal figure typically drawn in profile but with its horns, antlers, and hoofs presented in frontal view. For Breuil, *twisted perspective* was a sign of archaic thought processes reflected in a primitive style of representation that was overcome during the Magdalenian period, when hoofs and horns were drawn from a consistently applied viewpoint, in what he considered proper perspective. He proposed that artistic development proceeded from simple to more complex forms; with this view in mind he discerned two cycles, each independently pursued and progressing from simple to more complex forms in engraving, sculpture, and painting. This progression proceeded from the schematic and stiff forms of early representations to more natural forms.

Breuil proposed that the first cycle of artistic development, which spans the Aurignacian–Perigordian period (32,000–21,000 BC), begins with hand stencils and macaroni finger tracings (fingers drawn over soft clay surfaces), proceeds to simple outline drawings and engravings of animals with their legs partially omitted, and culminates in large animals painted in red flat wash and in the bichrome giant figures. The second cycle covers the Solutreo–Magdalenian period (20,000–10,000 BC), which also begins with simple outlines of animals, progresses to black figures with flat wash, is followed by filling in and hatching of the outlined areas, and again culminates in the bi- and polychrome paintings of Lascaux and Altamira. According to Breuil, this cycle ended with a major change in style toward abstract designs practiced during the Azilian period (8,000 BC).

This scheme was superseded by one proposed by the influential Leroi-Gourhan (1967, 1972, 1982), who based his analysis of styles of representation on more securely dated figures. In designing his criteria, he acknowledged the influence of Luquet's classification of styles of children's drawings, especially the distinction between intellectual and visual realism. Luquet, a student of child and prehistoric art, revived long-abandoned ideas regarding the aesthetic evolution of mankind that could be followed in the development of children's drawings (Haddon, 1895; Luquet, 1930). Leroi-Gourhan incorporated develop-

mental parallels in the stages outlined by Luquet in his own, more detailed criteria for classification of cave art. On the basis of the figurative status of cave art representation, he proposed four styles that would encompass the development of Paleolithic art as a continuous developmental progression.

Style I comprises an archaic purely geometric *prefigurative* phase (40,000–25,000 BC) exemplified by carved blocks with deeply incised patterns and crude, difficult-to-discern figures composed of stiff contours. He proposed that the parietal art of this period is limited to the daylight areas of caves and shelters. Style II (25,000–20,000 BC) refers to a better drawn animal in profile with a sinuous neck–back line, elongated head, an oval eye, incompletely drawn limbs, with horns and antlers depicted in twisted perspective. These somewhat schematic figures include only the minimum necessary for recognition of the object. Style III (20,000–15,000 BC) is a period of complete artistic mastery and encompasses the magnificently drawn animal figures of Lascaux (17,000 BC), in which the essentials of form are depicted without, however, full attention to detail and anatomical correctness. Thus, for example, animals are portrayed with relatively small heads and short limbs, swollen bodies, and horns in semitwisted 3/4 frontal perspective. Style IV (15,000–10,000 BC) is characterized by an analytical approach to visual accuracy that yields better proportioned figures, greater modulation and modeling of lines and coats, and overall anatomical correctness. It is a period of high technical achievements, of elaborate realism, of planning to fit cave art into the maximum available space while maintaining accurate proportions. During this period the deeper parts of the caves were also decorated, and Style IV reaches its clearest expression in the cave paintings of Altamira (14,000 BC).

This account of the progression of parietal art, which shows the impact of Luquet's classification of children's drawings, delineates a development from the linear outline to the more painterly and volumetric style of the later periods, a scheme that can account for some of the evidence but not for all the findings according to Bahn (Bahn, 1996; Bahn & Vertut, 1988). Leroi-Gourhan himself recognized that not all the data could be accommodated by his

four styles, a view that has become more emphatic with the discovery of additional caves: Cosquer in 1991–1992, Foz Coa in 1995, and Chauvet in 1995 with its radiocarbon dating of 32,000 BC. Radiocarbon dating of wall art in the Cosquer cave has identified a progression from the lines of early finger tracings to hand stencils (27,000 BC), which fits well with Leroi-Gourhan's Style I and is followed by figurative art of mostly animals that might be accommodated by Style II, dated 18,500 BC. Between these two dates, the cave seems to have been abandoned, and there is no clear continuity between these two styles. Furthermore, it is now known from the Chauvet cave that sophisticated techniques for wall art were invented by the Aurignacians at an early date (Figure 93a–b), and that perspective, shading, outlining, movement, and reliefs date back more than 30,000 years. Jean Clottes (1996, 2001) linked the technical sophistication of the cave paintings to the ivory statuettes discovered in southwest Germany and envisioned a commonality of beliefs over a broad region extending from the Ardèche region of France to Swabian Jura in Germany.

A reassessment of the available findings points toward many beginnings over an extended region and period of time rather than a singular linear development from archaic to naturalistic styles that ignores aesthetic preferences. According to Ruspoli (1986), the artists at Lascaux created a harmonious style of their own, and their works are a unique mixture of authentic details and workshop mannerism. Considering the unusual dimensions of the animals depicted with small heads and huge bodies, he argued that the artists' intentions were to render volume dramatically, which led to their invention of an original kind of artificial but pictorially successful perspective. Their use of trick or twisted perspective, which represents the head and the body in profile and other features in 3/4 frontal or back view and deliberately avoids overlap, makes for clear and expressive images. Thus, for example, at Lascaux, the bulls and cows have one S-shaped and one C-shaped horn, a convention that serves a pictorial purpose. Other conventions are seen in the form of ears: rectangular shapes for the bulls and triangular ones for the cows. Some aspects are unusual, such as the flying gallop of horses extending all four legs.

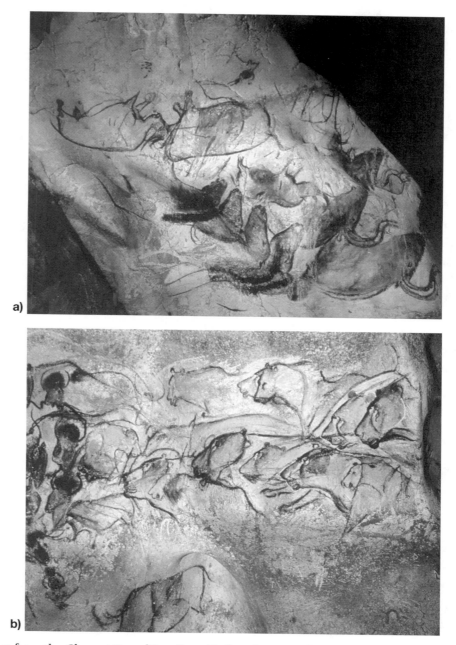

FIGURE 93. Art from the Chauvet-Pont-d'Arc Cave. Earliest known Paleolithic wall art, 32,000 BC, **a.** *Panel With Horses.* b. *Panel of Lions,* detail. **Note.** Reprinted with permission of the French Ministry of Culture and Communication, Régional Direction for Cultural Affairs, Rhône-Alps, Régional Department of Archeology.

Although this depiction is not realistically correct, it creates a dynamic image of motion, a finding also described by Leroi-Gourhan, who noted great diversity in the depiction of the legs, usually of same size (no foreshortening) and in varying pairings of front and rear legs. These examples, rather than revealing artistic naiveté or ignorance, suggest a delib-erate deviation from a perspective projection of the image in the service of an artistic conception that valued expressive qualities over anatomical correct-ness.

Bahn (1996) adopted a similar position and noted that the combination of side and frontal views in the pictorial representation of an animal enhanced

the beauty and the impact of the image and suggested its volumetric properties. He considered these pictorial styles as conventions that appear at different artistic periods, including modern Western art. He noted that true perspective renderings can be found in the early phases, as in some ibex at Gargas; the deer of Labattut; and the lion, bison, and ibex at Chauvet, and that twisted perspective is not a reliable developmental marker. In Bahn's view, Paleolithic art did not have a single beginning, or a single climax, and instead of conceiving of its development as a straight line, he proposed a more circuitous path, a "punctuated equilibrium" with occasional flashes of brilliance. He found considerable variability in accomplishments according to regions and the skills of individual artists and noted examples of simple or unskilled images alongside brilliantly detailed animals in the same cave and dating from the same period. According to Bahn, the two approaches coexisted during the whole Upper Paleolithic period, and rather than conceiving of an archaic period, he pointed to individual differences in artistic talent such as the sophistication and beauty of the Vogelherd animals, dated 32,000 BC. A similar and perhaps even more extreme view was expressed by Jean Clottes (1996), who stated that the first European *Homo sapiens* not only knew how to work ivory and make beautiful statuettes from it, but also had full mastery of graphic techniques. He considered their artistic abilities identical to those of their successors, rejected the notion that art began from clumsy and crude beginnings, and conjectured that from the very start these were great artists.

The true beginnings of this artistic period in human prehistory are unknown, and because the early works made in the open air from bark, wood, and other perishable materials are irretrievably lost, it is possible only to speculate about the early antecedents of the graphic and plastic arts (Leroi-Gourhan, 1982). Although we cannot know the form and style of the earliest figurative efforts, nor the passage of time for its transformation, among art historians there is a general consensus that art is not created by inspiration alone and that it takes extensive experience with the medium to perfect a style, a position that is quite compatible with views held by many students of child art.

PORTABLE ART

The distinction between portable and parietal art is not always clear-cut, and carved or incised blocks of stone of similar style may be found in caves and open-air locations. Portable art includes but is not limited to painted bone and stone, engravings on bone and antler, bas-relief on blocks of fallen rock, body ornaments, and sculptures. The oldest evidence for the making of personal ornaments comes from burial sites where literally thousands of beads and pendants have been found, the majority carved of ivory, dating to 40,000 BC. Pierced animal teeth have been dated even earlier in Bulgaria (43,000 BC) and in other regions such as Moravia and Spain (White, 1993). Pierced marine, freshwater, and fossil shells made into necklaces, pendants, or bracelets have also been found. The great majority of these ornaments were made of ivory, and even some of the famous Vogelherd animal statuettes were pierced for suspension (Hahn, 1993). That these ornaments served vital social functions can be inferred from the role they played in the burial of apparently important individuals. For example, at a burial site in Sungir, which is situated on the outskirts of Vladimir, 150 km east of Moscow, the bodies of an adult man and two adolescents were decorated with thousands of beads made from ivory, arranged in dozens of strands. The body of the man displayed 2,936 beads and fragments, the boy was adorned with 4,903 beads, and the girl had a similar number of carefully designed and carved ivory beads. An estimated 45 minutes to 1 hour was required to carve each bead; thus, the man's beadwork took more than 2,000 hours and that of each child more than 3,500 hours. Clearly a tremendous amount of time, planning, and labor was required to execute such a project. White stated that evidence from Sungir and other sites of Aurignacian age attests to a high degree of social and technological complexity from the very beginning of the Upper Paleolithic period in Europe. During this period centers of production arose that specialized in crafting tools, tooth pendants, shells sewn into clothing, ivory beads, and statuettes.

Aurignacian figural art can be found in many locations, but the most famous of animal sculptures

("statuettes" because of their smallness) has been found in Central Europe, in Vogelherd (discovered in 1931), Hohlenstein-Stadel (discovered in 1935–1939, 1956–1960), and Geissenklosterle (1973–1983, 1985–1989). The earliest radiocarbon dating of the ivory statuettes is 32,000 BC. They are beautifully carved in the round, quite graceful and naturalistic in appearance, and made of local sources (Figure 94). Fully sculptured figures were made from the interior portion of tusks; flat half-relief figures were made of short flakes from the exterior portion of tusk. The last stage included polishing, a very time-consuming endeavor given the hardness of ivory. It is estimated that an investment of 40 hours was necessary to reproduce the Vogelherd horse and 10 hours for the piercing of the two holes between the fore- and hind legs. On the basis of size, detail, and carving style of the animal figures found in these locations, several artists must have been involved in their production. At other sites, animals were modeled from clay and fired in kilns. The simplest free-standing figures from the Upper Paleolithic are terracotta models. The master pieces that date from such an early period, 32,000 BC and perhaps even earlier, suggest that a long artistic tradition preceded them.

The first human sculptures also date from approximately the same period, for example the sculpture of a man carved of ivory found in a burial site in Brno (Moravia), dated 32,000 BC and the woman of Willendorf (Austria), a small female figure carved in limestone (Figure 95). It was carved in the round, lacks facial features, and displays an elaborate design that covers a large part of the head, including the front. Past interpretation of this design as hair has recently been challenged by anthropologists who study textiles and basketry and who identify the pattern as an elaborately woven cap (Anger, 1999; Soffer, Adovasio, & Hyland, 2000). She is one of the famous so-called Venus figures, endowed with large breasts, hips, and abdomen; a prominent bellybutton; and short legs and was once colored red (Figure 95). At some sites, female figures are more numerous than animal statuettes and mostly sculpted in the round, the best known of which is the Venus of Dolni Vestonice (Moravia, 23,000 BC), a faceless and armless figure with large breasts and protruding hips (Figure 96). Several figures are shown wearing clothing.

Delporte (1993) classified the more numerous female figures of the Gravettian period (25,000–20,000 BC) into four groupings: those from Western

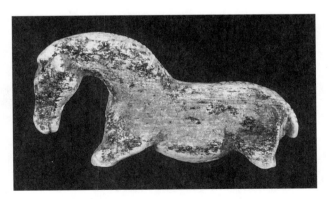

FIGURE 94. Sculpture of a horse from the Vogelherd cave. Earliest known Paleolithic animal sculpture, 32,000 BC. *Note.* Foto Hilde Jensen, with the permission of Harald Floss, Universität Tübingen, Institut für Ur-und Frühgeschichte und Archäologie des Mittelalters, Abteilung Ältere Urgeschichte und Quartärökologie.

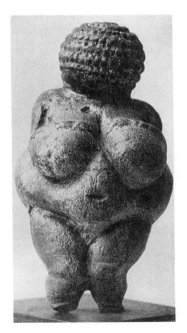

FIGURE 95. Venus of Willendorf. Earliest known Paleolithic sculpture of a woman, 32,000 BC. *Note.* From Vienna, Naturhistorisches Museum. Copyright 2001, Foto Marburg/Art Resource, New York, S0127178; C0054103. Reprinted with permission.

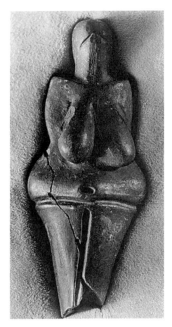

FIGURE 96. Venus of Dolni Vestonice. Paleolithic sculpture of a woman, 23,000 BC. *Note.* From Moravian Museum, Brno, Czech Republic. Copyright 2001, Foto Werner/Forman/Art Resource, New York, S0162710; C0054103. Reprinted with permission.

Europe, the Moravian group from Central Europe, the Russian group, and the Siberian group. He reported that the statuettes in certain sites such as Brassempuoy (France) are extremely heterogeneous in form, displaying both schematic and faceless figures as well as naturalistically detailed ones.

The Moravian group is even more heterogeneous, comprising naturalistic and hyperstylized figures of humans and animals. The Russian group is more homogeneous; all the figures are sculpted in the round, composed of a spherical head that lacks facial features, a well-defined neck, large breasts, and thin arms resting on an extended abdomen. The figures differ in posture and may be standing, crouching, or sitting. The Siberian group of figures is also fairly homogeneous, characterized by a long hairstyle, facial features, and bodies that are not well modulated but are often dressed in clothing.

ARTISTS AND STYLE

Most students of prehistoric cave art consider the parietal paintings, engravings, and sculptures the work of experienced artists with extensive practice in their art. Within each cave, the sophistication of the paintings and engravings can vary significantly, which has been interpreted as representing different periods as well as individual differences in the talents of artists and their pictorial competence. Although it is reasonable to assume that the simpler figures with their stiff outlines and one-dimensional and incomplete legs stem from an earlier date, these works may also reflect the activity of less gifted artists. This seems to be Bahn and Vertut's position (1988) in their reference to the sporadic output of relatively few highly gifted artists that can be traced to the beginnings of the cave art as it is currently known.

The theme of the great majority of parietal paintings and engravings centers on such powerful and dangerous animals as mammoth, bison, lion, auroch, horse, bear, rhinoceros, and reindeer. The animals are almost always presented in profile, often with a frontal eye, at times with the head turned in 3/4 view, with S- and C-shaped horns, with legs left incomplete or ending in a Y-shape, and with multiple legs indicating movement or speed. The flat washes, shading, multiple lines, overlapping figures, and their style of representation succeed in evoking the vitality of the feared animals.

From the beginning of the available evidence as documented in the Chauvet cave, the artists seemed to aspire to represent a naturalistically convincing image of an animal, and their knowledge of its shape, stance, coat, and expression indicates acute observation of the animals and their habits. These are provocative findings and, with some of the parietal art of the Chauvet cave dating back to 32,000 BC (Figure 93a–b), at the very least they require an adjustment in dating the earliest figurative art. Leroi-Gourhan's prefigurative archaic Style I, which was supposed to characterize this period, needs to be revised, perhaps pushed back several thousand years. The parietal art of Chauvet clearly indicates that the Aurignacians invented sophisticated representational techniques at an early date, which calls for a revision of the current views of the symbolic abilities of Cro-Magnon human in Europe. The art of the Chauvet cave does not represent a true beginning, and much of it is the work of a master virtuoso artist working in an established tradition. Of course, no

one knows what exactly preceded it, what the steps are, or the times between the early marks of circles, dots, and lines and the figurative art of 32,000 BC.

It seems clear that these early humans had significant representational capacities that were called on to create images that played a crucial role in the rituals and ceremonies that governed their relations to the natural and supernatural world. Given their artistic talents, cultural traditions, and communal support, these humans may have advanced rapidly. Once techniques became available and pictorial conventions established, even less inventive artists could rely on the models developed by the originators of the naturalistic style. This does not mean photographic likeness, given their deliberate deviations from realism in the depiction of small heads and large bodies and their styles of representing eyes, ears, antlers, horns, legs, and hoofs and also given their faceless sculptures of humans. Overall, their style and chosen themes remained relatively unchanged over 25,000 years, suggesting that, despite changes in the fabrication of tools, weapons, bead production, and other crafts, there was considerable continuity in communal organization, worldview, and religious practices and that the sculptures and parietal art forms continued to perform a satisfactory, perhaps similar function for a long time.

According to Leroi-Gourhan, cave art was contingent on communal involvement in maintaining the artistic traditions practiced by the few artists of great talent. The preparations for parietal art took many weeks and included constructing the scaffolding to reach the higher elevation of cave walls, felling the trees that would serve for scaffolding, manufacturing the coloring matter, and preparing the lamps and oil and the brushes. All of these activities required communal planning and extensive investment of time and resources.

SIGNIFICANT FINDINGS

To summarize the previous sections, naturalistic representation appeared early in the history of recorded cave art, in wall and portable art. In terms of its sociocultural aims, level of artistic sophistication, and the communal support that enabled this activity, there is a vast gulf that separates this prehistoric art from child art. The earliest beginnings of Paleolithic art cannot be discerned with any certainty, but the great animal paintings of Chauvet and the beautiful sculptures in the round that date to 32,000 BC testify to an already established artistic tradition of skilled craftspeople, a far cry from the development observed in children. The current findings do not invariably suggest an evolution from simple and static outline figures to a more naturalistic representation, and there is considerable evidence that different kinds of representational models and skill levels coexisted over long periods, reflecting variation in talent and in the intent of the artist. The notions that early sculpture evolved from one- to two-dimensional and finally to three-dimensional representation, and that the early sculptures were at best flattened two-dimensional figures, can no longer be maintained. In this case, there may well be an instructive analogy with children's early three-dimensional treatment of their clay sculptures, suggestive of common basic representational concepts in the three-dimensional medium. The tendency to omit the facial features is also common to the early Paleolithic figures of humans and children's sculptures. Although I dare not draw any comparison between the figurative aspects of children's drawings and those of the Paleolithic artists, it is quite striking to find similar structuring tendencies in their compositions, for example, the emphasis on symmetry.

Finally, the record of cave art demonstrates the importance of art making for modern humans, the urge and capacity to represent the world in a symbolic medium that provides some degree of permanence and continuity of a socially transmitted meaning system. It was a socially sanctioned activity that could flourish only with communal support. In the child's fascination with art making, the persistent creation, and continued elaboration of images, there is an echo of this symbol-making capacity of humans and our intense preoccupation with it.

MEANING AND THE CULTURAL CONTEXT

Beyond the aesthetic response to the images of cave art and the many unanswered questions about the virtuosi artists and how they acquired their skills looms the issue of their meaning. The 19th-century view of the decorated objects that were the first to

be discovered emphasized a playful decorative tendency of hunters who had free time on their hands, especially during the winter months. It is a view akin to "art for art's sake," a pleasure in aesthetic creation. In the 20th century, Abbé Breuil (1952) became the proponent of hunting magic; he saw the images as a collection of individual pictures, some of which could be interpreted as an animal pierced by a spear, the hoped-for outcome of magical rituals that empower the hunter vis-à-vis his prey. This quite reasonable hypothesis ignored the fact that only a few of the Paleolithic images depict a pierced animal either directly or by implication of a nearby fallen spear. Bahn (1996) mentioned that fewer than 15% of the figures are marked in such a way and that the restricted range of animal species depicted does not correlate with the animals that were hunted for food.

Although the hypothesis of sympathetic magic has not been completely discarded, Leroi-Gourhan's analysis of cave layout has gained ascendancy. He considered cave art a symbolic system of representing the living world, as the expression of concepts regarding the natural and supernatural organization of this world. Figural art as well as the geometric markings present a coherent and meaningful image system that indicates a high cultural level of the society. In his structuralist framework, Leroi-Gourhan considered subject matter central for interpretation. The images are not a collection of edible species, and they were not hunted for food; they represent a hierarchy of powerful animals, a binary system of male and female pairs that are, above all, symbols of male and female sexuality and fertility.

In recent times, renewed attention has been called to shamanic practices that seem to appear in hunter–gatherer societies at different times and across widely different locales (Bahn & Vertut, 1988; Clottes & Lewis Williams, 1996). Shamans are ritual practitioners esteemed for their power to enter altered states of consciousness and their supernatural ability to foretell the future, heal the sick, change the weather, and control animals. The shaman combines the role of healer, priest, magician, and artist and provides the link between this world and the spirit world. From this perspective, Paleolithic images are spirit animals.

How does one conceive of the cognitive capacities of the societies that authorized and supported cave art over 25,000 years, a period of remarkable stability in the relationship of the artist and his community? In the views of Alexander Marshak (1972, 1985, 1995), the Europeans of 40,000 years ago were exceptionally skilled and intelligent people who created a sophisticated material culture and invented notational systems to record lunar cycles. The marks used for notational purposes differ from the symbolic representations used in portable and parietal art. His analysis of themes points to cognitive capacities that underlie the creation of time-factored stories, seasonal rites, and mythical stories that are passed from one generation to the next. Although it is impossible to "read" these images and marks, one can understand that they represent a complex composition that is well organized, purposeful, notational, and part of a tradition that comprised storied sequences. In Marshak's view, the art forms, notations, and symbols imply continuity and periodicity in the economic and cultural life of the Upper Paleolithic hunter, and for 25,000 years their way of life and the mythology based on it found expression in rituals that involved cave art and mobiliary representational items. According to Marshak, the hunter's culture was based on modern cognitive and symbolic capacities (see also White, 1986a, 1993).

In a similar vein, Leroi-Gourhan (1982) emphasized the hierarchically coordinated images of the animals in cave art and the use of symbolic formulae that remained unchanged since the Aurignacian period. The paintings and engravings in the caves of Lascaux, Altamira, and Niaux give evidence of a highly developed cultural level and of an economy that could support and sustain the ideology expressed in the various symbolic forms. The mastery attained in engravings, paintings, and mobiliary items implies that there were ample opportunities to practice these art forms, including the extensive reworking of previous images. The technical and symbolic skills that made this art possible indicate advanced cognitive capacities of the artists and the culture that sustained it.

Jean Clottes (1996) is perhaps the most outspoken proponent of the theory that the intelligence and creativity of the Upper Paleolithic artists do not

differ from that of the present and that they were endowed with similar abilities in all areas of perception and thinking. He especially lauded the originality of the Chauvet artists and their departure from what may have been established practices and representational conventions.

This is not a universally accepted view of the intelligence of these prehistoric people, and students of the development of scientific thought may find the evidence for logical reasoning insufficient. In the context of more modern versions of "ontogeny repeats phylogeny," and consonant with Piaget's views on the parallelism between the stages of intellectual development in children and the history of scientific thinking, Peter Damerow (1998) argued that cognitive development in the Paleolithic period constitutes an early stage, a transition from sensory–motor intelligence to preoperative thinking. Preoperative forms of thought are characteristic of childhood reasoning during ages 2 to 7 years. Although children during this stage make use of symbolic processes, their mental activity is perception bound and based on imagery. This form of thought is merely intuitive; it lacks coherence, systematic inquiry, and quantification of knowledge and uses inadequate concepts of number and measurement. It is a prelogical mental activity incapable of reversible thought processes, which are essential for logical reasoning. Reversibility becomes the hallmark of the concrete operational period when thought becomes systematically organized and logical. On the basis of his analysis of the available implements and art forms, Damerow concluded that there was no convincing evidence that a level higher than preoperative thinking was achieved at that time. Only during the Neolithic revolution of living in stable settlements, with the cultivation of crops, domestication of animals, trade, and a more complex social organization, is there evidence for accounting practices, the invention of genuine notations, and eventually of written languages. With these techniques of measurement and numerical calculation, a new intellectual level, that of concrete mental operations, has been achieved.

A similar position has been espoused by Sidney Blatt (1994), who saw parallels between child art and the art historical development of spatial–representational concepts. In Blatt's analysis, prehistoric artists used topological concepts of space that emphasized the contours or boundary of an individual object represented in isolation, without depth or perspective, and without concern for composition as an integrated unit. Adopting the Piagetian perspective of cognitive development, Blatt assigned the content and structure of this ancient art to the sensory–motor/preoperational level.

Another position that challenged the symbolic–cognitive interpretation of Paleolithic art and questioned the social meanings attributed to it was formulated by John Halverson (1987). Perhaps under the influence of Luquet (1930), who considered the early beginnings of figurative art as "a disinterested activity in its initial phase" (p. 111), he questioned the significance of cave art and proposed that it might best be seen as art for art's sake, or "representation for representation's sake." In this view, Paleolithic art is based on a low level of symbolic activity that neither connotes nor denotes meaning beyond the pleasure of engaging in the activity. Relating his interpretation to both Luquet and Piaget, he considered this art as typical of an early stage of cognitive development where representation and play are not yet clearly distinguished and serve no useful function. His position can be seen as a variant of the theory of the innocent eye and shares some common ground with a recapitulation theory in which ontogeny repeats phylogeny. Halverson outlined a hypothetical developmental sequence that begins with three-dimensional figures such as the sculpted animal figures and Venuses that date to an early period (32,000 BC), progresses to figures in relief, and eventually reaches, via abstractive reflection, the two-dimensional portrayal of wall paintings. According to Halverson, the true significance of Paleolithic art lies in the history of consciousness, the process by which the self becomes aware of its mental operations and attains a new level of abstract reflection. In a further elaboration of the relation between Paleolithic art and cognition, Halverson (1995) referred to a *generalized mental image* as the source of the prehistoric depictions that "appear to imply the expansion of conceptual thought and the beginnings of operational thought" (p. 233).

A close adherence to a theoretical position, in this case, Piaget's theory of genetic epistemology, has

profoundly influenced the interpretation of a remote historical period. Damerow tended to downplay the significance of the early settlements; the building of huts in areas to which the nomadic hunters returned at the end of the hunting season; the evidence of established workshops for the production of tools and ornaments; the proportionate reduction of engraved animal schemas to fit the dimensions of tools or batons; trade across distances; the invention of the needle for sewing clothes; the skill of the hunters; the communal investment of time, effort, and materials in the preparation of cave art; and the elaborate arrangements for the burial of the dead. These activities required extensive and sustained planning and a knowledge of the social and ecological environments that is beyond the intuitive thought processes that Piaget attributed to the preoperational child. By no stretch of the imagination do these activities match the mental age of a preschool child. In the words of Jahoda (1980), whom Damerow quoted, "No society could function at the preoperational stage, and to suggest that a majority of any people are at that level is nonsense almost by definition" (p. 116; see also Damerow, 1998, p.249).

It is somewhat surprising that Damerow and Blatt considered the art forms of the Paleolithic consistent with preoperational reasoning; in Piaget's analysis, the preoperational period comprised the immature drawings of general purpose global forms that ignore the true shape, size, and proportions of the real object, which rules out naturalistic portrayals. Blatt's analysis and interpretation of Paleolithic art has been criticized by Marx Wartofsky (1994), who wrote about the Lascaux paintings:

> *In elegance of line and in the extraordinary sensibility to the vitality of the animals' motions, I don't think there has been anything to beat it in the way of animal drawings. In this respect I don't think one can speak of progress in the drawing of animals.* (p. 238)

Toward the end of his essay, Damerow (1998) acknowledged that the application of Piaget's genetic epistemology to diverse cultures and historical periods may mask genuine competencies and that

"operatory cognitive structures may evolve in different forms depending on the nature of the activities and their coordination, from which they are constructed by reflective abstraction" (p. 266).

Halverson's proposal to view Paleolithic art as merely play, devoid of any real meaning for the individual and his or her social group, rests to some extent on a misreading of Piaget's views on play. The playful activities that are engaged in for mere functional pleasure, as motor actions or rituals, are pre-symbolic activities typical of the sensory–motor stage of infancy, which extend over the first two years of life. Once symbolic processes emerge, pretense play moves into center stage with its ability to transform objects and identities, to substitute one object for another, and to create an imaginary world that satisfies the desires of the preschool child. The transformational aspect of pretense play and its ability to go beyond the concrete here and now gives evidence of a precocious ability for abstraction, first articulated by Vygotsky (1933/1966). For Piaget, symbolic play presents clear evidence of the children's representational mind that enables them to use imaginative play to bend reality to the needs of their ego and to provide the kinds of satisfaction, however temporary, that adults are likely to deny them. It is true that Piaget underestimated the cognitive competence that underpins make-believe games and that he saw its further development in terms of greater accommodation to and imitation of reality. Since the 1970s, much evidence has been provided for the cognitive significance and rule-governed character of symbolic play (Aronson & Golomb, 1999; Dansky & Silverman, 1973; Golomb & Barr-Grossman, 1977; Golomb & Cornelius, 1977; Golomb & Galasso, 1995; Gopnik & Wellman, 1994; Leslie, 1987; Salz & Brodie, 1982; Singer & Singer, 1990; Sullivan & Winner, 1991).

Halverson's hypothetical sequence of artistic development from three-dimensional figures to two-dimensional drawings has not stood the test of time. Since Halverson's publication in 1987, the newly discovered caves of Chauvet and Cosquer with their early radiocarbon dating of 32,000 and 27,000 BC, respectively, clearly indicate that sculpting in the round of the earliest known figures from Vogelherd, Geissen-Klosterle, and Hohlenstein-Stadel coincides

with the earliest figural wall paintings yet found from the same period.

BEYOND PALEOLITHIC ART

At the end of the Ice Age, with major changes in climate and landscape due to retreating ice and rising temperatures and sea level, the long-established patterns of hunting large game began to change, with different animal species pursued by hunters, who used such new tools as the bow and arrow and also boats for fishing. Habits began to change gradually from a nomadic to a more settled existence, and the deep caves were either abandoned or forgotten. New river, lake, and forest cultures emerged in Europe along with different art forms.

Large-scale art and small-scale artists' and craftspeople's work disappeared in southeastern Spain, which presents a major disruption in artistic traditions (Sanders, 1985). Shallow overhanging rock shelters continued to be used, but the art forms in the Spanish Levant reflect the new lifestyle and culture of the times: Groups of hunters are depicted pursuing their prey and cornering and killing it. There are also narratives of battles among competing groups, which, with a growing population staking out claims to hunting territory, may have become more numerous. The new art forms in southeastern Spain differ radically from Paleolithic art in theme, spatial composition, and figural characterization. The novelty is in the depiction of space and action, with multiple figures grouped as a unit in the pursuit of its object. The small human figures are mostly composed of one-dimensional lines similar to stick figures; they bend and stretch as they aim for their goal, and the total composition is alive with energy. Interestingly, animals continue to be portrayed two- or three-dimensionally, although they are much simplified from the perspective of an earlier period. In this region, the naturalistic art of the Paleolithic era has been abandoned (Figure 97a–b).

In Scandinavia, far from sheltered settlements and often on steep rock faces above the sea or a lake, there is an echo of the earlier Paleolithic images in rock carvings. According to Sanders (1985) the engravings are of animals, mostly elk depicted with only two limbs, large and at right angles to the line of sight. They are reminiscent of some of the early Paleolithic drawings and engravings but seem to lack the artistry of the earlier works. Sanders considered them stereotypes of an iconography with which the artist was familiar and reproduced somewhat mechanically. In later versions, the animals' internal organs are depicted, using an X-ray style. This period also saw the production of small, simplified figures of animals made from amber and carved in the round. These sculptures indicate that during this period, and in these regions, the art of carving continued.

Other signs that speak of some continuity between the late Paleolithic styles and the Mesolithic period (9,000–6,000 BC) can be found in a mountainous part of Calabria, on an island off the west coast of Sicily, and in shelters on the north coast of Sicily. In these areas, engravings of animals and humans are represented in a naturalistic style, sometimes in thematically complex compositions.

THE INNOCENT EYE REVISITED

The notion that young children have an undistorted and authentic view of the visual world that becomes degraded as cognitive and linguistic capacities evolve and dull or distort the senses has emerged at different times. A similar position has been espoused regarding the perceptual acuity of primitive people, that is, of preliterate hunter–gatherers. In brief, the conception of the *innocent eye* refers to a hypothetical state of pure vision and of a mind dominated by its perceptual experiences. This imagery draws on the Romantic tradition of viewing the child as close to nature, uncorrupted by cultural practices, and also on a vision of primitive humans as original and more authentic beings. Regarding the visual-perceptual superiority of primitive humans, an issue that has engaged ethnographers of the 19th century and contemporary social scientists, the data collected over the past 100 years do not appear to support this assumption (Cole, 1996). Of course, the study of perceptual acuity in preliterate hunters and fishermen of the 19th and 20th century cannot bear directly on people who lived 20,000–30,000 years ago, but it is suggestive nevertheless. In this context the view that prehistoric people are endowed with

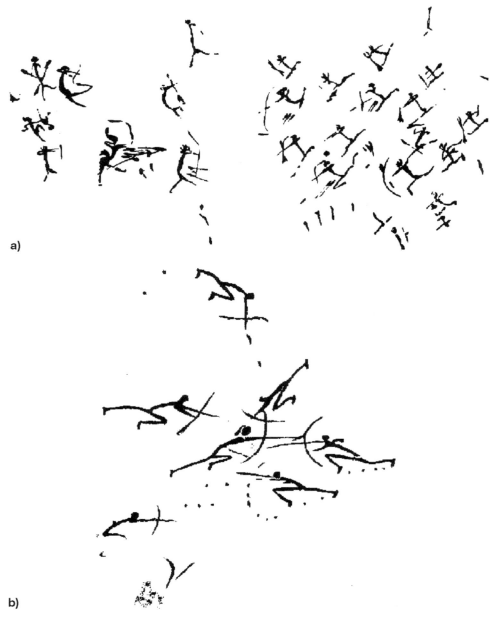

FIGURE 97. Mesolithic rock paintings of battle scenes. a. Rock painting at Morella la Vieja, Castellon, Spain. b. Rock painting at Les Dogues, Ares del Maestre, Castellon, Spain. *Note.* Reproduced with the permission of Rafael Martínez Valle, director of the Museum de la Valltorta, Spain.

exceptional visual-perceptual capacities continues to endure, for example, in the references of art historians (Sanders, 1985; Torbrugge, 1968) and in theories that assume that the development of Paleolithic art began with naturalistic representations. In the view of Max Verworn (1908), the earliest art forms, termed *physioplastic art,* consist of a faithful reproduction of an object, and only later in development

does this art form come under the control of cognitive processes, which leads to an *ideoplastic art.* The latter is based on knowledge that goes beyond the immediate perceptual view, a position also adopted by Torbrugge, who saw an irresistible process of stylization: As thought becomes more intellectual, depiction becomes more abstract.

Regarding child art, psychologists have tradition-

ally drawn on perceptual theories. In the Empiricist tradition that dominated psychological theorizing until the 1960s, retinal projections of a scene were supposed to constitute the child's primary sensory data. From this view of perception it would follow that young children would draw in perspective because this is how they were supposed to see the world. Because this is not the way children draw, investigators needed to account for the flat, two-dimensional and disproportional drawings, and they considered factors that prevented children from gaining access to their phenomenal perception. In their different ways, Bühler, Luquet, and Sully appealed to some version of the innocent eye and how it is superseded by cognitive and linguistic factors that corrupt the earlier concrete images and replace them with concepts of the object, disregarding their actual appearance (Bühler, 1930; Haddon, 1895; Sully, 1897). Costall (1997) has termed this the *repression theory* of child art. Luquet (1930), a student of Abbé Breuil who studied children's drawings quite intensively, addressed this problem in his theory of perception that distinguishes the model as a three-dimensional object and the image comprising only two dimensions:

> But the bulk of the object, its possession of a third dimension, is not a natural attribute of the visual sense ... an object having three always presents itself to the eye as a field of color limited by a contour and showing but two. That which constitutes the third dimension is not a visual sensation, but an idea that the object which at the moment gives a visual sensation of a certain shape in two dimensions has offered and will again, from another viewpoint, cause other visual sensations also in two dimensions but of a different form.... (p. 9)

He considered the two-dimensional visual percept in need of knowledge to complete the image. Consequently, artists face a dilemma: They have to choose between representing what they know or what they see. The third dimension is only recaptured by the *idea of the object* and can be presented only in a se-

ries of different two-dimensional representations. Luquet's account of intellectual and visual realism in drawing represents the artist's efforts to deal with the complexities of pictorial representation, and he comes close to seeing both styles as legitimate efforts to represent the object, a viewpoint Piaget ignored.

As shown from the above account, Luquet's view of the development of graphic representation is closely tied to his theory of the two-dimensional character of visual perception. The visual percept provides an incomplete rendition of an object or scene, and it is the mind that mediates between the individual's more extensive knowledge and his or her percept of a momentary view. Although Luquet considered Intellectual Realism in drawing, which reflects the drawer's knowledge, and Visual Realism, which represents his projective view, as legitimate artistic approaches to the problem of perception and representation, ultimately he viewed Intellectual Realism as a developmentally earlier phenomenon. Indeed, he delineated a developmental progression from Intellectual to Visual Realism in the child's development, and applied this stage conception to his analysis of Paleolithic art, with Intellectual Realism as an indicator of an earlier historical period. Despite significant differences in Luquet and Piaget's accounts of perceptual processes, Piaget adopted Luquet's stage-based classification and considered Visual Realism as the achievement of the middle to late childhood years, closely related to the child's ability to apply Euclidean and projective principles to spatial representation.

The theory of the innocent eye of childhood and of the purity of childhood perception has not stood the test of time. Theories of perception have moved away from the earlier retinal theory, and clearly children's drawings give no evidence of retinal sensations being translated into perspectival depictions of objects and scenes. However, the appeal of the innocent precognitive eye has not completely been abandoned, and has been resurrected by some students of the art of children and adults with autism.

Since the publication of Lorna Selfe's book on Nadia, an artistically gifted child with mental retardation and autism, the question of the relationship between autism and artistic giftedness has engendered wide-ranging interpretations (Selfe, 1977,

1995). Given the general view of a close relationship between intelligence and artistic achievement, the beautiful animal drawings of a young child with severe retardation and autism were indeed puzzling (Figure 42a–b). Explanations that are based on the child's conceptual and linguistic deficits ranged from Nadia's deficient symbolic processes and her inability to abstract, to her failure to create the basic representational forms of normally developed children. These interpretations left her a prisoner of a fixed and frozen point of view (Arnheim, 1980; Pariser, 1981; Selfe, 1977, 1995).

In more recent analyses, Constance Milbrath and Brenda Siegel proposed that these children see the world as *visual surfaces* and assemble "a whole from its parts, bottom-up rather than top-down" (Milbrath & Siegel, 1996, p. 69). In their view of normally developing individuals, conceptual understanding acts as a brake on the precocious appearance of perspective in drawing, and it is this deficiency in conceptual reasoning that, in addition to talent, underlies the precocious perspectival renderings of Nadia and other gifted individuals with autism. A more radical reference to the innocent eye has been proposed by Julia Kellman (1996, 1998), who referred to Marr's microgenetic view of the visual perceptual processes. This account begins with an *image* that represents intensity value at each point in the image, proceeds to the *primal sketch,* which yields a low level two-dimensional representation, then to the *2-D sketch* that provides viewer-centered information, and culminates in the three-dimensional perception and recognition of objects in their canonical form (Marr, 1982). Only the last phase of this process yields the conscious perception of an event; the earlier phases are silent neurophysiological processes that occur in a fraction of a second. Kellman contended that the savant artist who has autism has access to the earlier phases, which determine the so-called realism in his or her drawings. How an unconscious neurophysiological process is being accessed has not been spelled out.

Despite the obvious appeal of different variants of the innocent eye hypothesis, the available data do not strongly support this position. In most known cases where researchers have access to the early beginnings of savants with autism (Becker, 1980; Buck,

1991; Morishima, 1974; Park, 1982; Wiltshire, 1987, 1989, 1991) there is a development from simple, more schematic beginnings to three-dimensional representations; Milbrath and Siegel and Kellman provide similar examples. The one exception appears to be Nadia, whose mother collected her drawings from approximately age 4. It is not known what her earliest efforts might have been like, and in the drawings that have been preserved we see skillful renderings in this precociously artistically talented preschooler who was fascinated by the illustrations in her picture books, and studied them intensively.

A more effective challenge comes from an empirical study that examined the drawing and copying skills of 9 children with autism and 8 children with mental retardation matched for mental age on 5 drawing and 4 copying tasks. The tasks were administered over eight consecutive sessions, yielding a total of 20 drawings and 16 copies per child (Golomb & Schmeling, 1996). Analysis of the results indicates that on the drawing tasks the performance of these two groups is comparable and does not reveal any superiority of the children with autism. However, on the copying of stimulus patterns, the children with autism performed at a higher level than their matched counterparts on variables that assessed graphic form, degree of detail, attention to occluding lines, and the depiction of depth. This finding is congruent with reports on the enhanced visual–spatial skills of this population (Grandin, 1992; Park, 1982; Sachs, 1985; Waterhouse, 1988).

Thus, children with autism who do not show a special talent or motivation for drawing do not fit the innocent eye profile. What about children with autism who show talent in the visual arts? The extensive research of Hermelin and O'Connor and their colleagues indicated that the drawing skills of savants are very similar to those of talented but normally developing children. Their findings suggest that graphic talent is relatively independent of conceptual intelligence and call into question the view that the graphic accomplishments of savants with autism are symptoms of their pathology (Hermelin, Pring, Buhler, Wolff, & Heaton, 1999; O'Connor & Hermelin, 1987a, 1987b, 1990; Pring & Hermelin, 1993; Pring, Hermelin, & Heavey, 1995). (For an alternative view of the savants' skills that considers

them in terms of a highly elaborated preconceptual representational system, see Miller, 1999.)

Considering these diverse findings, I may now conclude that the theory of the innocent eye of childhood, of the purity of perception of primitive people and those with autism has not been supported by the childhood and prehistoric data. Artistic development in childhood is a protracted process, although it can be accelerated in the case of the gifted and highly motivated child. There is little evidence for the assumption of the innocent eye that translates retinal images into naturalistic depiction. It is a hard-won achievement that takes talent and cultural supports.

ART OF THE YOUNG IN AGE AND HISTORY

A comparison of the art of children and Paleolithic artists reveals some similarities, but above all it reveals major differences in style and level of skill. Comparing the ontogenetic beginnings of contemporary children, whose environment provides an abundance of pictorial images and is generally supportive of their artistic endeavors, with the experiences of prehistoric artists, members of a hunter–gatherer society, can be instructive for our understanding of child and prehistoric art.

From the available evidence, which is detailed and well informed in the case of children and more truncated in the case of the prehistoric artists, it can be inferred that all beginnings are fumbling, crude, simple, and linear, whether this occurs at a particular historical point or in a later period as novices make their first efforts to produce art. In a general sense it appears that Leroi-Gourhan's Style I and perhaps also Style II are quite comparable to the early phases of representational development in children. Figural differentiation always begins with simple outline forms, which later become more detailed as well as structurally reorganized. In composition, there are also striking parallels in the patterns identified by Leroi-Gourhan: an early tendency to align figures, which appear to float on an imaginary horizontal axis; simple symmetrical arrangements (mirror symmetry); symmetry of mass with an equivalent mass on each side; and, somewhat later, the oblique symmetry of compositions that are diagonally aligned. Artists from both periods are not much concerned with the size and scale of the items depicted, although the internal proportions of the prehistoric artist's figures are much superior to those of children's figures.

The differences are most striking when we consider the style of depiction in the two-dimensional medium. Almost from the beginnings of the records of Paleolithic art forms that have survived, there is a distinctive tendency toward a naturalistic style of depiction that transforms the earlier, more schematic outlines into recognizable animal species. Of course the term *naturalism* covers a broad range of forms and by no means refers to a photographic kind of realism. Despite major differences in the talent with which parietal artists represented their objects, often dating from the same historical period and presented side by side in the same cave, the earliest parietal art dating from 32,000 BC already aims for a naturalistic depiction of its animals. Children, however, tend to adhere to the flat, two-dimensional and disproportionate child art style for most of the childhood years. The exceptions to this rule of spontaneously developing child art are the drawings of highly gifted children, for example, Eitan (described in chapter 1), and other artistically gifted children (Golomb, 1995; Milbrath, 1998; Paine, 1981; Pariser, 1995a; Warner, 1981; Winner, 1996). These highly talented children, having fairly rapidly mastered the simpler orthographic representational drawing systems, work incessantly to teach themselves more advanced systems that can depict the volume and three-dimensional aspects of objects. These children grow up in a culture rich in realistic images, and it is not surprising that the gifted ones endeavor to discover the rules of perspective displayed in photographs and book illustrations that enable them to create more realistic scenes. However, the overwhelming majority of children and adolescents who do not receive specialized instruction never reach this level of depiction and either abandon their pictorial efforts or stay at the level of their childhood art.

Despite the impressive pictorial achievements of highly gifted children at fairly young ages, their work does not approach the sophistication of the great Paleolithic artists: the expressive power of their animal images and their techniques to depict tex-

ture, posture, detail, and even animation. Paleolithic art is a cultural achievement of a style that was sanctioned over generations of artistic production. These achievements are beyond the level of gifted children before the end of their childhood years.

These two diverse sets of findings are instructive from the perspective of hypothetical developmental trajectories. Child art does not have a universal and uniform endpoint in optical realism or in any other particular art form. The style, theme, and medium valued by the sociocultural environment determine to a large extent the arts pursued at the end of childhood by those whose talents, motivation, and training destine them for a career in the arts. The finding that Paleolithic art, from an early period, aimed for a naturalistic depiction of its animal figures indicates that naturalism is only one of many diverse systems of representation that humans invent and find satisfactory for their purposes. Realism in art is not an inevitable outcome of developmental forces, and its decline at the end of the Ice Age, with its radical transformation in the Spanish Levantine narrative art, suggests otherwise.

From the study of child art, researchers have found that pictorial skills emerge gradually and lawfully; it is a sequentially ordered progression, at least in its early phases. From this perspective it can be surmised that the Paleolithic parietal and portable arts do not represent true beginnings, but more likely are the products of artistic mastery and of a mental capacity that exceeds the competence of the early and middle childhood years. A previously held notion, recently restated by Halverson, that a representation in a two- or three-dimensional medium is the product of the artist's mental image, is no longer a viable interpretation. From the study of the development of child art we have learned that children tend to use diverse models depending on the task, theme, and medium—clear evidence that the reference to a unified mental image as the source of the representational model is inadequate. The mental image hypothesis comes close to being a printout

notion of the mind but misses the very constructive nature of the creative process involved in the invention of representational concepts that mediate between the percept of an object and the constraints imposed by a particular medium.

Strikingly, children's early clay figures, although primitive in construction, are modeled in the round, as are the earliest known sculpted figures of animals and humans. Other similarities are equally intriguing, namely, the tendency to omit facial features, to model hair at times quite elaborately, and to omit arms. In sculpture, the omission of facial features does not strike us as a "deficiency," but as a deliberate emphasis on the structure of the body unencumbered by competing facial features. Later historical periods have seen increasing schematization of the figure and its reduction to two dimensions, once again an indication that there are many viable and alternative representational methods, and that the notion of a linear development from one- to two- and then three-dimensional portrayals in sculpture is a theoretically derived model that does not account for the actual historical developments. Three-dimensional conceptions appear to underlie all representational art, but the means by which such a conception finds expression in two- and three-dimensional media differ significantly across regions, eras, cultures, and developmental level.

Artistic conceptions that are meaningful to the members of a community tend to become the dominant mode of representation, which assures continuity in terms of themes, styles, and their refinements that is so evident in Paleolithic art. Along with conservative tendencies, there are historically significant discontinuities that represent a radical break with established conventions that no longer answer the needs and concerns of the artists of a community. Such a break with tradition occurred at the beginning of the 20th century; it encompassed the rejection of realism in painting and sculpture, a search for new forms, and a fascination with the language of child art, a topic I take up in the next chapter.

CHILD ART AND THE MODERN ARTISTS

The revolution that swept over the art world at the beginning of the 20th century was based largely on a rejection of long-established Western artistic traditions rooted in naturalism. Although the individual artists and the movements they represented differed, there was a striking affinity between the paintings of the modern artists and the paintings of children, a reflection of their interest in child art and their familiarity with it. Along with a rejection of established artistic pictorial conventions came a desire to return to a simpler and more direct mode of experiencing the world and representing it with the sincerity and freshness that they attributed to children's art work. At different times in their lives, artists such as Léon Bakst, Marc Chagall, André Derain, Raoul Dufy, Wassily Kandinsky, Ernst Ludwig Kirchner, Paul Klee, Mikhail Larionov, Lionel Feininger, Johannes Itten, André Masson, Joan Miro, and Gabriele Münter were clearly influenced by the style of children's drawings, which is most pronounced in Klee's work and somewhat later in the art of Jean Dubuffet. Many of the artists treasured their own childhood works, which they had preserved, and they also collected the drawings of their friends' children (Fineberg, 1997, 1998).

These artists' interest in child art coincided with their discovery of African and Oceanic sculptures, which gave a new impetus to their anti-academic and anti-intellectual stance. What sparked their fascination with child art? What aspects of this work engaged the artists, and what meanings did they attribute to the child's relationship to his or her work? Indeed, how were their own aspirations related to child art, and what did their adoption of a childlike and more primitive style signify? To answer these questions, I explore the influence of the so-called *cult of childhood* that flourished in the 19th century.

The cult of childhood has many sources, but one of its most influential figures is certainly Jean Jacques Rousseau, who attacked the value of established educational practices and promoted the view that culture corrupts the intrinsically good nature of the child (see chapter 1 for a discussion of Rousseau). In the 19th century, it became fashionable to contrast nature and culture, to assume the innate goodness of children and attribute their fall from grace to an enforced enculturation that ignored the natural stages in their development. Toward the end of that century, there is a shift from a purely abstract concern with "childhood" to a study of actual children and their physical and mental development. It is also during this time that the first baby biographies appear, among them Charles Darwin's observations on his first-born child and the first publications on children's drawings.

The modernist revolution in the arts has its antecedents in the late 19th century. These are most pronounced in Paul Cézanne's innovations, his color composition, geometrization of landscape, and indifference to linear perspective; in Vincent van Gogh's emotion-laden brush strokes and use of bright and pure colors; and in Paul Gauguin's technique of simplification, deformation, ornamentation, strong color contrasts, lack of perspective, and reduction of a scene to a single pictorial plane—to mention the most representative artists who broke with academic

traditions and went beyond the refinements of the natural landscape of the impressionists. Among these artists, the influence of Rousseau's philosophy is most pronounced in Gauguin's case, in his rejection of urban civilization, his desire for a simple, more natural lifestyle of people living in a "state of nature," which he expressed in his art and mode of living.

Not long thereafter, in the beginning of the 20th century, artists discovered primitive and child art, and in many cases the two were seen as representing beginnings, pointing to a common artistic origin. Primitive art, which referred mostly to African and Oceanic sculptures, played a major role in the evolving conceptions of the Fauves in France. In the case of Henri Matisse, a central figure in this movement, the impact of primitive and child art can be seen in the simplification of unmodeled forms that were inspired by the flat contours of children's drawings and their undifferentiated use of color. Matisse and André Derain studied the drawings of children to discover their original perception of the world and to recapture the freshness and innocence of their art. Pablo Picasso, too, was immensely interested in child art. Childlike images appear relatively early in his sketchbooks and continue to play a significant role in the sketches for paintings and sculptures made in his later years (e.g., the childlike sketches for his horse in his famous painting *Guernica*). He was fascinated by the drawings of his own children, especially during their early years, and spoke about the "genius of childhood" as a highly creative period that vanishes once children grow up.

The influence of child art was most pronounced on the members of two organizations of artists, the *Brücke* and *Blaue Reiter* in Germany, especially the artists that constituted the *Blaue Reiter* (Goldwater, 1986; Rubin, 1984). In their different styles, these artists favored the flatness of pictorial space, simplification of forms and their distortion, and the use of primary contrasting colors. They avoided modeling and emphasized the stiffness and lack of individual expression of their figures. In their quest for a more authentic language able to penetrate below the surface of reality to a deeper, more truthful layer, they sought inspiration in the works of children and of "primitives" (as they understood the term) and often

sought out the art of people with mental illness. In terms of the artists' affinity to child art, Kirchner explicitly stressed the connection between his childhood drawings and his adult art, as illustrated in a series of woodcuts modeled on his preschool drawings of a train. Münter, Kandinsky, and Klee were among the artists who deliberately used children's artworks as models for their variations on the child's theme. Respect for child artists found expression in the many illustrations of children's drawings that were published in the journal of the *Blaue Reiter* (Fineberg, 1997).

For these artists, the language of naturalism was inadequate to express the intensity of their often violent and destructive emotions, which the expressionist painters of the *Brücke* considered to be at the core of human nature. Their concern was not with beauty but with their perception of truth. For Kandinsky, Franz Marc, and Klee, members of the *Blaue Reiter*, the search was for a pictorial language that could express the spiritual needs of humans, and they turned to the language of child art to come closer to the inner truth and harmony of things. They thought of the child as a being endowed with a superior vision and an ability to express feelings with sincerity. Thus, the turn to the language of child art was an attempt to recapture some of the freshness and innocence of the child's perceptions and to revitalize the artist's creative spirit. Altogether, the belief in the restoring capacity of child art had strong mystical overtones.

This interest in children's drawings was felt widely in the work of diverse artists. It could be seen in the childlike images of the surrealist painter Joan Miro and in Marc Chagall's paintings of a child's fairytale world of fantasy and wonder, executed in a style that deliberately ignores scale and uses transparencies (X-ray pictures) and colors that enhance the dreamlike quality of his themes.

THE CULT OF CHILDHOOD: THE CHILD AS ARTIST AND SOURCE OF INSPIRATION

The concept of childhood as an identifiable and distinct stage in human development appears relatively late in Western history. According to Ariès (1962), until the 17th century, children younger than age 7

years were seen as infants unable to understand the adult world with its rules and demands for manners. A child who had reached age 5 or 6 was deemed ready to leave his or her mother or nurse and attend school. At first schools served only the upper classes, but soon charity schools for the poor or lower classes were founded. The children of the poor might attend these schools for a few years, after which they were most commonly apprenticed to a master craftsman in whose house they lived as servants. In the 18th and 19th centuries, the lower classes disappeared from the secondary schools of France and England, which became the exclusive domain of well-to-do families (Ariès, 1962). The children of the poor were sent to work, and in the 19th century it became common practice to employ them in factories and mines. The Factories Inquiries Committee in England issued in 1833 a report on child labor in which the majority of its members concluded that a 12-hour workday was not harmful for children. Given this view on child labor, it is not surprising that laws that limited the number of hours a child could work daily were enacted fairly late. In the United States, the Fair Labor Standards Act of 1938 set the minimum age for employment at 14. Thus, family, social, and economic forces determined that children of the lower classes entered the adult work force at a young age, despite the newly evolving ideas about childhood as a stage between infancy and adulthood.

These harsh conditions for the children of the poor coexisted with the newly evolving conceptions of children and childhood, usually attributed to the writings of Rousseau and his followers. With their writings came a concern with educational methods that would foster the development of a more enlightened human being. That these views were not limited to educators can be seen in the writings of poets and artists who evoked the image of childhood as a period of creative inspiration, rich in imagination, with an unspoiled perception of truth and beauty. This vision of childhood found expression in the work of the Romantic poets of the 19th century, who extolled the child's innocence, which they took to be a mark of "genius." In their desire to free themselves from the burden of civilization's constraints, the poets promulgated a return to a more

natural state, the state of childhood and of the origins of humankind. Conceptions of childhood and of primitive humans tended to merge, and notions of childhood as a recapitulation of humankind's early stages of mental development became popular (Häckel, 1874).

Much was written about this hypothetical early stage in a child's development but, with few exceptions (see Töpffer, 1848), little attention was given to what children actually drew or to their narratives. The gap between the idealized version of childhood and the behavior of real children was too wide. Only at the end of the 19th century did artists, among them the artist and educator Franz Cizek, actually examine children's drawings. Cizek was one of the first to appreciate the aesthetic quality of child art, and in 1897 he established special art classes for children.

The cult of childhood that had flourished in the 19th century (Boas, 1966) reached its full impact on the artists of the 20th century. It coincided with the newly formulated depth psychology of Sigmund Freud and Carl Jung that stressed the enduring significance of the childhood years for later development and highlighted the nature of a human's infantile desires, impulses, fears, and primitive thought processes that continued, often subterraneously, to affect adult life. It also coincided with the scholarly pursuits of academic psychologists intent on studying the nature of the child and children's mental development.

Given this preoccupation with childhood and its relationship to the adult's mental and emotional life, it is not surprising that many modernist artists, at the beginning of the 20th century, turned to their own childhood works and to the drawings of their children and those of their friends. Several artists, among them Kandinsky, Münter, and Klee, established significant collections of children's drawings and studied them extensively. Unlike previous generations of artists who at times included a child's drawing within their own paintings to contrast its primitiveness with their own skillful rendering (e.g., Giovanni Francesco's portrait of a boy, ca. 1520), the modernist painters came to appreciate the aesthetics of child art. So long as the imitation of reality was the goal of the painter, child art of course fell short

on all dimensions of artistic evaluation. But the modern artist who rejected the imitation of external reality and strove to depict the inner life of deeply held feelings, saw in child art a key to access the internal world. Child art was now seen as a primal language, the language and feelings of their lost childhood—a childhood remembered, imagined, desired, or reconstructed.

What the artists valued above all was the spontaneity and freedom from conventions that characterize child art. Propelled by their urge to represent their thoughts and feelings simply and directly, the artists saw in child art the expression of an unspoiled artistic vision, the carrier of an inner truth to which they could resonate. In their enthusiasm for child art, they endowed the child with an inquisitive mind, a superior perception of reality, and a rich imagination able to penetrate the mysteries of nature and see things without prejudice as they truly are. This notion of "original vision" might refer to optics of light projected on the retina or more metaphorically to the freshness of seeing things for the first time. Implicit in this view is the notion that acquired knowledge and skill interfere with this primordial, intuitive state of mind.

When looking for a new way of artistic expression with the ardent desire to be freed from acquired traditions, where can one turn if not to one's beginnings in childhood? This search can take different forms in the arts, for example, in the works of Münter, Kandinsky, Klee, and Feininger. Münter studied children's drawings very carefully and frequently transferred the child's model unchanged to her canvas. As Fineberg (1997) demonstrated, Münter made nearly exact copies of children's houses using the dark outlines, bold colors, and flattened forms that are so characteristic of children's drawings and paintings (Figure 98a–b). For Kandinsky, child art had a spiritual meaning in that the child ignores external reality and expresses an internal state of mind that directly speaks to the viewer. In Kandinsky's art, the child's model inspired the simplification of form and composition of his colorful abstractions, the deliberate disjunctures of scale and space, and the discontinuities of viewpoint that yield isolated figures floating in an undefined space (Figure 99a–b). The disruption of narrative coherence and

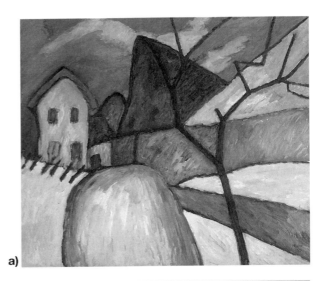
a)

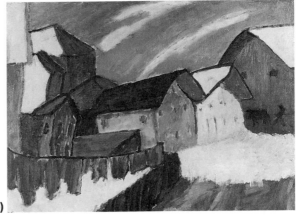
b)

FIGURE 98. a. Gabriele Münter, *The Blue Gable*, 1911. Oil on canvas. *Note*. From the Krannert Art Museum, University of Illinois, Urbana Champaign. Copyright 2001, Artists Rights Society (ARS), New York/ VG Bild-Kunst, Bonn. Reprinted with permission. b. Gabriele Münter, *Village Street in Winter*, 1911. Oil on cardboard on wood. GMC 664. *Note*. From the Städtische Galerie im Lenbachhaus, Munich. Copyright 2001, Artists Rights Society (ARS) New York/VG Bild-Kunst, Bonn. Reprinted with permission.

the discontinuity of viewpoint were meant to evoke a deeper underlying emotion and meaning. Kandinsky saw in child art a universal graphic language that enables the artist to gain access to his or her inner spiritual consciousness.

Among the modernist artists, Klee engaged in the most extreme reduction of forms and most consistently adopted the style of children's drawing with

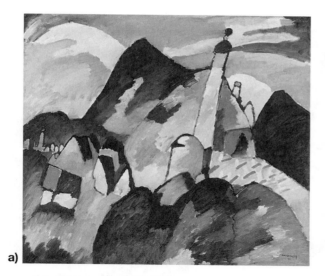

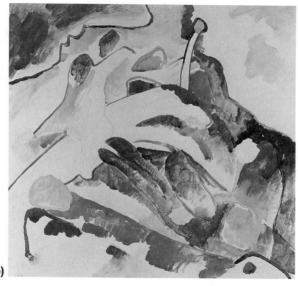

FIGURE 99. a. Wassily Kandinsky, *View of Murnau With Church*, 1910, oil on canvas. *Note.* From Stedelijk van Abbe Museum, Eindhoven, the Netherlands. Foto Peter Cox. Copyright 2001, Artists Rights Society (ARS), New York/ADAGP, Paris. Reprinted with permission. b. Wassily Kandinsky, *Sketch for Composition II*, 1910 (also titled Two Riders and a Reclining Figure), oil on canvas, GMS 353. *Note.* From Städtische Galerie im Lenbachhaus, Munich. Copyright 2001 Artists Rights Society (ARS), New York/ADAGP, Paris. Reprinted with permission.

of children's drawings but commentary on what engaged the artist. By immersing himself in the content and style of the drawings he had made in his childhood years, and somewhat later in the drawings of his son Felix, Klee hoped to reenter the mental state of his younger self and draw on its mood for his adult creations. Klee assumed that the technique of child art might give him access to an *in-between world* shared by children, madmen, and savages that "exists between the worlds our senses can perceive" (Klee, 1964). One senses in his work and diaries the need to return to primal beginnings, a personal quest for identity reflected in the childlike figures that represent the artist in different phases of his life, refer to diverse events, and express his changing views of the world in which he lived. If in his early years Klee tended to idealize the innocence of childhood and its pure expression in children's drawings; in his last years, according to Werkmeister (1977), he revised his attitude and also depicted children as metaphor for corruption and violence. Of course, keep in mind that despite the deliberate adoption of certain childhood characteristics in their drawings and paintings, these artists were experts in their field and not novices like children. Child art became a source of inspiration for these artists who could maintain the duality of living in two worlds while aware of the distance that exists between the adult and the child. Perhaps one can speak here of a controlled regression to recapture the intensity and truth of the child's perceptions.

Thus, child art inspired these and other modernist artists in their search for meaning and authenticity, and it became the starting point in their exploration of the medium and the creation of a new vocabulary of forms, colors, and composition. As Fineberg (1997) pointed out, artists in the years following World War II continued to be influenced, more or less consciously, by child art as illustrated in the work of the COBRA (an acronym for Copenhagen, Brussels, and Amsterdam) artists from The Netherlands, Belgium, and Denmark; Dubuffet in France; and Mark Rothko, Arshile Gorky, and Jackson Pollock in the United States. This interest in child art was sustained by the artists of subsequent generations and aided them in their search for origins, whether in the form of a primary spiritual

its whirls and scribbles, tadpoles with huge heads, stick figures, and creatures with triangular or hourglass bodies that populate his unique compositions (Figure 100a–c). These compositions are not copies

FIGURE 100. a. Paul Klee, *Human Helplessness*, 1913, pen and ink on paper mounted on cardboard, No. 256 (937). b. Paul Klee, *When I Was Still Young*, 1938, black paste on paper mounted on cardboard, No. 1252. c. Paul Klee, *Dancing From Fear*, 1938, watercolor on paper mounted on cardboard, No. 122. *Note.* From Paul Klee-Stiftung, Kunstmuseum Bern. Copyright 2001 Artists Rights Society (ARS), New York/VG Bild-Kunst, Bonn. Reprinted with permission.

quest; belief in the primacy of the child's emotions, perceptions, and desires; or deliberate regression to a preverbal level of gesture and touch. What these artists have in common is an abiding respect for the child's creations. However, what was revolutionary in the early decades of the 20th century became, according to Fineberg (1997), part of the visual experience that artists since the 1950s have taken for granted. The modern artists' fascination with the mental life of the child and their views of the child as artist and of the artist as child, raise the question of the relationship between their philosophies of childhood and contemporary psychological perspectives.

PSYCHOLOGICAL PERSPECTIVES ON CHILD DEVELOPMENT

In their efforts to reconstruct childhood and to provide a valid picture of the child's nature at the different phases of its development, psychologists have composed narratives that reflect the concerns and viewpoints of their creators. So there are Piagetian and Freudian child models and, of course, variations and revisions of their respective positions. It is im-

portant to acknowledge that even the scientific approach to the study of childhood fails to deliver the "real child," that is, childhood as experienced from the perspective of the subject, and that at best the fictional child of literature and science makes sense to its generation of parents, teachers, and professionals. With this qualification in mind, I review several currently dominant conceptions of childhood and development.

The Piagetian Child

Piaget has rather sharply distinguished between the early childhood years that characterize the preoperational period—from ages 2 to 7 years—and the concrete operational period that follows it and extends to the middle and late childhood years—from ages 7 to 11 or 12 (see chapter 1 for a discussion of Piaget's theory). From ages 2 to 4, children acquire the symbolic capacity to use language, evoke images, engage in make-believe play, tell stories, report on dreams, sing songs, dance, imitate absent models, and make their first gestural scribble drawings (Piaget, 1926, 1928, 1929, 1951; Piaget & Inhelder, 1956).

The younger child lives in an almost magical world where every object is endowed with intentions and feelings, where animism holds sway, and where the child's mental and emotional life is experienced as continuous with the rest of the world in which everything participates in the same emotion-laden realm of thought, desire, and feeling. Piaget described the mental world of preschoolers as suffused with egocentricity, the inability to distinguish between their own point of view and that of others. It is an emotional world where wishes rule supreme and where children in symbolic play themes reorder the world according to their needs and the desire to escape the dominant power of the adult. Children attribute their fears, wants, and intentions to everything around them, especially to those phenomena they cannot directly control. Prelogical reasoning aids children in their effort to make sense of encounters with the observable world, a form of thought where, according to Piaget, everything can be connected with everything else, where everything has a simple cause in wishes and intentions, and contradictions are readily ignored.

To the preschool and kindergarten children, dreams are real events that occur in the bedroom, in front of their eyes; they come from the outside, through the open window or on the wings of birds. In the early years, the world is one of almost endless possibilities, with the preschooler's gender identity not yet fixed, so that a wish or prayer may still turn a girl into a boy or vice versa. The child is a realist in the sense that the appearance of behavior, hairstyle, and clothing determine gender and that the amount of damage one has done determines the degree of naughtiness regardless of intentions. The great mental divide that separates animate things from inanimate ones, that separates physical from psychological events, that differentiates between subjective and objective realms, that distinguishes between what can be known and that which is unknowable will transform this world. A growing intellectual detachment eventually deprives adults of our naive sense of harmony and belonging to this world; this detachment occurs in the transition to concrete operational reasoning where logic and reasoning begin to hold their sway. From now on children will examine nature as distinct from their being

and will measure, calculate, analyze, and categorize objects according to their qualities and quantifiable attributes.

Gradually, the child will be able to consider multiple perspectives, inquire into the rules that govern games and social relations, deanimate the physical world, and abandon his or her earlier intimacy with nature. As scientific curiosity begins to dominate the growing child's relation to the world of inanimate objects, and to some extent also to the world of plants and animals, the earlier poetic union is lost or deliberately abandoned. Only the poet at special moments is able to recreate the earlier felt communion with nature and to revitalize this connection, but Piaget did not address the artist or the artist's creations. The earlier period, which seems so rich in fantasy and imagination, appeared to Piaget as undisciplined thought, incapable of monitoring its own processes, subject to the superficial impressions generated by sense perceptions and not yet screened through a reflective intelligence. Thus, development proceeds from a somewhat erratic and prelogical intelligence to rational thought that subjects its mental processes to experiment, empirical verification, and logical consistency.

Piaget Reassessed

Piaget's profile of the preschool child's immature mind and its many deficiencies has, of course, not gone unchallenged, and diverse studies have provided compelling evidence for cognitive competencies Piaget did not anticipate. Studies have shown that four-year-olds do have some insights into their own minds and those of others, that they understand that intentions and wishes lead to actions, and that people can have different intentions. They often refer to their thoughts or minds as causes of action and emotion; they can engage in trickery, deliberately mislead someone and, in a meaningful context, seem to understand that people can entertain a false belief. They often distinguish between information that is available to them and not to another and emphasize the difference between "reality" and "pretense." Their pretense play behavior indicates that it is not an arbitrary act but a rule-governed activity that can be shared with a play partner. When condi-

tions are personally relevant, the child can adopt the perspective of another, show empathy when someone is hurt, and understand what actions might remedy the situation. The portrait of this reasonable and thoughtful child is a far cry from the Piagetian preschooler enveloped in his or her egocentric universe. One might see this revision as a kind of rehabilitation of the young child (Aronson & Golomb, 1999; Golomb & Galasso, 1995; Golomb & Kürsten, 1996; Leslie, 1987; Perner, 1991; Sullivan & Winner, 1993; Wellman, 1990).

The Freudian Child

In the psychoanalytic account of early development, the emphasis is on the emotional life of the child who is beset with conflicts that are of an intrapsychic as well as interpersonal order. In Freud's view, humans are endowed with a complicated psychosexual constitution, and the journey from childhood to adulthood is precarious and beset with difficulties. In this account it is inevitable that some of the child's deepest wishes and desires will be frustrated, and they need to be delayed and sublimated into behaviors that are socially acceptable. Thus, for example, the child's love for his or her parents brings frustrations, fears, anger, and aggression, and its free expression poses the risk of retribution, which calls for some inhibition of these impulses. For development to proceed normally, the child's love for the parent of the opposite sex needs to be modified or even repressed, and instinctual desires will have to undergo considerable transformation before they can be integrated into forms of behavior that are deemed socially appropriate for the adult. Issues of sex, where babies come from and how they are born, dominate those preschool years, along with intense feelings of rivalry with siblings and aggression toward them. Along with these feelings come fears of abandonment, of harm to the self, and of the threat of dying. Nightmares are quite common during these years and reflect the child's concern about his or her safety, insecurity and feelings of badness, and fears of punishment for not meeting the parents' standards of goodness.

Of course this rather pessimistic view has also undergone revision, with a newer emphasis on the child's desire for competence and a genuine pride in growing up. This child not only is seen as bemoaning old losses, such as weaning from the breast and the stress of toilet training, but also seems to have a stake in graduating to new and more autonomous sorts of behavior. Above all, the emphasis seems to have shifted from a preoccupation with stage-specific instinctual needs and desires to a concern with relationships.

Attachment and the Social Child

The socialization of the Freudian child is a somewhat drawn-out process; he or she begins as a being mostly concerned with the gratification of its libidinal desires and then comes to love the mother as a function of her nursing and care-taking role. The mother is the first love object, and relations to the siblings are characterized by rivalry and aggression —emotions that are only slowly tempered and perhaps never completely overcome. Children are seen as selfish; their needs dominate the evolving personality and their behavior. Morality is born out of the conflicts that characterize the oedipal period, ages 3 to 5 years; it is the outcome of fierce contradictory feelings about the parents and results in a compromise formation that reestablishes emotional balance. Children renounce the instinctual desires; identify with the parent of the same sex; and incorporate the parent's values, strictures, and norms into their developing conscience.

This somewhat stark view of the social nature of the child has been modified in the writings of John Bowlby and kindred analysts who have reformulated the nature of the child's tie to his or her mother and stressed the universal importance of attachment. Under the influence of Harry Harlow's work on love in Rhesus monkeys and the work of major ethologists on imprinting in birds, and the documentation that basic human expressions such as smiling, crying, and babbling are universal across cultures, Bowlby revised the psychoanalytic theory of the origin of the bond between mother and child and formulated his ideas about the basis of human social relations (Bowlby, 1958, 1969; Eibl-Eibesfeldt, 1975; Harlow, 1958; Lorenz, 1952; Tinbergen, 1951). He proposed to view this relationship within an evolutionary framework that postulates an intrinsic fit between

behaviors the infant emits and to which the mother responds. Such behaviors include sucking, clinging, smiling, crying, and following, which are designed to enhance the proximity between the mother and the child as social partners whose interaction provides the basis for their mutual attachment. The biological function of attachment behavior in the infant and reciprocal maternal behaviors protect the infant from danger and enhance its chances for survival.

Thus, from the very beginning of its life, the infant is perceived as a social creature with well-developed social tendencies to engage the mother and to interact with her; no longer is she seen as a creature propelled by instincts in search of an object that can reduce bodily tension. In Bowlby's account, attachment behavior and its successful outcome promotes healthy development. Severe impediments such as losses, neglect, or abuse predict pathology. One might say that Bowlby replaced Freud's complex evolution of instinctual impulses and their transformation via sublimation or defensive mechanisms with his emphasis on attachment formation and its fate in development. The Freudian account is subordinated to Bowlby's primary emphasis on attachment and the role of love.

THE RATIONAL AND EMOTIONAL CHILD: A CONTEMPORARY VIEW

The foregoing review of the mental life of the child provides contrasting portraits, a reminder that researchers tend to see and then study phenomena that attain a certain credibility at a particular time and place and thus reflect the zeitgeist. Are these portraits irreconcilable, merely the product of cultural relativism, or do they provide more enduring insights about the human condition and how this is played out in childhood? To begin with, it is necessary to emphasize that childhood in contemporary Western societies is a long, drawn-out process of schooling and dependency on adults. Of course, factors that affect these youngsters may not apply in cultures where childhood ends at ages 7 or 8 and the child is supposed to provide income in some form. With this qualification in mind, I turn to a brief review of what is known from the studies of

children, conversations with them, and other forms of observation.

There seems to be a general consensus that certain cognitive competencies emerge earlier in young children than Piaget predicted. Research on children's understanding of minds, dreams, intentions, false beliefs, feelings, and wishes, as well as their ability to communicate with peers, indicates a more sophisticated and differentiated approach to mental phenomena, as distinct from physical ones, than Piaget assumed. In terms of the child's social and moral tendencies, the human child displays not only aggression but also prosocial behaviors such as empathy and even altruism. The desire to grow up, to be autonomous, coexists with the need for dependency and the tendency to engage in regressive behaviors. Despite the new contours of the portrait of the rational child's desire to understand cause and effect, and his or her competencies in many domains, the child's concerns first outlined by Freud and his followers are also clearly in evidence. This can be seen in curiosity about birth and sex, worries about dying, anger at a younger sibling who has "replaced" the older child, and resentment and aggression that inevitably result from the state of dependency and parental demands. The child's intense need for love and affirmation conflicts with the desire to be autonomous and with the temptation to challenge the authority of the parent.

Despite considerable progress in logical reasoning and some decline in the belief in magical creatures and their powers, the five- or six-year-old child who knows that fairies and witches exist only in fairytales, that they are "pretend" creatures and thus not likely to be encountered in real life, can be acutely afraid of witches when at night alone in bed. When I inquired of Mali, age 6, whether she still woke up afraid of witches and ran to her parents' bed for safety, her reply was, "I don't need this anymore because mom has told me that Tara, our dog who lies in front of my door, would bark and scare the witch away." This reaction comes from a very logically reasoning child whose fears can be assuaged only by references that make emotional sense. Other four- and five-year-olds may express intense fear of masked people even though they know that it is only a game, part of a festival, and that the mask

can be removed to reveal a friendly person underneath. The strength of this emotional response indicates that there is more to childhood, and perhaps to adulthood as well, than the ability to reason from premises, to verify conclusions, and to ask for evidence. Children may well be aware of the so-called unreality of their fears but nevertheless assign priority to their emotions.

Thus, for example, Evie, age 5, is afraid of television programs that show some fear-evoking themes, however limited. She explained that "the picture gets into my mind, it stays there, I can't get rid of it, and it will come back in my dreams." She thus takes precautions to avoid such material. Similarly, Sam created a pretense play scenario of giants; he scares himself with his imaginary invention, repeatedly cancels the theme, denies the giant's presence ("no, there is no giant"), only to resurrect and then eliminate it (Golomb & Kürsten, 1996). Children search for meaningful solutions to their dilemmas, as the following example highlights. A five-year-old who saw a film about the birth process promptly declared that she would never have a baby, despite the fact that she plays for many hours mother to her doll-children and is quite passionate about them. Several weeks later, after seeing a musical about Annie, an orphan who is adopted by a kindly man, she inquired whether there are also babies in orphanages. Given an affirmative answer, she decided that she would adopt babies, a creative solution to an issue that had engaged her for many weeks.

Children evoke the theme of death and abandonment recurrently, especially in regard to themselves and their parents. There is the fear that the parent may die and the child would have to manage his or her affairs alone, the dubious consolation that the older sibling will die first, and the uncertainty that the parent can protect the child from random violence as depicted on the news. Thus, the many emotional concerns highlighted by psychoanalytic writers comprise a major part of the child's waking and dreaming life. Of course, this is not only a story of woe, and children also like to tease, make fun of the adult's errors, play with words and puns, invent imaginative metaphors, play jokes, enjoy "disgusting" references (e.g., to anal activities), and find this enormously amusing.

An often-neglected aspect in the study of children's mental life concerns their curiosity and the many questions the young child entertains that may become the mainspring for later creativity in science and art. Rejecting a view that emphasized the child's conceptual deficiencies, philosopher Gareth Matthews (1994) took the young child's philosophical questions seriously, and psychologist Howard Gardner (1993) considered the childhood years a time for the imagination to roam freely and to pose the eternal questions of existence. All children raise questions about the physical world and about social relations that are deeply puzzling: whether the moon follows the child at night, the rising and setting of the sun, the force of gravity and why people don't fall off the earth, the behavior of a compass, sexual relations, and relations with siblings. Some children persist in their questioning and find the answers routinely supplied not satisfying. Their need for understanding, for going beyond conventional explanations, may lead to productive pursuits in adolescence and adulthood. This view of the intrinsic creativity of the child's mind has been extended to the realm of the visual arts in Gardner and Winner's proposal that the productions of four- to six-year-olds are aesthetically superior to those made by older children, who struggle to learn the artistic conventions of realism (Winner, 1982). A similar position is espoused by poet Korney Chukovsky (1971), who admired the linguistic genius of the young child and its creative inventions.

To what extent does this rather complex portrait of the human child match the images of childhood that can be discerned in the writings of many modern artists? Extensive studies of children's evolving personality, cognition, and understanding of social relations provide evidence for the sincerity of their beliefs, the intensity of their experience, the depth of their feelings of right and wrong, the passion of their art making, and their search for making sense of the world. Of course, the return passage of the adult artist to childhood memories and experiences is not equivalent to being a child in the actual context of its life. All children at some moments in time want to grow up and acquire the competence, freedom, and authority of the adult. The child's mental life reflects both the day-to-day reality of the present

time and the future course as anticipated and imagined. These two trajectories of the child and the adult may intersect, but they are not identical.

THE APPEAL OF CHILD ART

The devaluation of long-established academic traditions that extolled realism or naturalism as the highest achievement of artistic creation coincided with an increasing alienation of the artist from social institutions. Artists turned inward in a process of self-evaluation and exploration of the artistic impulse and its goals. No longer was imitation of the external world a desired objective; no longer were artists intent on creating on canvas an illusory appearance of the three-dimensional world. Instead of representing the beauty of the natural world, artists searched for *truth*.

The cult of childhood led to the revival of various recapitulation theories that depicted the child as passing through distinct evolutionary stages. It encouraged artists who no longer found meaning in established styles to search for their own authentic beginnings; it legitimized the desire to reexperience their childhood self and made regression respectable. Along with this shift in values and aspirations came a rediscovery of the two-dimensional characteristics of the pictorial medium and what it could contribute to a newly evolving aesthetic. With the traditional standards destroyed, child art could be viewed within a changing artistic conception.

I now return to an issue previously introduced, namely, the appeal of child art to the modern artist and the consumer of art, and I explore the relationship between the artist's construction of the nature of childhood and its expression in the child's creations. Once again I attempt to identify the characteristics of the child art style that engage the modern viewer.

As previously seen, child art emphasizes the flatness of the drawing or painting; its simple lines and irregular contours create disproportionate figures whose bright, unmixed colors evoke an unmediated emotional response in the viewer. The drawings are simple, unrefined, and unfinished-looking products, often endowed with colorful designs that clearly do not replicate reality. They appeal to the symbolizing adult, who probes this work for its subjective meaning. Not distracted by technical virtuosity, the viewers are drawn into an in-between world while trying to decipher the child's mind and meaning, which remain elusive and somewhat enigmatic (see Figures 10, 22a–b, 23a–b, 24a–b, 25, 40, 45, 47). We are fascinated by these figures with their large heads and huge eyes whose generic expression seems to reveal an internal state of the child's mind and soul. The lack of perspective in these works enhances the immediacy of the effect; there is no psychological distance between the viewer and the drawing, or so it seems. The unintended irregularities of the figures suggest spontaneity, freedom, directness; nothing is withheld, and nothing diverts our attention from the subject portrayed. Because the child artist has not, and cannot yet, divulge his or her full meaning, the viewer must complete the process of interpretation, which calls for active engagement. Perhaps the naive expectation that a child's drawing should consist of conventional forms, and the discovery of untaught archaic forms, also captures the attention of the viewer, especially the artist. The large figures aligned on an imaginary line do not represent a familiar scene; they appear as characters from another life, as carriers of a different meaning often embedded in the ornamental designs of a transfigured world.

But child art is not merely enigmatic; children's compositions use various techniques of centering and symmetry in the distribution of figures and the rhythmic patterning of colors, an indication of an early aesthetic that underlies their designs. Their art conveys their observations and even good-humored commentary, as can be seen in this drawing of a five-year-old artist going for a walk with her tall grandfather, more than twice the size of the little girl (Figure 46; see color insert). They intend to walk down the street, but the dog on a leash pulls the grandfather in the opposite direction. The grandfather is awkwardly bent backward as he tries to hold on to the dog. The scene, which also includes the wall of the garden, the street, and a bench, is set within a colorful dotted background that unifies the composition. This picture is full of life and humor despite the limited pictorial skills of the artist.

For these and other reasons, child art in its sim-

ple, uncomplicated, and colorful style appeals to the sensibilities of the modern artist. To the extent that this art form engenders in the artist a desire to explore the child's mentality, the act of drawing like a child and adopting its posture and expression of effort may well evoke images that relate to the adult's own childhood, a feeling of times past, of an earlier and sincere identity. For some artists this may indeed present an entry point into the emotional life of their younger self, to a time before analysis and training subvert the artist's sensibility and aspirations —in short, to a magical world that has been lost to the adult.

THE CHILD AS ARTIST: ANOTHER LOOK

The modernist artists, mentioned in the beginning of this chapter, alluded to children's perception as more truthful and to "seeing" the world differently, and they found support for this view in child art. How might the child's different view of the world find expression in his or her drawings? Suppose the notion that the child's experiences are intense, not yet modulated or repressed, and that the emotions refer to deeply felt events are accepted; how might these experiences be translated into pictorial form? This question calls for a review of the forms children's art takes as they gain experience with the medium and attain different levels of mental maturity. Before I proceed, keep in mind that not every scribble or brush stroke qualifies as the art of children, and the progression I will delineate characterizes children who love to draw and paint and who continue to explore the medium and develop their skills over long periods of time.

A tentative outline of the emerging style of child art and the developing skills of its practitioners suggests the following phases. In general, given access to the materials, four- to five-year-olds most commonly discover the relative ease with which they can create simple forms and figures. Children make discoveries, invent animate tadpole creatures, and engage in a good deal of playful exploration. It is quite magical to create on the blank page, out of nothing, creatures and other objects over which one can have some control. During this early phase of artistic development the child's intention is to create

forms that are meaningful and entertaining. Realism or the copying of nature does not enter the child's mind; it is an alien concept, utterly inconceivable, an idea that is not spontaneously incorporated into the child's representational conceptions.

Soon figures appear, often large ones, extending over the whole page, with each item presented separately, its individual existence acknowledged by declaring its identity as person, animal, house, plant, or other significant object. Very quickly children begin to align their figures on an imaginary horizontal axis, an alignment that suggests an intrinsic although not explicitly stated relationship. To meet the child's requirements, the figures ought to be recognizable, able to state what they are. Establishing their identity takes precedence over other dimensions such as size, which plays only a minor role, whereas side-by-side placement of the items declares the content and importance of the figures.

Somewhat later, five- to six-year-olds tend to introduce differentiation in the size and shape of their figure, to mark additional characteristics such as gender and perhaps the age of the referent. Although quite simple and primitive in appearance, these figures show a highly abstract thought process of visual thinking and problem solving in the pictorial domain. Children invent far-reaching equivalences and accept their dual nature, namely, that a figure is but a representation and not a real copy of the thing and that it can stand for the thing in some playful and tentative way. Beyond this representational act, children take pleasure in embellishing and adorning figures and their surround, selecting colors and shapes as ornaments. The initial indifference to size and color realism is not so much a function of "seeing" the world differently in a psychological sense or in terms of the optics of visual perception. It follows a graphic logic of representing items that are important enough to be included as equals, aided by an intuitive strategy of grouping by similarity of size.

It is not easy to make the case that the child, from a perceptual point of view, lives in a different world. Children are very observant about appearances and the emotions of other people; they can also scrutinize a picture and discover the hidden figures that are embedded in the design or irregulari-

ties that are not easily discerned. In general, their style of representation does not reflect a perceptual or a conceptual deficit; it is the pictorial judgment of a beginner who is developing a pictorial vocabulary of forms and colors and attempts to organize its elements in a meaningful way. This interpretation of the style of child art does not preclude an acknowledgment that children's understanding of their world is colored by their emotions and their stage-related conceptions; they see the world with freshness and experience it with intensity that is dimmed in the ordinary adult. Children live in a world of giants that tower over them, and it is reasonable to assume that their experience of themselves and their world is qualitatively different from that of the ordinary adult.

As narrative intent crystallizes, as the ambition to clearly portray an event becomes more pronounced, children are faced with new problems of composition and spatial relations: how to portray the passage of time; an ongoing event; and feelings of happiness, anger, and sadness. At this point the act of drawing and painting becomes more reflective, concerned with corrections and with learning from one's own experience and from the models of others. Older children become aware of the need to be more explicit in the depiction of relations; they now understand that mere proximity, alignment, or symmetry of arrangement does not tell the whole story as intended. Of course, there are significant individual differences in the style children perfect and in their talent and motivation, as I documented in chapter 1. With increasing age and cognitive competence, the culturally sanctioned models begin to play a larger role, and children pay more attention to the artistic styles valued in their community. This, however, is not the period that intrigued the modernist artists that was discussed previously, whose interest mostly focused on the early productions of young children. Many of these children were the offspring of artists and were talented and more experienced than their ordinary peers.

To what extent is the child artist akin to the adult artist, and can there be some degree of continuity between them? Child art is ahistorical; it is not reflective, not concerned with artistic traditions or conventions, and does not address the nature of the relationship between perception and pictorial representation that engages many artists. Child art does not break with tradition; it is in many respects self-contained and self-limiting. From this perspective, there exists a vast gulf between the child artist and the adult. Indeed, many art historians have emphasized the differences between the child and the adult artist, among them André Malreaux (1956), who stated that no painter ever progresses directly from his drawings as a child to his mature work. In his view, artists do not stem from their childhood but from their conflict with the achievements of their predecessors. Unlike the adult, the gifted child is not in control of his or her gift; it is this gift that controls him or her. Malreaux maintained that the art of childhood dies with the end of childhood.

Of course, no one can contend that the child's intentions and aspirations are identical to those of the adult and that the technical issues concern both to the same degree. However, as Arnheim (1974) pointed out, there are similarities in the significance and intensity of the emotion the child artist brings to his or her work, which is reminiscent of the adult artist. In the case of artistically talented children, the need to create can be intense; these children appear driven to draw and paint (Duncum, 1984; Winner, 1996). But beyond similarities in the motivation to draw and the time devoted to such an enterprise, art historians have identified continuities of style, theme, and its elaboration that date from the artist's childhood years. Thus, David Pariser (1995a) pointed to similarities in the art of the young Toulouse-Lautrec and Picasso and their more mature works, and other authors have identified additional characteristics (Staaller, 1986). Of course, Klee is a particularly clear example of an artist consciously searching for his connection with his child art style.

Our fascination with child art and the importance and aesthetic value attributed to its various forms have to be seen in their cultural context. As Diana Korzenik (1995) pointed out, the abstract paintings made by four-year-olds with fat brushes and drippy paint elicited a great deal of enthusiasm during the 1960s and 1970s, when art educators compared them to the works of the abstract expressionists that had dominated the art world after

World War II. Howard Gardner in his book *Artful Scribbles* (1980) popularized the notion that preschoolers paint like abstract expressionists and that their early work is more aesthetically pleasing than the art made during the middle childhood years, when children aim for greater realism and thus lose the spontaneity of the earlier period. In the following decades, artists paid greater attention to the older child, whose artistic conventions were patterned on cartoons and comic books, a practice praised by the art educators Brent and Marjory Wilson (1977, 1982), who encouraged this kind of enterprise. This devotion to cartooning received additional acknowledgment as other advertising techniques became fashionable, for example, Roy Lichtenstein's halftone dots from printer's images (Korzenik, 1995).

Does consideration of styles and their appreciation within a historical–cultural context diminish the attraction felt for child art or devalue its aesthetic? It seems to me that we recognize in the child's representational efforts a kindred spirit eager to make sense of its world, to create beauty and truth, and to transform the world in imaginative and highly personal ways. In this sense the modern artists recognized the sincerity of children's art and the value of giving expression, not always consciously understood, to their thoughts and feelings.

CHILD ART RECONSIDERED: NEW PERSPECTIVES ON ARTISTIC DEVELOPMENT

Child art, as all art, is a uniquely human endeavor, a testament to a fundamental capacity to represent the world in a visual and relatively permanent medium that leaves a tangible record of the artist's actions. As a symbolic activity, it has significant personal and social implications that affect communication with self and others.

To understand child art and its place in human development, I have situated child art and its ontogenetic development within a wider sociocultural and historical perspective, beginning with an account in the two-dimensional pictorial medium and the three-dimensional medium of clay. This inquiry into the beginnings of child art and its developmental trajectories has yielded new insights into its relationship to perception, cognition, motivation, and cultural factors. By focusing attention on the *processes* rather than the finished *products* by which children define their topic, monitor their activity, and judge their work, I discovered the inadequacy of the various deficit hypotheses that implicated conceptual immaturity as the main reason for the simple childhood drawings. Particularly illuminating are studies that keep the content constant while providing children with different representational tasks: drawing and modeling a person; completing unfinished figures; constructing figures out of flat, unmarked geometric shapes; drawing on dictation; and selecting the "best picture" out of a set of figures that vary in degree of detail (Golomb, 1973, 1974). The findings from these and related studies indicate that the child's underlying concept is quite accurate,

at times rich in perceptual detail that contrasts with the drawing of a simple tadpole figure.

CRITIQUE OF STAGE THEORIES

A modeled human can differ significantly from its drawn counterpart, which is simpler in structure than a figure constructed of flat geometrical shapes, and a dictation always includes more parts than the child's drawing. It is not likely that the child's underlying conception of the object, in this case a human, and his or her ability to evoke the image and its defining attributes changes markedly over a period of minutes or hours. The remarkable diversity of representational solutions offered by the same child, over the same time interval, provides a serious challenge to the conceptual theorists. Apparently, the young child defines each task according to some minimal structural requirements that are medium specific and depend on the tools at his or her disposal. Thus, the abstract two-dimensional medium of paper and crayons or felt-tipped markers can yield quite satisfactory tadpoles or open-trunk figures, whereas the modeled man or snowman is more likely to boast a trunk.

Likewise, a figure-drawing completion task of a head and facial features elicits differentiated humans that include a trunk, again an indication that children respond to the nature of the task and what they think it requires. When asked to select the best figure among a series ranging from tadpoles to graphically more differentiated figures, children who draw a so-called conventional figure composed of

head, trunk, and limbs often select an open-trunk figure, claiming that they like its "slim body." In general, kindergarteners prefer more differentiated figures and scenes than the ones they draw (Golomb & Helmund, 1987). These examples militate against a simple or generic version of the *internal model hypothesis*; they suggest that the underlying concepts are quite accurate and that children translate them into workable models, depending on their definition of the task, the nature of the medium, and the whims of the moment.

If we also consider the art of the Anasazi and of the Mesolithic artists of the Spanish Levant, all of whom were functioning adults, it does not seem likely that perceptual or conceptual constraints are directly responsible for young children's primitive drawings. Children, like all novices, tend to use forms economically, and their comments indicate that their simplified version will have to do. There is a significant gap between the child's knowledge and a performance that requires the monitoring of drawn forms, labeling them, remembering the assigned meaning, and organizing the emerging figure both spatially and temporally. To the extent that drawing is a pleasurable activity initiated by the child and under his or her control, the drawn figure has to meet, at first, only minimal standards of likeness that afford identification. The notion of making a "copy" is as yet a truly alien conception, and in the history of art it is mostly associated with the artists of the Renaissance and their followers. What changes with development is the growing repertoire of forms, differentiated use of line, and inclusion of more detail—all of which enable the child to communicate his or her intention more effectively. Depending on the child's inclination, he or she can create a better likeness to the model or accentuate decorative and expressive qualities that enrich the drawing, tendencies that in Western societies may lead to greater realism in the portrayal of a scene.

For children who are motivated to draw, paint, and model, there is a developmental progression toward greater competence that, however, need not be synonymous with optical realism. For some highly dedicated drawers, such as Eitan, this form of realism is intensely pursued in the quest for optical fidelity to a scene. For others, like Varda, who grew

up in a similar environment, color, expression, and ornamentation are of central concern, and Yani's work demonstrates the intention to master the techniques of classical Chinese painting. With the exception of highly talented and motivated children, most youngsters do not progress much beyond the typical flat, two-dimensional style of child art and its representational constraints. Without specific training, the majority of children never attain the ability to draw in perspective. Here Western culture and its conception of artistic development play a significant role. Unlike 19th-century schooling in Europe and America (Korzenik, 1985, 1995), where drawing in perspective was an integral part of training in visual literacy to prepare children for their role as skilled workers in an industrial economy, contemporary Western culture has emphasized spontaneity, expression, and inventiveness in child art at the expense of professional instruction.

There are alternative approaches that emphasize close attention to a scene, encourage active visual and tactile exploration of an object, value drawing from observation, and altogether involve the educator actively in the child's artistic activity (Edwards, Gandini, & Forman, 1993; Smith & Fucigna, 1988). An instructive example can be found in the educational philosophy of Loris Malaguzzi and his colleagues that underpins the practices in the preschools of Reggio Emilia, an old and well-established city in northern Italy (Edwards et al., 1993). In these preschools the art of the young is actively fostered, and art making plays a central role in the educational curriculum. Children discuss their projects at length with their peers; study the objects they wish to draw, paint, or model with clay; concretely explore the object, for example, a sculpture of a lion situated in the town square; measure dimensions; study photographs and other illustrations; and work with the assistance of a professional artist who is a member of the staff in a well-equipped studio. The resulting work, created over many sessions, is child art at its most expressive, aesthetically pleasing, but also diverse in style and execution, reflecting the child's individuality and talent.

The diversity of early models previously mentioned, the surprising competence found in the artwork of the preschool children from Reggio Emilia

and the work of young talented children all militate against traditional accounts of stage theories that link pictorial development with specific cognitive operations. The usual account that begins with a so-called *symbolic* stage characteristic of tadpole figures; advances to the drawing of *conventional* figures composed of head, body, and limbs typical of the stage of intellectual realism; and progresses to visual realism and drawing in perspective, is somewhat suspect. These stage-typed representations are all graphic equivalents, and they are best understood in terms of changing criteria of adequacy or effectiveness. For example, the drawn horizontal line that distinguishes between an open-trunk figure and a conventional figure can best be seen as the refinement of a graphic schema that, like the stick figure, represents its object quite effectively without attributing its use to a better visual or conceptual analysis of the object.

Just as young gifted children challenge the hypothesized linkage to a stage of concrete operational reasoning, so do less talented but highly motivated children who fail to show in their drawings the predicted progression toward perspective. An illuminating example of the latter kind comes from Charles, a boy who from an early age became fascinated with trains and drew them incessantly throughout his childhood, ages 2 to11 years (Hildreth, 1941). Despite continued interest, practice, and maturing cognitive capacities, his trains are drawn in orthographic or horizontal oblique projection, and the perspective rendering of the scene remains primitive. Charles's drawings never reach the sophisticated level of Eitan who, between ages 2 to 4, invents effective drawing and connotation systems that enable him to create realistic portrayals of the objects that interested him. The daily record of Eitan's drawing efforts chronicle his visual thinking and problem-solving strategies.

In both cases there is graphic problem solving which, in the case of young Eitan, reaches an intuitive but sophisticated level of rendering objects and scenes in perspective. Charles's solutions progressed from global circular forms to rectangular shaped locomotives and cars in their canonical side view, supplemented with small, horizontally or vertically attached regions meant to represent additional sides (front, rear, top) of the cars. By virtue of his interests and practice, Charles, age 11, included more details in the depiction of wheels and locomotives but failed to attain an effective level of three-dimensional representation of his favorite subject.

TALENT AND DOMAIN SPECIFICITY

These and related examples (Beck, 1928; Goldsmith, 1992; Golomb, 1992a, 1992b, 1995; Milbrath, 1995, 1998; Paine, 1981; Pariser, 1995b; Warner, 1981; Winner, 1996; Zimmerman, 1995) indicate that developmental changes in pictorial differentiation are not strictly age related but also depend on talent, motivation, familial support, and cultural values. What changes with some highly motivated six- or seven-year-olds is the critical assessment of their work that involves a search for more effective techniques. This requires cognitive abilities to plan, to monitor the ongoing action, to learn from experience and from other models, to persist, and to evaluate one's work. That artistic development cannot simply be equated with the development of logical–mathematical reasoning is further attested by the remarkable drawings of savants with autism and the different, although equally striking paintings of adults with mental retardation (Kläger, 1992, 1993, 1996, 1997). In general, however, even talented children and savants for whom models and materials are provided by adults attain full mastery only in the late childhood and adolescent years.

Reports on visual giftedness in the arts suggest considerable domain specificity in the organization of this mode of intelligence, a position proposed by Howard Gardner (1983), who maintained that spatial intelligence is not a unitary concept but comprised an amalgam of different abilities. In this context, the art educator Andrea Kárpáti (1997) noted that a contest in Hungary, "Let's Design Objects," brought to light hundreds of highly innovative youngsters ages 6 to 16 who were precocious in design but "many of whom were unable to give an appropriate graphic representation of the objects they invented, modeled, and produced in real space" (p. 79). Most children who excelled in construction had mediocre or even poor drawing skills. The majority of these children would not have been able to pass

the drawing tests required for entrance into a high school that emphasizes the visual arts.

In line with this view of giftedness and visual–spatial abilities, Ellen Winner concluded from her extensive review of the literature on IQ and artistic giftedness that there is a disjunction between these domains of intelligence. Whereas IQ tests assess verbal and numerical abilities and abstract reasoning, drawing relies on visual–spatial skills that include the ability to see, remember, visualize, and transform images. The artistically talented excel in their short-term and long-term visual memory and can access an internal visual lexicon of images, abilities that are unrelated to verbal IQ (Winner, 1996). Thus, the abilities of normally developing gifted individuals can operate independently of other intellectual, social, and emotional capacities.

This interpretation found additional support from the work of Hermelin and O'Connor and their colleagues, who reported that artistic individuals, both savants and mentally normally developed adolescents, do not differ in their perceptual and conceptual analysis of a scene and its transposition to the pictorial medium. Their studies indicate that, in both groups of talented individuals, the act of creative visual–spatial problem solving is quite comparable, testifying to an intelligence that, in many cases, bypasses verbal skills (Hermelin & O'Connor, 1990; Hermelin, Pring, Buhler, Wolff, & Heaton, 1999; O'Connor & Hermelin, 1987a, 1987b, 1990; Pring & Hermelin, 1993; Pring, Hermelin, & Heavey, 1995). These investigators concluded that talent in the visual arts is independent of IQ, an interpretation that is congruent with Gardner and Winner's position. This finding does not mean that visual–spatial thinking is the only avenue pursued by all artists, but it suggests that at certain levels of artistic creation, visual–spatial forms of intelligence may dominate in the production of a painting or sculpture. This theoretical framework can, perhaps, also subsume the aesthetic dimension of art making in people with mental retardation, which has been stressed by Max Kläger, who studied their drawings and paintings over many decades. Their paintings, reminiscent of child art, are self-motivated and exhibit the major characteristics of art: unity, intensity, complexity, symmetry, and the expressive use of color. Kläger stated that children as well as adults with disabilities use pictorial forms of thinking that are predominantly preconscious or preverbal and that this language, relatively unaffected by prevailing cultural models, is close to the primary process of archaic thinking.

DIVERSE ARTISTIC DEVELOPMENTAL TRAJECTORIES

With few exceptions (Arnheim, 1974, 1986, 1997; Golomb, 1994, 1999; Kindler, 1999; Kindler & Darras, 1997a; Pariser, 1983, 1995b; Wolf & Perry, 1988), the singular focus on the acquisition of perspective in drawing has biased the current accepted view and made researchers insensitive to the pictorial logic that underlies child art and its diverse developmental trajectories that appealed to the modern artist. An important corrective to the view of a linear development through specified stages of cognitive development has been proposed by art educators Brent and Marjory Wilson (1977, 1982, 1984, 1985). These researchers distinguished between school art and the narrative art of youngsters who model their stories on cartoon characters that depict, in a series of frames, protagonists in battle with their enemies, in struggles that involve destruction, victory, and defeat, themes that have a special appeal to boys. These graphic narratives undergo differentiation in their own stylistic formats; the characters are depicted in their diverse actions, poses, and orientations that communicate their intent in time frames that do not use perspective projections.

More recently, Kindler and Darras (1994, 1997a, 1997b, 1998) developed an innovative account of artistic development that considers early iconic antecedents and the pursuit of various developmental trajectories, often on parallel tracts, that serve different communicative intentions. They noted that visual imagery serves a broad range of purposes such as making maps, logos, and decorative art for which the criterion of realism is useless. To illustrate that artistic development is a plurimedia (multiple formats in diverse media) endeavor, Kindler offered a description of Antoni's (age 9) pictorial world, which included a range of qualitatively different pictorial systems. Antoni's imagery reflects his interest in

sports, and Kindler provided examples of a variety of drawings all concerned with the game of hockey. His repertoire encompassed multiple formats that use visual, gestural, and vocal cues. His action pictures are constructed as maps in which circles serve as symbols for players in a bare-essence narrative, whereas his pictorial narration and description calls for greater attention to detail. According to Kindler (1999), Antoni draws neither what he sees nor what he knows but uses pictorial imagery to depict what matters. "What is included and what is omitted in a drawing, or the amount of detail and differentiation in an image is guided by a choice, and not by developmental readiness to perceive or produce certain types of pictorial representations" (p. 340).

The narrative impulse in the pictorial arts is not limited to the childhood years. A moving testament to the power of such a narrative for the artist who recounts her life's history and for the audience who visits the exhibit can be seen in paintings by Charlotte Salomon. The 23-year-old artist used this format to tell her life's story during World War II, shortly before her incarceration and death at the concentration camp of Auschwitz. It is a period of great upheaval, of anxiety and risk to her life, and in nearly 800 small gouaches that are often further subdivided into narrative sections, she conveys with simple lines, limited color palette, and accompanied by words and musical references, the full drama of her existence. In a compelling autobiographical series of 400 paintings that were exhibited in October 2000 in the Museum of Fine Arts in Boston, her childhood was reviewed in *Life? Or Theatre? A Play with Music* (see also a publication by Lane, 1981).

ART HISTORICAL VIEWS

This emphasis on nonlinear developmental trajectories, on a repertoire of multiple streams and plurimedia, an argument also made by Wolf and Perry (1988), is quite compatible with Willats's (1997, 2000) view that diverse drawing systems serve different purposes and that perspective rendering is only one system among other projective drawing systems that are not necessarily sequentially ordered. In this context, an art historical perspective, especially one that includes the findings from the strik-

ingly naturalistic art of the Paleolithic period, can provide a much-needed corrective to developmental psychologists who are committed to a linear stage conception in the visual arts. Such a conception implies that during development, earlier, more primitive forms of representation are transformed and subsumed under more advanced forms, presumably an irreversible process that does not seem to apply to the arts where early symbolizations remain accessible and are used under varying conditions. The stage conception, with its exclusive emphasis on children's artistic limitations and its negative evaluation of their preference for frontal views, leads to a one-sided interpretation that focuses on cognitive constraints and biases. Here Gombrich's reference to the "Egyptian" in us is a reminder that the preference for frontal views has a long artistic history, one not limited to children. Gombrich (1969) proposed that all pictorial representation begins with schematic forms and that it takes special efforts to overcome the natural trend toward schemas. In his words "The 'Egyptian' in us can be suppressed, but he can never quite be defeated" (p. 395).

The notion that artistic development is destined to reach a stage of optical realism ignores the history of art and cross-cultural research. Gombrich (1950, 1969, 1973, 1982) stated emphatically that representation is never the same as making a replica; the forms of art are neither duplicates of what the artist sees in the world, nor of his thoughts about the object. The forms of the artist are the product of tradition and acquired skills in a given medium. The notion of duplication or imitation of reality misses the point that likeness does not depend on an identity of elements but is based on structural relations within a matrix, a conception akin to Arnheim's view of equivalences. Gombrich rejected the 19th-century position that the evolution of art is progressive and aims toward increasing perfection in the creation of illusions. Gombrich believed art is born of art, and not of nature; he stressed that the artist, through a process of making and matching and working within an artistic tradition, creates his or her works. He rejected the familiar distinction between seeing and knowing, between perception and conception, and between seeing and drawing.

In all styles, the artist has to rely on a vocabulary

of forms, and it is the knowledge of this vocabulary rather than of the accurate perception of objects that distinguishes the skilled artist from the novice. The skilled artist succeeds in overcoming the pull toward schematic representation (the child's pictorial language), which is the primary schema. The illusionist painter has learned to attend to the highly artificial situation of one-eyed static vision, which has no biological relevance. The correct portrait is not a faithful record of a visual experience; it is a faithful construction of a relational model where meaning rather than fidelity to optical realism is the ultimate aim of the artist. According to Gombrich, perspective developed in response to the demands of narrative art, but because a single projection does not give adequate information about the object concerned and because not one but an infinite number of related configurations are possible, the artist's choice has to be guided by the invariant characteristics of the object and scene. This position implies a rejection of an extreme relativism that considers art forms as mere conventions, a position Gombrich has refuted (1973, 1982). The images of nature are not conventional signs like words, and equivalences are not made arbitrarily. For this author of major works that extol the virtue of naturalism and its successive approximations to the goal of realistic renderings, drawings and paintings are not simple correlates of intelligence, nor a function of studying nature or of adopting a strictly view-centered approach, a reminder that ought to be taken seriously by students of children's drawings.

In a different context, and of special significance for studying children's modeling with clay, is the view of the art historian Rudolf Wittkower (1977), who noted that Michelangelo always worked with the ideal frontal position in mind, which he considered the principal view of the sculpture. Wittkower remarked that the insistence on many views is new in the history of sculpture and that this preference is a question of style and not of maturity. A similar position is espoused by art historian Leonard Robert Rogers (1969), who noted that the language of sculpture is governed by rules and principles that belong to the art of sculpture and not to the science of anatomy.

In conclusion, artistic development in the child,

and throughout history, does not have a single endpoint. Child art branches out in different directions, depending on individual factors, the purpose of the drawing, and the cultural milieu. Under favorable conditions, child art need not be arrested during the middle childhood years, and art in its many forms may be pursued throughout a person's life (Schaefer-Simmern, 1948).

My review has shed some light on the child art developmental question, namely, *what* develops and *how* this comes about. The "what" question refers to the intention to represent an aspect of the inner or outer world of events and feelings in a visual and tangible manner. It draws on general symbolic capacities that involve perceptual–motor and broadly cognitive skills. The "how" question refers to the models children evolve and the manner in which their continued engagement with their own work and familiarity with models that they can understand lead to changes in pictorial representation. It is an activity deeply embedded in the sociocultural framework, and only within its context can artistic development be discussed.

In summary, the schematic drawings produced by children and adults do not directly map image onto paper. The development of graphic representation in children of different eras and geographical locations indicates that pictorial representation is based on the invention of equivalences across a broad range of forms. Pictorial representation is a construction that is never mistaken for the real object. It is an interpretation and indicates an awareness that it merely "stands for" an aspect of reality. In the same child, dependent on the task, the theme, the mood, and the intention, different competencies may be portrayed using one-, two-, and three-dimensional lines and shapes for the same part.

Drawing, from the very beginning, is a symbolic representational enterprise, and it continues to be so regardless of the conventions used. The distinction between drawing what children know and what they see poses a false dichotomy. Older children include more detail, are able to sustain their efforts for a longer time, and consider revisions and the learning of techniques that will enhance their pictorial competence and thus permit a more comprehensive pic-

torial statement. This can be accomplished within an orthographic projection system or by adopting other projection systems. The developmental changes, however, do not support the notion that graphic development proceeds from knowledge to vision, a position that has been challenged in the literature (Arnheim, 1974; Cox, 1993; Golomb, 1992a, 1992b, 1999; Hagen, 1986; Kindler, 1999; Kindler & Darras, 1998; Lee & Bremner, 1987; Michelmore, 1985; Pariser, 1995b; Smith & Fucigna, 1988; Wolf & Perry, 1988).

My critique of Piaget's account of drawing development and of the assumed close correspondence between the acquisition of spatial concepts and children's realistic renderings does not imply a critique of his overall account of the construction of intelligence, but it calls attention to an inconsistency in his approach to drawing. Piaget's emphasis on action as the essential means for the construction of sensory–motor intelligence implies actions that are performed on objects that exist within a social and physical space. Piaget's understanding of the acquisition of concrete operations during the middle school years again focuses on the child's encounter with the material world of objects, their arrangements and re-arrangements that lead to the construction of reversible mental operations. His theory postulates an interactive and self-regulating organism; it entails the view that the nature of the world of objects and materials plays an essential role in the way humans construct knowledge and engage in adaptive behavior. Piaget's theorizing about the arts, in which he had not shown a sustained interest, ignored his own principles about the material world as a medium for intelligent interaction. Instead, cognitive structures derived from particular experiences and interactions became the model for all domains of representation, a view that investigators of the child's theory of mind and researchers of the psychology of child art have challenged.

Children, over time, acquire more knowledge and skills in all domains of human concern, including the pictorial realm. The central question here concerns the course of development, the nature of representational change, and the principles underlying this change. Previous theorists, including Piaget, have paid insufficient attention to the nature of pic-

torial representation, the role of the medium, and the cultural context. They posited realism as a milestone in intellectual development rather than viewing it as one of several possible pictorial achievements. Simplicity of representational model, lack of skill and practice, and indifference to the demands of realism in art and to the cultural expectations of making accurate copies of reality need not indicate that the artist's conception of the object is limited or distorted, arrested at a primitive stage of conceptual development. Development in children's drawings can best be viewed in terms of the discovery of effective graphic descriptions that are quite object specific rather than some general and slowly evolving conception of space (Lee & Bremner, 1987).

The conception of graphic "completeness" in the drawing of a human or of fidelity to the object is to a large extent a convention dependent on how the body is segmented, or what we include and exclude. When, for example, Western children draw genitals, clinicians tend to get concerned and wonder why the convention of a sexless or clothed body has been violated. Likewise, there is not a good explanation why some three-year-old tadpole drawers include eyelashes and pupils but omit the trunk. Whatever the child's or the adult's mental image might be, it is not identical with the graphic schema that is its representation.

Among the multiple developmental trajectories suggested by Wolf and Perry and by Kindler and Darras, the development toward narrative competence within its cultural context can be clearly distinguished. This involves conveying information about the nature and function of the object, the action and intention of the protagonists, and the layout of a scene. It requires effective control of line and form, orientation, gesture, action, and spatial relations that go beyond the single plane and its alignment strategies. The boy Eitan is an example of this orientation to drawing.

But we also discern an equally valid drive toward expression in the artist's reliance on color, shape, and compositional principles that are independent of optical realism and that value ornamentation and delight in its aesthetic appeal. With the mastery of lines, regions, and contours, the artist intent on realism gains greater power to depict his or her scenes

effectively, whereas the artist who values expression above realism gains greater freedom in his or her depiction by avoiding the constraints of realism and anatomical fidelity. In Western children and adult artists, the tension between the demands for differentiation of form that will render space realistically and the desire for expression that violates norms of naturalism is often observed.

Child art flourishes where tools are made available and where this activity is valued or at least tolerated. In this art form the child can be seen in his or her multiple roles: as creator–inventor of a first and basic pictorial vocabulary, as a participant in a peer culture that promotes its own variants, and as a member of a community that promulgates certain views of art. Art making occurs in a cultural context; it is always the product of effort, of training, and of norms valued and aspired to. Understanding the historical and social context within which art making occurs and the long route education and development take, provides a new appreciation of the cognitive and aesthetic dimensions of child art.

I hope that my extensive reviews of child art in two- and three-dimensional media, the art of preliterate people, prehistoric art, and the artists of the 20th century who were inspired by children's paintings will contribute to the development of new perspectives on child art and its diverse developmental trajectories.

References

Alland, A. (1983). *Playing with form: Children draw in six cultures*. New York: Columbia University Press.

Anastasi, A., & Foley, J. (1936). An analysis of spontaneous drawings by children of different cultures. *Journal of Applied Psychology, 20,* 689–726.

Anastasi, A., & Foley, J. (1938). A study of animal drawings by Indian children of the North Pacific coast. *Journal of Social Psychology, 9,* 363–374.

Anati, E. (1967). *Evolution and style in Camonican rock art.* Brescia, Italy: Edizione Banca Populare di Sondrio.

Andersson, I., & Andersson, S. B. (1997). *Aesthetic representations among Himba people in Namibia.* Unpublished manuscript, Linköping University, Sweden.

Andersson, S. B. (1995a). Local conventions in children's drawings: A comparative study in three cultures. *Journal of Multicultural and Cross-Cultural Research in Art Education, 13,* 101–111.

Andersson, S. B. (1995b). Projection systems and X-ray strategies in children's drawings: Comparative study in three cultures. *British Journal of Educational Psychology, 65,* 455–464.

Anger, N. (1999, December 14). Furs for evening, but cloth was the Stone Age standby. *The New York Times.*

Antinucci, F. (Ed.). (1989). *Cognitive structure in non-human primates.* Hillsdale, NJ: Erlbaum.

Ariès, P. (1962). *Centuries of childhood: A social history of family life.* New York: Vintage Books.

Arnheim, R. (1966). *Toward a psychology of art.* Berkeley: University of California Press.

Arnheim, R. (1969). *Visual thinking.* Berkeley: University of California Press.

Arnheim, R. (1974). *Art and visual perception.* Berkeley: University of California Press.

Arnheim, R. (1980). The puzzle of Nadia's drawings. *Arts in Psychotherapy, 7,* 79–85.

Arnheim, R. (1986). *New essays on the psychology of art.* Berkeley: University of California Press.

Arnheim, R. (1988). *The power of the center.* Berkeley: University of California Press.

Arnheim, R. (1997). *The split and the structure.* Berkeley: University of California Press.

Aronson, J., & Golomb, C. (1999). Preschoolers' understanding of pretense and the presumption of congruence between action and representation. *Developmental Psychology, 35,* 1414–1425.

Bahn, P. G. (1996). Foreword. In J. M. Chauvet, E. B. Deschamp, & C. Hillaire (Eds.), *Dawn of art: The Chauvet cave* (pp. 7–12). New York: Harry N. Abrams.

Bahn, P. G., & Vertut, J. (1988). *Images of Ice Age.* New York: Facts on File.

Baillargeon, R. (1987). Young infants' reasoning about the physical and spatial characteristics of a hidden object. *Cognitive Development, 2,* 179–200.

Baldwin, J. M. (1895). *Mental development in the child and the race.* New York: Macmillan.

Ballard, P. B. (1912). What London children like to draw. *Journal of Experimental Pedagogy, 1,* 185–197.

Barnes, E. (1894). A study of children's drawings. *Pedagogical Seminary, 2,* 455–463.

Beck, W. (1928). *Self-development in drawing. As interpreted by the genius of Romano Dazzi and other children.* New York: Putnam.

Becker, L. (1980). *With eyes wide open* [Film]. Austin, TX: Creative Learning Environments.

Belo, J. (1955). Balinese children's drawings. In M. Mead & M. Wolfenstein (Eds.), *Childhood in contemporary cultures* (pp. 52–69). Chicago: University of Chicago Press.

Belting, H. (1987). *The end of history of art?* Chicago: University of Chicago Press.

Bergemann-Konitzer, M. (1930). *Das plastische Gestalten des Kleinkindes* [The plastic creation of the preschool child]. Weimar, Germany: H. Böhlaus Nachfolger.

Bernheimer, R. (1961). *The nature of representation: A phenomenological inquiry*. New York: New York University Press.

Blatt, S. J. (1994). Concurrent conceptual revolutions in art and science. In M. B. Franklin & B. Kaplan (Eds.), *Development in the arts* (pp. 195–226). Hillsdale, NJ: Erlbaum.

Boas, G. (1966). *The cult of childhood* (Vol. 29). London: University of London, Warburg Institute.

Bowlby, J. (1958). The nature of the child's tie to his mother. *International Journal of Psychoanalysis, 39,* 350–373.

Bowlby, J. (1969). *Attachment and loss: Vol. 1. Attachment.* New York: Basic Books.

Boysen, S. T., Berntson, G. G., & Prentice, J. (1987). Simian scribbles: A reappraisal of drawing in the chimpanzee (*Pan troglodytes*). *Journal of Comparative Psychology, 101,* 82–89.

Breuil, H. (1952). *Four hundred years of cave art*. Montignac, France: Centre d'Étude et de Documentation Préhistorique.

Brown, E. V. (1975). Developmental characteristics of clay figures made by children ages three through the age of eleven. *Studies in Art Education, 16*(3), 45–53.

Brown, E. V. (1984). Developmental characteristics of clay figures made by children: 1970–1981. *Studies in Art Education, 26*(1), 56–60.

Brown, E. V. (1986, December). A critical need: Children and clay. *School Arts,* pp. 20–21.

Buck, L. (1991). Creativity in the retarded. *Empirical Studies of the Arts, 9,* 75–95.

Buck, L., Kardeman, E., & Goldstein, F. (1985). Artistic talent in "autistic" adolescents and young adults. *Empirical Studies of the Arts, 3,* 81–104.

Bühler, K. (1930). *The mental development of the child.* London: Routledge & Kegan Paul.

Burenhult, G. (1993). The rise of art. In G. Burenhult (Ed.), *The first humans.* San Francisco: Harper.

Burt, C. (1921). *Mental and scholastic tests.* London: P. S. King & Son.

Burton, J. M. (1981, February). Developing minds: With three dimensions in view. *School Arts,* pp. 76–80.

Carothers, J. T., & Gardner, H. (1979). When children's drawings become art: The emergence of aesthetic production and perception. *Developmental Psychology, 15,* 570–580.

Case, R. (1991). *The mind's staircase.* Hillsdale, NJ: Erlbaum.

Champfleury. (1869). *Histoire de l'Imagerie Populaire* [The history of popular imagery]. Paris: Michele Levy Frères.

Champfleury. (1874). *Les enfants* [The children]. Paris: J. Rothschild.

Chukovsky, K. (1971). *From two to seven.* Berkeley: University of California Press.

Clottes, J. (1996). Epilogue. In J. M. Chauvet, E. B. Deschamp, & C. Hillaire (Eds.), *Dawn of art: The Chauvet cave* (pp. 89–128). New York: Harry N. Abrams.

Clottes, J. (Ed.). (2001). *La grotte Chauvet: L'Art des origines* [The Chauvet cave: The beginnings of art]. Paris: Edition du Seuil.

Clottes, J., & Courtin, J. (1996). *The cave beneath the sea: Paleolithic images at Cosquer.* New York: Harry N. Abrams.

Clottes, J., & Lewis Williams, D. (1996). *The shamans of prehistory.* New York: Harry N. Abrams.

Cole, M. (1996). *Cultural psychology: A once and future discipline.* Cambridge, MA: Belknap-Harvard.

Costall, A. (1995). The myth of the sensory core: The traditional versus the ecological approach to children's drawings. In C. Lange-Küttner & G. V. Thomas (Eds.), *Drawing and looking* (pp. 16–26). London: Harvester Wheatsheaf.

Costall, A. (1997). Innocence and corruption: Conflicting images of art. *Human Development, 40,* 133–144.

Court, E. (1981). *The dual vision: Factors affecting Kenyan children's drawing behavior.* Paper presented at the 24th Congress of the International Society Through Art, Rotterdam, Holland.

Court, E. (1989). Drawing on culture: The influence of culture on children's drawing performance in rural Kenya. *Journal of Art and Design Education, 8,* 65–88.

Court, E. (1994). Researching social influences in the drawings of rural Kenyan children. In D. Thistlewood, S. Paine, & E. Court (Eds.), *Drawing, art and development* (pp. 219–260). London: Longmans.

Cox, M. (1992). *Children's drawings.* London: Penguin.

Cox, M. (1993). *Children's drawings of the human figure.* Hove, East Sussex, England: Erlbaum.

Cox, M., & Bragal, C. (1985). The representation of spatial relationships in the drawings of ESN (M) and normal children. *Educational Psychology, 5,* 279–286.

Damerow, P. (1998). Prehistory and cognitive development. In J. Langer & M. Killen (Eds.), *Piaget, evolution, and development* (pp. 247–269). London: Erlbaum.

Dansky, J. L., & Silverman, I. W. (1973). Effects of play on associative fluency in preschool-aged children. *Developmental Psychology, 9,* 38–43.

DeLoache, J. S., Pierroutsakos, S. L., & Troseth, G. L. (1996). The three 'R's of pictorial competence. In R. Varta (Ed.), *Annals of child development* (Vol. 12, pp. 1–48). Philadelphia, PA: Jessica Kingsley.

Delporte, H. (1993). Gravettian female figurines: A regional survey. In H. Knecht, A. Pike-Tay, & R. White (Eds.), *Before Lascaux: The complex record of the early Upper Paleolithic* (pp. 243–276). Boca Raton, FL: CRC Press.

Dennis, W. (1957). Performance of Near-Eastern children on the Draw-a-Man test. *Child Development, 28,* 427–430.

Dennis, W. (1960). The human figure drawings of Bedouins. *Journal of Social Psychology, 52,* 209–219.

Dennis, S. (1991). Stage and structure in children's spatial representations. In R. Case (Ed.), *The mind's staircase* (pp. 229–245). Hillsdale, NJ: Erlbaum.

Deregowski, J. B. (1978). On reexamining Fortes' data: Some implications of drawings made by children who have never drawn before. *Perception, 7,* 479–484.

Duncum, P. (1984). How 35 children born between 1724 and 1900 learned to draw. *Studies in Art Education, 26*(1), 93–102.

Edwards, C., Gandini, L., & Forman, G. (1993). *The hundred languages of children: The Reggio Emilia approach to early childhood education.* Norwood, NJ: Ablex.

Eibl-Eibesfeldt, I. (1975). *Ethology: The biology of behavior* (2nd ed.). New York: Holt, Rinehart & Winston.

Fineberg, J. (1995, April). The innocent eye: What the moderns saw in children's art. *Art News,* pp. 118–125.

Fineberg, J. (1997). *The innocent eye.* Princeton, NJ: Princeton University Press.

Fineberg, J. (Ed.). (1998). *Discovering child art.* Princeton, NJ: Princeton University Press.

Fortes, M. (1940). Children's drawings among the Tallensi. *Africa, 13,* 293–295.

Fortes, M. (1981). Tallensi children's drawings. In B. Loyd & J. Gay (Eds.), *Universals of human thought* (pp. 46–70). Cambridge, England: Cambridge University Press.

Freeman, N. H. (1977). Children's planning problems in representational drawing: Experimental evidence on organisational process and the development of human figure drawing. In G. E. Butterworth (Ed.), *The child's representation of the world* (pp. 3–29). London: Plenum.

Freeman, N. H. (1980). *Strategies of representation in young children.* London: Academic Press.

Freeman, N. H. (1987). Current problems in the development of representational picture production. *Archives de Psychologie, 55,* 127–152.

Freeman, N. H., & Cox, M. (1985). *Visual order.* London: Academic Press.

Gardner, B. T., & Gardner, R. A. (1989). A test of communication. In R. A. Gardner & B. T. Gardner (Eds.), *Teaching sign language to chimpanzees* (pp. 181–197). Albany: SUNY Press.

Gardner, H. (1980). *Artful scribbles.* New York: Basic Books.

Gardner, H. (1983). *Frames of mind: The theory of multiple intelligences.* New York: Basic Books.

Gardner, H. (1993). *Creating minds: An anatomy of creativity seen through the lives of Freud, Einstein, Picasso, Stravinsky, Eliot, Graham, and Gandhi.* New York: Basic Books.

Gardner, R. A., & Gardner, B. T. (1978). Comparative psychology and language acquisition. *Annals of the New York Academy of Sciences, 309,* 37–76.

Gering, V. (1998). The children's studio. In C. Golomb (Ed.), *The pavilion of painting* (pp. 87–91). Haifa, Israel: Ach.

Goldsmith, L. (1992). Wang Yani: Stylistic development of a Chinese painting prodigy. *Creativity Research Journal, 5,* 282–293.

Goldwater, R. (1986). *Primitivism in modern art.* Cambridge, MA: Harvard University Press.

Golomb, C. (1972). Evolution of the human figure in a three-dimensional medium. *Developmental Psychology, 6,* 385–391.

Golomb, C. (1973). Children's representation of the human figure: The effects of models, media, and instructions. *Genetic Psychology Monographs, 87,* 197–251.

Golomb, C. (1974). *Young children's sculpture and drawing.* Cambridge, MA: Harvard University Press.

Golomb, C. (1983a). On imaginary or real décalage in children's representations: Compositional trends in drawing, completion, and selection tasks. *Visual Arts Research, 9*(2), 71–81.

Golomb, C. (1983b). Young children's planning strategies and early principles of spatial organization in drawing. In J. Sloboda & D. Rogers (Eds.), *Acquisition of symbolic skills* (pp. 81–87). London: Plenum Press.

Golomb, C. (1992a). Eytan: The early development of a precociously gifted child artist. *Creativity Research Journal, 5,* 265–279.

Golomb, C. (1992b). *The child's creation of a pictorial world.* Berkeley: University of California Press.

Golomb, C. (1994). Drawing as representation: The child's acquisition of a meaningful graphic language. *Visual Arts Research, 20*(2), 14–28.

Golomb, C. (1995). (Ed.). *The development of artistically gifted children: Selected case studies.* Hillsdale, NJ: Erlbaum.

Golomb, C. (1999). Art of the young: The many faces of representation. *Visual Arts Research, 21*(2), 35–50.

Golomb, C., & Barr-Grossman, T. (1977). Representational development of the human figure in the familial retardate. *Genetic Psychology Monographs, 95,* 247–266.

Golomb, C., & Cornelius, C. B. (1977). Symbolic play and its cognitive significance. *Developmental Psychology, 47,* 175–186.

Golomb, C., & Farmer, D. (1983). Children's graphic planning strategies and early principles of spatial organization in drawing. *Studies in Art Education, 24*(2), 87–100.

Golomb, C., & Galasso, L. (1995). Make-believe and reality: Explorations of the imaginary realm. *Developmental Psychology, 31,* 800–810.

Golomb, C., & Helmund, J. (1987). *A study of young children's sensitivity to drawing and painting.* ERIC Document Reproduction Service No. ED 281 624.

Golomb, C., & Kürsten, R. (1996). On the transition of pretense play to reality: What are the rules of the game? *British Journal of Developmental Psychology, 14,* 203–217.

Golomb, C., & McCormick, M. (1995). Sculpture: The development of three-dimensional representation in clay. *Visual Arts Research, 21*(1), 35–50.

Golomb, C., & Schmeling, J. (1996). Drawing development in autistic and mentally retarded children. *Visual Arts Research, 22*(2), 5–18.

Gombrich, E. H. (1950). *The story of art.* London: Phaidon Press.

Gombrich, E. H. (1969). *Art and illusion.* London: Phaidon Press.

Gombrich, E. H. (1973). Illusion and art. In R. L. Gregory & E. H. Gombrich (Eds.), *Illusion in nature and art* (pp. 93–243). New York: Charles Scribner's Sons.

Gombrich, E. H. (1982). Image and code: Scope and limits of conventionalism in pictorial representation. *The image and the eye* (pp. 278–297). Oxford, England: Phaidon Press.

Goodenough, F. (1926). *Measurement of intelligence by drawings.* New York: Harcourt, Brace, & World.

Goodman, N. (1968). *Language of art.* Indianapolis, IN: Bobbs-Merrill.

Gopnik, A., & Wellman, H. M. (1994). The theory theory. In L. A. Hirschfeld & S. A. Gelman (Eds.), *Domain specificity in cognition and culture* (pp. 257–293). New York: Cambridge University Press.

Götze, C. (1898). *Das Kind als Künstler* [The child as artist]. Hamburg, Germany: Boysen & Maasch.

Grandin, T. (1992). *Thinking in pictures.* New York: Bantam-Doubleday.

Grossman, E. (1980). Effects of instructional experience in clay modeling skills on modeled human figure representation in preschool children. *Studies in Art Education, 22*(1), 51–59.

Haas, M. (1998). *Preschool children's exploration and expression with art materials.* Haifa, Israel: Ach.

Haas, M., & Gavich, Z. (2000). *Toddlers experience art materials.* Haifa, Israel: Ach.

Häckel, E. (1874). *The evolution of man: A popular exposition of the principal points of human ontogeny and phylogeny.* New York: International Science Library.

Hacker, P. (1991). Seeing, representing and describing. In J. Hyman (Ed.), *Investigating psychology* (pp. 119–154). London: Routledge.

Haddon, A. C. (1895). *Evolution in art.* London: LTD.

Haddon, A. C. (1904). Drawings by natives of New Guinea. *Man, 4,* 33–36.

Hagen, J., Lewis, M., & Smilansky, S. (1988). *Clay in the classroom: Helping children develop cognitive and affective skills for learning.* New York: Peter Lang.

Hagen, M. A. (1986). *Varieties of realism.* Cambridge, England: Cambridge University Press.

Hahn, J. (1993). Aurignacian art in Central Europe. In H. Knecht, A. Pike-Tay, & R. White (Eds.), *Before Lascaux: The complex record of the early Upper Paleolithic* (pp. 229–242). Boca Raton, FL: CRC Press.

Hall, S. (1883). *The content of children's minds.* New York: D. Appleton.

Hall, S. (1892). Notes on children's drawings. Literature and notes. *Pedagogical Seminary, 1,* 445–447.

Hall, S. (1904). *Adolescence.* New York: D. Appleton.

Halverson, J. (1987). Art for art's sake in the Paleolithic. *Current Anthropology, 28*(1), 63–71.

Halverson, J. (1995). Paleolithic art and cognition. *Journal of Psychology, 126,* 221–236.

Harlow, H. (1958). Love in infant monkeys. *Scientific American, 200*(6), 68–74.

Harris, D. B. (1963). *Children's drawings as measures of intellectual maturity.* New York: Harcourt, Brace & World.

Harris, D. B. (1971). The case method in art education. In G. Kensler (Ed.), *A report on preconference education research training program for descriptive research in art education* (pp. 29–42). Reston, VA: National Art Education Association.

Havighurst, R. J., Gunther, M. K., & Pratt, I. E. (1946). Environment and the Draw-a-Man test: The performance of Indian children. *Journal of Abnormal and Social Psychology, 41,* 50–63.

Hermelin, B., & O'Connor, N. (1990). Art and accuracy: The drawing ability of idiot savants. *Journal of Child Psychology and Psychiatry, 31,* 217–228.

Hermelin, B., Pring, L., Buhler, M., Wolff, S., & Heaton, P. (1999). A visually impaired savant artist: Interacting perceptual and memory representations. *Journal of Child Psychology and Psychiatry, 40*, 1129–1139.

Hildreth, G. (1941). *The child mind in evolution.* New York: Kings Crown Press.

Hoag, J. (1959). *Observational study of a kindergarten group using constructional material.* Unpublished doctoral dissertation, University of California, Berkeley.

Itakura, S. (1994). Recognition of line-drawing representations by a chimpanzee (*Pan troglodytes*). *Journal of General Psychology, 12*, 189–197.

Iverson, I. H., & Matsuzawa, T. (1996). Visually guided drawing in the chimpanzee (*Pan troglodytes*). *Japanese Psychological Research, 38*, 126–135.

Iverson, I. H., & Matsuzawa, T. (1997). Model-guided line drawing in the chimpanzee (*Pan troglodytes*). *Japanese Psychological Research, 39*, 154–181.

Ives, W., & Rovet, J. (1979). The role of graphic orientations in children's drawings of familiar and novel objects at rest and in motion. *Merrill-Palmer Quarterly, 25*, 281–292.

Jahoda, G. (1980). Theoretical and systematic approaches in cross-cultural psychology. In H. C. Triandis & W. W. Lambert (Eds.), *Handbook of cross-cultural psychology* (Vol. 1, pp. 69–141). Boston: Allyn & Bacon.

Jahoda, G. (1981). Drawing styles of schooled and unschooled adults: A study in Ghana. *Quarterly Journal of Experimental Psychology, 33A*, 133–143.

Jahoda, G. (1989). Our forgotten ancestors. In J. J. Berman (Ed.), *Cross-cultural perspectives: Nebraska symposium on motivation* (pp. 1–40). Lincoln: University of Nebraska Press.

Karmiloff-Smith, A. (1990). Constraints on representational change: Evidence from children's drawing. *Cognition, 34*, 57–83.

Karmiloff-Smith, A. (1992). *Beyond modularity: A developmental perspective on cognitive science.* Cambridge, MA: MIT Press.

Kárpáti, A. (1997). Detection and development of visual talent. *Journal of Aesthetic Education, 31*(4), 79–92.

Katz, D. (1906). Ein Beitrag zur Kenntniss der Kinderzeichnungen [A contribution to the understanding of children's drawings]. *Zeitschrift für Psychologie und Physiologie der Sinnesorgane, 41*, 241–256.

Kellman, J. (1996). Making sense of seeing: Autism and David Marr. *Visual Arts Research, 22*(2), 76–89.

Kellman, J. (1998). Ice age, autism, and vision: How we see/how we draw. *Studies in Art Education, 39*(2), 11–25.

Kellogg, R. (1959). *Why children scribble.* Palo Alto, CA: National Press.

Kerschensteiner, G. (1905). *Die Entwicklung der Zeichnerischen Begabung* [The development of drawing talent]. Munich, Germany: Gerber.

Kindler, A. M. (1999). "From endpoints to repertoires": A challenge to art education. *Studies in Art Education, 40*(4), 330–349.

Kindler, A. M., & Darras, B. (1994). Artistic development in context: Emergence and development of pictorial imagery in early childhood years. *Visual Arts Research, 20*(2), 1–13.

Kindler, A. M., & Darras, B. (1997a). A map of artistic development. In A. M. Kindler (Ed.), *Child development in art* (pp. 17–44). Reston, VA: National Art Education Association.

Kindler, A. M., & Darras, B. (1997b). Development of pictorial representation: A teleology-based model. *Journal of Art and Design Education, 16*, 217–222.

Kindler, A. M., & Darras, B. (1998). Culture and development of picture repertoires. *Studies in Art Education, 39*(2), 147–167.

Kläger, M. (1992). *Krampus: Die Bilderwelt des Willibald Lassenberger.* [Krampus: The images of Willibald Lassenberger]. Hohengehren, Germany: Schneider Verlag.

Kläger, M. (1993). *Die Vielfalt der Bilder: Kunstwerke entwicklungsbehinderte Menschen* [Manifold paintings: Artworks of developmentally handicapped people]. Stuttgart, Germany: Konrad Wittwer.

Kläger, M. (1996). Two case studies of artistically gifted Down syndrome persons. *Visual Arts Research, 22*(2), 35–46.

Kläger, M. (1997). *Verständnis für Kinderkunst* [Understanding child art]. Hohengehren, Germany: Schneider Verlag.

Kläger, M. (1998). Some remarks on color dominance. In C. Golomb (Ed.), *The pavilion of painting* (pp. 92–94). Haifa, Israel: Ach.

Klee, F. (Ed.). (1964). *The diaries of Paul Klee 1898–1918.* Berkeley: University of California Press.

Korzenik, D. (1985). *Drawn to art: A nineteenth-century American dream.* Hanover, NH: University Press of New England.

Korzenik, D. (1995). The changing concept of artistic giftedness. In C. Golomb (Ed.), *The development of artistically gifted children* (pp. 1–29). Hillsdale, NJ: Erlbaum.

Krampen, M. (1991). *Children's drawings. Iconic coding of the environment.* New York: Plenum Press.

Krause, P. (1914). *Entwicklung eines Kindes* [A child's development]. Leipzig, Germany: E. Wunderlich.

Krötzsch, W. (1917). *Rhythmus und Form in der freien Kinderzeichnung* [Rhythm and form in children's drawings]. Leipzig, Germany: A. Haase.

Lamprecht, K. (1906). Les dessins d'enfants comme source historique [Children's drawings as historical source material]. *Bulletin de l'Academy Royale de Belgique (classe des lettres), 9–10,* 457–469.

Lane, A. (1981). *Charlotte: Life or theatre?* London: Penguin Books.

Lange-Küttner, C., & Reith, E. (1995). The transformation of figurative thought: Implications of Piaget's and Inhelder's developmental theory for children's drawings. In C. Lange-Küttner & E. Reith (Eds.), *Drawing and looking* (pp. 75–92). London: Harvester Wheatsheaf.

Lark-Horovitz, B., Lewis, H. P., & Luca, M. (1967). *Understanding children's art for better teaching.* Columbus, OH: Charles E. Merrill.

Lee, M., & Bremner, G. (1987). The representation of depth in children's drawings of a table. *Quarterly Journal of Experimental Psychology, 39A,* 479–496.

Leroi-Gourhan, A. (1967). *The art of prehistoric man.* New York: Harry N. Abrams.

Leroi-Gourhan, A. (1972). *The roots of civilization.* New York: McGraw Hill.

Leroi-Gourhan, A. (1982). *The dawn of European art.* Cambridge, England: Cambridge University Press.

Leslie, A. M. (1987). Pretense and representation: The origins of the theory of mind. *Psychological Review, 94,* 412–426.

LeVine, R., Dixon, A., LeVine, S., & Richman, A. (1994). *Child care and culture: Lessons from Africa.* New York: Cambridge University Press.

Levinstein, S. (1905). *Kinderzeichnungen bis zum 14ten Lebensjahr* [Children's drawings till age 14]. Leipzig, Germany: Voigtlander.

Lévy-Bruhl, L. (1923). *Primitive mentality.* New York: McMillan.

Lévy-Bruhl, L. (1966). *How natives think.* New York: Washington Square Press. (Original work published 1910)

Leyh, E. (1980). *Children make sculpture.* New York: Van Nostrand Reinhold.

Lorenz, K. Z. (1952). *King Solomon's ring.* New York: Thomas Y. Crowell.

Löwenfeld, V. (1939). *The nature of creative activity.* New York: Harcourt, Brace & Co.

Löwenfeld, V. (1947). *Creative and mental growth.* New York: Macmillan.

Lukens, H. T. (1896). A study of children's drawings in the early years. *Pedagogical Seminary, 4*(1), 79–110.

Luquet, G. H. (1913). *Les dessins d'un enfant* [The drawings of a child]. Paris: F. Alcan.

Luquet, G. H. (1927). *Le dessin enfantin* [Childhood drawings]. Paris: F. Alcan.

Luquet, G. H. (1930). *The art and religion of fossil man.* New Haven, CT: Yale University Press.

Maitland, L. (1895). What children draw to please themselves. *Inland Educator, 1,* 77–81.

Malreaux, A. (1956). *The voices of silence.* Garden City, NY: Doubleday.

Mandler, J. M. (1988). How to build a baby: On the development of an accessible representational system. *Cognitive Development, 3,* 113–136.

Mandler, J. M. (1998). Representation. In W. Damon, D. Kuhn, & R. S. Siegler (Eds.), *Handbook of child psychology: Vol. 2. Cognition, perception, and language* (5th ed., pp. 255–308). New York: Wiley.

Marr, D. (1982). *Vision: A computational investigation into the human representation and processing of visual information.* San Francisco: W. H. Freeman.

Marshak, A. (1972). *The roots of civilization.* London: Weidenfeld & Nicolson.

Marshak, A. (1985). Theoretical concepts that lead to new analytical methods, modes of inquiry and classes of data. *Rock Art Research, 2,* 95–111.

Marshak, A. (1995, July/August). Images of the Ice Age. *Archeology,* 28–36.

Märtin, H. (1932a). Die plastische Darstellung der Menschengestalt beim jüngeren Schulkinde [The plastic representation of the human figure by young elementary school children]. *Zeitschrift für Pedagogische Psychologie, 33,* 257–273.

Märtin, H. (1932b). Stile und Stilwandlungsgesetze der Kinderzeichnung. [Style and its transformation in children's drawings]. *Zeitschrift für Jugendkunst, 2,* 211–226.

Martlew, M., & Connolly, K. J. (1996). Human figure drawings by schooled and unschooled children in Papua New Guinea. *Child Development, 67,* 2743–2762.

Matthews, G. B. (1994). *The philosophy of childhood.* Cambridge, MA: Harvard University Press.

Matthews, J. (1984). Children drawing: Are young children really scribbling? *Early Child Development and Care, 18,* 1–39.

Matthews, J. (1994). Deep structures in children's art: Development and culture. *Visual Arts Resarch, 20*(2), 29–50.

Matz, W. (1912). Eine Untersuchung über das Modellieren sehender Kinder [A study of modeling of sighted children]. *Zeitschrift für angewandte Psychologie, 6,* 1–20.

Matz, W. (1915). Zeichnen und modellier Versuch an Volkschülern, Hilfschülern, Taubstummen und Blinden [Drawing and modeling of elementary and junior

high school students, deaf and blind pupils]. *Zeitschrift für Angewandte Psychologie, 10,* 62–135.

McBride, L. R. (1986). *Petroglyphs of Hawaii.* Hilo: Hawaii Petroglyph Press.

Meili-Dworetzky, G. (1981). Kulturelle Bedingungen des Zeichenstils und seines Wandels. In K. Foppa & R. Groner (Eds.), *Kognitive Strukturen und ihreEntwicklung* [The cultural determinants of drawing style and its transformation]. Bern, Switzerland: Hans Huber.

Meili-Dworetzky, G. (1982). *Spielarten des Menschenbildes* [Playful depictions of the human figure]. Bern, Switzerland: Hans Huber.

Michelmore, M. C. (1985). Geometrical foundations of children's drawings. In N. Freeman & M. Cox (Eds.), *Visual order* (pp. 289–309). Cambridge: Cambridge University Press.

Milbrath, C. (1995). Germinal motifs in the work of a gifted child artist. In C. Golomb (Ed.), *The development of artistically gifted children* (pp. 101–134). Hillsdale, NJ: Lawrence Erlbaum.

Milbrath, C. (1998). *Patterns of artistic development.* New York: Cambridge University Press.

Milbrath, C., & Siegel, B. (1996). Perspective taking in the drawing of a talented autistic child. *Visual Arts Research, 22*(2), 56–75.

Miles, H. L. (1990). The cognitive foundations for reference in a signing orangutan. In S. T. Parker & K. R. Gibson (Eds.), *"Language" and intelligence in monkeys and apes* (pp. 511–539). New York: Cambridge University Press.

Miles, H. L., Mitchell, R., & Harper, S. (1996). Simon says: The development of imitation in an enculturated orangutan. In A. Russon, K. Bard, & S. T. Parker (Eds.), *Reaching into thought: The minds of great apes.* New York: Cambridge University Press.

Miller, L. K. (1999). The savant syndrome: Intellectual impairment and exceptional skill. *Psychological Bulletin, 125,* 31–46.

Minardi, T. (1987). On the essential question of painting from its Renaissance to the period of its perfection. In J. C. Taylor (Ed.), *Nineteenth-century theories of art.* Berkeley: University of California Press. (Original work published 1843)

Morishima, A. (1974). Another van Gogh of Japan: The superior artwork of a retarded boy. *Exceptional Children, 41,* 92–96.

Morishima, A., & Brown, L. F. (1977). A case report of the artistic talent of an autistic idiot savant. *Mental Retardation, 15,* 33–36.

Morra, S. (1995). A neo-Piagetian approach to children's drawings. In C. Lange-Küttner & G. V. Thomas (Eds.), *Drawing and looking* (pp. 93–106). London: Harvester Wheatsheaf.

Morris, D. (1962). *Biology of art.* London: Methuen.

Müller, U., & Overton, W. F. (1998). How to grow a baby: A reevaluation of image-schema and Piagetian action approaches to representation. *Human Development, 41,* 71–111.

O'Connor, N., & Hermelin, B. (1987a). Visual graphic abilities of the savant artist. *Psychological Medicine, 17,* 79–90.

O'Connor, N., & Hermelin, B. (1987b). Visual memory and motor programme: Their use by savant artists and controls. *British Journal of Developmental Psychology, 78,* 307–323.

O'Connor, N., & Hermelin, B. (1990). The recognition failure and graphic success of idiot savant artists. *Journal of Child Psychology and Psychiatry, 31,* 203–215.

Ormond, R. (1981). *Sir Edwin Landseer.* New York: Rizzoli.

Paget, G. W. (1932). Some drawings of men and women made by children of certain non-European races. *Journal of the Royal Anthropological Institute, 62,* 127–144.

Paine, S. (Ed.). (1981). *Six children draw.* London: Academic Press.

Pariser, D. (1981). Nadia's drawings: Theorizing about an autistic child's phenomenal ability. *Studies in Art Education, 22*(2), 20–31.

Pariser, D. (1983). The pitfalls of progress: A review and discussion of Gablik's 'Progress in Art.' *Visual Arts Research, 9*(1), 41–54.

Pariser, D. (1995a). Lautrec—Gifted child artist and artistic monument: Connections between juvenile and mature work. In C. Golomb (Ed.), *The development of artistically gifted children* (pp. 31–70). Hillsdale, NJ: Erlbaum.

Pariser, D. (1995b). Not under the lamppost: Piagetian and neo-Piagetian research in the arts. A review and critique. *Journal of Aesthetic Education, 29*(3), 94–108.

Pariser, D. (1999). Looking for the muse in some of the right places. *American Journal of Education, 107,* 155–169.

Park, C. C. (1982). *The siege.* Boston: Little, Brown.

Parker, S., & McKinney, M. (2000). *Origins of intelligence: The evolution of cognitive development in monkeys, apes, and humans.* Baltimore: John Hopkins University Press.

Patterson, F. G., & Linden, E. (1981). *The education of Koko.* New York: Holt, Rinehart & Winston.

Perner, J. (1991). *Understanding the representational mind.* Cambridge, MA: MIT Press.

Phillips, L. A., Inall, M., & Lauder, E. (1985). On the discovery, storage, and use of graphic depiction. In N.

Freeman & M. Cox (Eds.), *Visual order* (pp. 122–134). Cambridge, England: Cambridge University Press.

Piaget, J. (1926). *Language and thought of the child.* London: Routledge & Kegan Paul.

Piaget, J. (1928). *Judgment and reasoning in the child.* London: Routledge & Kegan Paul.

Piaget, J. (1929). *The child's conception of the world.* New York: Harcourt, Brace & World.

Piaget, J. (1950). *The psychology of intelligence.* New York: Harcourt Brace.

Piaget, J. (1951). *Play, dreams, and imitation.* New York: W. W. Norton.

Piaget, J. (1971). *Biology and knowledge.* Chicago: University of Chicago Press.

Piaget, J., & Inhelder, B. (1956). *The child's conception of space.* London: Routledge & Kegan Paul.

Piaget, J., & Inhelder, B. (1969). *The psychology of the child.* London: Routledge & Kegan Paul.

Piaget, J., & Inhelder, B. (1971). *Mental imagery in the child.* London: Routledge & Kegan Paul.

Piaget, J., Inhelder, B., & Szeminska, A. (1960). *The child's conception of geometry.* London: Routledge & Kegan Paul.

Porath, M. (1997). A developmental model of artistic giftedness in middle childhood. *Journal for the Education of the Gifted, 20,* 201–223.

Potpeschnigg, L. (1912). Aus der Kindheit der bildenden Kunst [From the childhood of the pictorial arts]. *Schriften für Erziehung und Unterricht,* No. 2. Leipzig, Germany: Seeman.

Pring, L., & Hermelin, B. (1993). Bottle, tulip, and wineglass: Semantic and structural picture processing by savant artists. *Journal of Child Psychology and Psychiatry, 34,* 1365–1385.

Pring, L., Hermelin, B., & Heavey, L. (1995). Savants, segments, art, and autism. *Journal of Child Psychology and Psychiatry, 36,* 1065–1076.

Reith, E. (1988). The development of use of contour lines in children's drawings of figurative and non-figurative three-dimensional models. *Archives de Psychologie, 56,* 83–105.

Reith, E. (1997). Drawing development. In A. M. Kindler (Ed.), *Child development in art* (pp. 59–79). Reston, VA: National Art Education Association.

Ricci, C. (1887). *L'Arte dei bambini* [The art of children]. Bologna, Italy: N. Zanichelli.

Riegl, A. (1893). *Stilfragen* [Issues of style]. Berlin, Germany: LTB.

Rogers, L. R. (1969). *Sculpture.* London: Oxford University Press.

Rogoff, B. (2000). *Culture and development.* New York: Oxford University Press.

Rouma, G. (1913). *Le langage graphique de l'enfant* [The graphic language of the child]. Brussels, Belgium: Misch & Throw.

Rousseau, J. J. (1762). *Emile.* New York: Barrons Educational Series, 1964.

Rubin, W. (1984). Modernist primitivism: An introduction. In W. Rubin (Ed.), *Primitivism in 20th century art* (Vol. 1, pp. 1–84). New York: Museum of Modern Art.

Ruskin, J. (1843). *Modern painters.* London: Smith, Elder, & Co.

Ruspoli, M. (1986). *The cave at Lascaux.* New York: Harry N. Abrams.

Sachs, O. (1985, April 25). The autistic artist. *New York Review of Books,* pp. 106–125.

Sachs, O. (1995). *An anthropologist on Mars: Seven paradoxical tales.* New York: Knopf.

Salz, E., & Brodie, J. (1982). Pretend-play training in childhood: A review and critique. *Contributions to Human Development, 6,* 97–113.

Sanders, N. K. (1985). *Prehistoric art in Europe* (2nd ed.). Harmondsworth, NY: Viking Penguin.

Saxe, G. B. (1991). *Culture and cognitive development.* Hillsdale, NJ: Erlbaum.

Schaafsma, P. (1980). *Indian rock art of the Southwest.* Albuquerque: University of New Mexico Press.

Schaefer-Simmern, H. (1948). *The unfolding of artistic activity.* Berkeley: University of California Press.

Schiller, P. H. (1951). Figural preferences in the drawings of a chimpanzee. *Journal of Comparative Physiological Psychology, 44,* 101–111.

Schubert, A. (1930). Drawings by Orotchen children and young people. *Journal of Genetic Psychology, 37,* 232–243.

Selfe, L. (1977). *Nadia: A case of extraordinary drawing ability in an autistic child.* London: Academic Press.

Selfe, L. (1995). Nadia reconsidered. In C. Golomb (Ed.), *The development of artistically gifted children* (pp. 197–236). Hillsdale, NJ: Lawrence Erlbaum.

Sherman, L., Landau, S., & Pechter, L. (1977). A study of the young child's development in the use of clay and Styrofoam as art media. *Canadian Review, 4*(1), 68–78.

Singer, D. G., & Singer, J. L. (1990). *The house of make-believe.* Cambridge, MA: Harvard University Press.

Smith, D. A. (1973). Systematic study of chimpanzee drawing. *Journal of Comparative and Physiological Psychology, 82,* 406–414.

Smith, N. R., & Fucigna, C. (1988). Drawing systems in children's pictures: Contour and form. *Visual Arts Research, 14*(1), 66–76.

Soffer, O., Adovasio, J. M., & Hyland, D. C. (2000). The "Venus" figurines: Textiles, basketry, gender, and status in the Upper Paleolithic. *Current Anthropology, 41*, 511–538.

Staaller, N. (1986). Early Picasso and the origins of cubism. *Arts Magazine, 60*(1), 80–92.

Stern, W. (1908). Sammlungen freier Kinderzeichnungen [Collections of children's free drawings]. *Zeitschrift für angewandte Psychologie und Psychologische Sammelforschung, 1*, 179–187.

Stern, W. (1909). Die entwicklung der Raumwahrnehmung in der ersten Kindheit [The development of spatial perception in early childhood]. *Zeitschrift für Angewandte Psychologie und Psychologische Sammelforschung, 2*, 412–423.

Stern, W. (1914). *Psychologie der frühen Kindheit* [The psychology of early childhood]. Leipzig: Quelle & Meyer.

Stern, C., & Stern, W. (1910). Die zeichnerische Entwicklung eines Knaben vom 4 bis zum 7 Jahre [Drawing development of a boy from age 4 to 7]. *Zeitschrift für Angewandte Psychologie, 3*, 1–31.

Sullivan, K., & Winner, E. (1993). When 3-year-olds understand ignorance, false belief and representational change. *British Journal of Developmental Psychology, 9*, 159–171.

Sully, J. (1896). The child as artist. In *Studies of childhood*. London: Appleton.

Sully, J. (1897). *Children's ways*. New York: Appleton.

Sundberg, N., & Ballinger, T. (1968). Nepalese children's cognitive development as revealed by drawings of man, woman, and self. *Child Development, 39*, 969–985.

Tarr, P. R. (1992). *Two-year-old children's artistic expression in a group setting: Interaction and the construction of meaning.* Unpublished doctoral dissertation, University of British Columbia.

Taylor, J. C. (Ed.). (1987). *Nineteenth-century theories of art.* Berkeley: University of California Press.

Thomas, G. V., & Silk, A. M. J. (1990). *An introduction to the psychology of children's drawings.* New York: New York University Press.

Thorndike, E. L. (1913). The measurement of achievement in drawing. *Teachers College Record, 14*(5).

Tinbergen, N. (1951). *The study of instinct.* Oxford, England: Oxford University Press.

Tomasello, M., & Call, J. (1997). *Primate cognition.* Oxford, England: Oxford University Press.

Topal, C. W. (1986). *Children, clay, and sculpture.* Worcester, MA: Davis.

Töpffer, R. (1848). *Rèflexions et menus propos un peintre génevois* [Reflections and remarks of a Genevon painter]. Paris: J.J. Dubochet & Lechevalier.

Torbrugge, W. (1968). *Prehistoric European art.* New York: Harry N. Abrams.

Treffert, D. A. (1989). *Extraordinary people.* New York: Bantam Press.

van Sommers, P. (1995). Observational, experimental, and neuropsychological studies of drawing. In C. Lange-Küttner & G. V. Thomas (Eds.), *Drawing and looking* (pp. 44–61). London: Harvester Wheatsheaf.

Verworn, M. (1908). *Zur Psychologie der primitieven Kunst* [Contribution to the psychology of primitive art]. Jena, Germany: Fischer.

Viola, W. (1936). *Child art and Franz Cizek.* Vienna: Austrian Red Cross.

Vygotsky, L. (1962). *Thought and language.* Cambridge, MA: MIT Press.

Vygotsky, L. (1966). Play and its role in the psychological development of the child. *Problems of Psychology, 6*, 62–76. (Original paper presented in 1933 at the Leningrad Pedagogical Institute)

Vygotsky, L. (1971). *The psychology of art.* Cambridge, MA: MIT Press.

Vygotsky, L. (1978). *Mind in society.* Cambridge, MA: Harvard University Press.

Warner, M. (1981). John Everett Millais, drawings from seven to eighteen years. In S. Paine (Ed.), *Six children draw* (pp. 9–22). New York: Academic Press.

Wartofsky, M. W. (1994). Is a developmental history of art possible? In M. Franklin & B. Kaplan (Eds.), *Development and the arts* (pp. 227–241). Hillsdale, NJ: Erlbaum.

Waterhouse, L. (1988). Speculations on the neuroanatomical substrate of special talents. In L. K. Obler & D. Fine (Eds.), *The exceptional brain: Neuropsychology of talent and special abilities* (pp. 493–512). New York: Guilford.

Wechsler, D. (1974). *Manual for the Wechsler intelligence scale for children.* New York: Psychological Corp.

Wellman, H. M. (1990). *The child's theory of mind.* Cambridge, MA: MIT Press.

Werkmeister, O. K. (1977, September). The issue of childhood in the art of Paul Klee. *Arts Magazine, 52*(1), 138–151.

Werner, H. (1957). *Comparative psychology of mental development* (rev. ed.). New York: International Universities Press.

Wertsch, J. (1985). *Vygotsky and the social formation of mind.* Cambridge, MA: Harvard University Press.

Wertsch, J. (1991). *Voices of the mind.* Cambridge, MA: Harvard University Press.

Westergaard, G. C., & Suomi, S. J. (1997). Modifications of clay forms by tufted Capuchins (*Cebus apella*). *International Journal of Primatology, 18,* 455–467.

White, R. (1986a). *Dark caves, bright visions: Life in Ice Age Europe.* New York: American Museum of Natural History/W. W. Norton.

White, R. (1986b). Rediscovering French Ice Age art. *Nature, 320,* 683–684.

White, R. (1993). Technological and social dimensions of "Aurignacian-Age" body ornaments across Europe. In H. Knecht, A. Pike-Tay, & R. White (Eds.), *Before Lascaux* (pp. 277–298). Boca Raton, FL: CRC Press.

Whiting, B. B., & Edwards, C. P. (1988). *Children of different worlds.* Cambridge, MA: Harvard University Press.

Willats, J. (1977). How children learn to draw realistic pictures. *Quarterly Journal of Experimental Psychology, 29,* 367–382.

Willats, J. (1997). *Art and representation.* Princeton, NJ: Princeton University Press.

Wilson, B., & Wilson, M. (1977). An iconoclastic view of the imagery sources in the drawing of young people. *Art Education, 30,* 4–12.

Wilson, B., & Wilson, M. (1979). Figure structure, figure action, and framing in drawings of American and Egyptian children. *Studies in Art Education, 21,* 33–43.

Wilson, B., & Wilson, M. (1982). *Teaching children to draw: A guide for teachers and parents.* Englewood Cliffs, NJ: Prentice Hall.

Wilson, B., & Wilson, M. (1984). Children's drawings in Egypt: Cultural style acquisition as graphic development. *Visual Arts Research, 10*(1), 13–26.

Wilson, B., & Wilson, M. (1985). The artistic tower of Babel: Inextricable links between culture and graphic development. *Visual Arts Research, 11*(1), 90–104.

Wiltshire, S. (1987). *Drawings.* London: Dent.

Wiltshire, S. (1989). *Cities.* London: Dent.

Wiltshire, S. (1991). *Floating cities.* New York: Summit Books.

Winner, E. (1982). *Invented worlds.* Cambridge, MA: Harvard University Press.

Winner, E. (1989). How can Chinese children draw so well? *Journal of Aesthetic Education, 23*(1), 41–63.

Winner, E. (1996). *Gifted children: Myths and realities.* New York: Basic Books.

Wittkower, R. (1977). *Sculpture, process and principles.* New York: Harper & Row.

Wolf, D. P. (1994). Development as the growth of repertoires. In M. B. Franklin & B. Kaplan (Eds.), *Development and the arts* (pp. 59–78). Hillsdale, NJ: Erlbaum.

Wolf, D. P., & Perry, M. D. (1988). From endpoints to repertoires: Some new conclusions about drawing development. *Journal of Aesthetic Education, 22*(1), 17–34.

Wollheim, R. (1987). *Painting as an art.* Princeton, NJ: Princeton University Press.

Wollheim, R. (1993). *The mind and its depth.* Cambridge, MA: Harvard University Press.

Wulff, O. (1927). *Die Kunst des Kindes* [The art of the child]. Stuttgart, Germany: Ferdinand Enke.

Wulff, O. (1932). Kernfragen der Kinderkunst und des allgemeinen Kunstunterrichts der Schule [Basic issues in child art and the teaching of art in the school]. *Zeitschrift für Aesthetik und allgemeine Kunstwissenschaft, 26*(1), 46–85.

Zerffi, G. G. (1876). *A manual of the historical development of art.* London: Hardwicke & Bogue.

Zimmerman, E. (1995). It was an incredible experience: The impact of educational opportunities on a talented student's art development. In C. Golomb (Ed.), *The development of artistically gifted children* (pp. 135–170). Hillsdale, NJ: Erlbaum.

Zsensun, Z., & Low, A. (1991). *A young painter: The life and paintings of Wang Yan—China's extraordinary young artist.* New York: Scholastic.

Author Index

Subject Index

Aesthetics
 of child art, modernist artists and, 119–120
 composition for, 29
 of gifted child, 35
Anasazi rock carvings, 85–87
 abstract designs in, 85, 86
 of humpback flute players, 85–86
 period of, 85
 representational figures in, 85, 86
 stability of representational patterns in, 95
Andersson, I.
 Nambian children's art and, 92–94
Andersson, S.
 Nambian children's art and, 92–94
Animal models
 differentiation in, 73–74, 75, 83
Animals
 in cave art, 100–101, 106
 dimensionality and, 68
 figural differentiation and representational models of, 81–82, 83
 mixed view of
 in drawings, 21, 25
 in sculpture, 69
 sculptures in prehistoric art, 104–105
 shamanic meaning of, 108
 tadpole and, 81–82
 three-dimensional modeling of, 65
 uprightness of, 66, 68, 70, 76
Apes
 drawing recognition in, 98
 mark making by, 97–98
Ariès, 118, 119
Armlessness
 in drawing, 21, 24
 in playdough models, 61
Arms
 in early human drawings, 20, 21, 22, 23
Arnheim, R.

on developmental stage progression, 35
on development of sculpture, 52
on equivalences of form, 16–17
on Piagetian orientation, 16
representational theory of graphic development, 16–18, 47
Artistic development
 art historian views of, 135–138
 communication intention and, 134
 diverse trajectories in, 134–135
 drive to expression in, 137–138
 "how" question in, 136
 linear stage conception of developmental psychologists, 135
 medium in, 137
 narrative art versus school art in, 134
 non-linear, 134, 135
 plurimedia in, 134
 visual imagery in, 134–135
 "what" question in, 136
Autism and mental retardation
 artistic giftedness and, 37–40
 comparison with normal children, 37–40
 Down syndrome artist and, 38
 giftedness and, 39–40, 113–114
 mastery of models and materials and, 133
 visual-spatial skills in, 114
Autistic savants, 37–40, 45–46

Balance
 in clay modeling, 64
 in early drawings, 21, 23
Blaue Reiter
 child art and, 118–119
Bowlby, J.
 attachment and socialization in, 124–125
Breuil, H., 113

Canonical orientation
 in drawing and sculpture, 12, 65, 81, 85
 in early drawings, 21, 22, 24, 25
 in frontal orientation of the human figure, 21, 81, 85
Cartooning, by child artist, 130
Cave art. See Parietal (cave) art
Child
 cognitive competencies of, 123–124
Child art
 aesthetic in, 127
 appeal of, 127–128
 characteristics of, 127
 composition in, 127
 conceptual immaturity, 3, 10–12, 84, 131
 developmental phases in, 128
 domain specificity and, 133–135
 graphic models of preliterate children universal factors in, 40
 historical review of, 3–6
 modernist artists and, 119–121
 narrative intent in, 129
 post-World War II art and, 121
 in preschool, 132–133
 recapitulation theories of, 127
 as source of inspiration, 118–122
 stage theories of
 criticism of, 131–133
 style of, hallmarks of, 3–4, 30
 intellectual and visual realism, 11, 12, 101, 113
 object-centered and view-centered, 12
 reading-off and romancing, 19, 53
 verbal designation, 54
 talent and, 45, 133–135
Child artist
 comparison with adult artist, 129
Child development
 attachment and socialization in, 124–125

About the Author

CLAIRE GOLOMB is a professor of psychology at the University of Massachusetts at Boston. She has written extensively on the development of child art and on children's imaginative development. She is the author of *Young Children's Sculpture and Drawing* and *The Child's Creation of a Pictorial World* and is the editor of *The Development of Artistically Gifted Children*.